WASHINGTON
BEER

A Heady History of
Evergreen State Brewing

MICHAEL F. RIZZO

AMERICAN PALATE

Published by American Palate
A division of The History Press
Charleston, SC
www.historypress.net

Copyright © 2016 by Michael F. Rizzo
All rights reserved

Front cover image by Rex S., via Flickr.

First published 2016

Manufactured in the United States

ISBN 978.1.46711.908.5

Library of Congress Control Number: 2016930883

This is dedicated to my best friend and lover. We've been through good times and hell. You have cared for me and loved me, and life is better with you in it.

CONTENTS

FOREWORD

There's no doubt that the state of Washington has been one of craft brewing's premier hotbeds. Due variously to Yakima Valley hops; regionally grown barley for malting in the enormous Great Western facility down in Vancouver (founded in 1934); and irrepressible characters and entrepreneurs such as Bert Grant, Robert Kufner and Charles Finkel, it simply makes sense that craft brewers would continue the proud tradition begun by innovators and pioneers like Henry Weinhard, Emil Sick and Andrew Hemrich. The eleven-ounce stubby was invented here, for crying out loud, in 1935, able through a distinctive shape and dubious marketing to withhold the equivalent of a whole twelve-ounce beer from purchasers of a twelve-pack. What brilliance!

In fact, there is an endless list of names connected to Washington's brewing history, names of people, beers and breweries, stretching back well before statehood and marching up imposingly to the present day. Nearly all of them are chronicled here by Mike Rizzo, whose book proves to be the ultimate argument settler where the trivia of Washington beer is concerned. For me, reading back through our state's illustrious past was a lot of fun. Who knew, for example, the connection between a number of local breweries and clam packing? Who knew that during Prohibition—sadly another idea first floated in the Evergreen State—as breweries scrambled to make ends meet by getting into other product lines, that such things as soap, coconut butter, pickles and soft drinks would do a little of their own pioneering? Olympia Brewing made a line of juice drinks from various fruits—an apple

"champagne" called Appleju and one made from loganberries called Loju. Take that, Lime-a-Rita! Out in Spokane, local boy Bing Crosby got so sick of the sight of barrels of pickles in his father's brewery that he finally threw it all over and headed down to Hollywood.

It's the modern era that must have been hardest to chronicle, as even though many of the participants are still knocking around, they've spun off and recombined so many times that the order in which things happened must at times have seemed like a brewing industry version of *Rashomon*. I've been around through much of it, and only a few times did I think I might have had anything more to add.

For there's truly never been a more active and exciting time in the history of brewing than now. Here in Washington, we've got three-hundred-odd breweries in operation, with many more on the way. One of my fondest realizations of the past twenty or so years is riding my bike along the Burke-Gilman Trail in Seattle and smelling boiling wort from a line of several breweries reaching from Ballard to Woodinville. These days, of course, it's possible to visit clusters of breweries on foot in neighborhoods across the state. It's an age more golden than the past.

It seems like ancient history now to recall arriving in Seattle in 1990, homebrew in hand and pounding the pavements looking for my first brewing job. At probably no more than thirty thousand barrels' production at the time, Redhook was the big craft brewery in the state, and it was a pretty substantial drop after that. Pyramid was next, I guess, and probably then Grant's or Hale's, which at the time had the two little breweries in Colville and Kirkland. A few of my alma-maters-to-be, Big Time and Pike Place Brewery, had just gotten off the ground, and there were the Noggins pubs and Pacific Northwest in Pioneer Square. Back then, we also had a few big breweries in Rainier and Olympia, of course. The Artesians were still fresh in everyone's minds, as were the clever Rainier ads—the one with the motorcycle running through its gears and the frogs that chanted "Rainier beer" years before they'd been co-opted to say "Budweiser." Don't get me started on Bud ads, please.

Another of my favorite memories of quirky local brewing is the day the beer all across town got cloudy. I'd been working at Elysian the morning of the Nisqually earthquake in February 2001, and despite the fact that the Douglas fir–framed building was probably one of the soundest and safest places to be, we all ran outside and watched the pavement ripple down the hill like a receding wave of water and the light poles flail like trees in a gale. Back inside, things got more or less back to normal, but in all the shaking,

one of our full conditioning tanks ended up knelt forward on the cellar floor, its legs bent backward under the dish bottom. The next day, when we emptied it, they popped right back out. Later that day, when I had a beer after work, I noticed that with all that sloshing back and forth, of course all the beer in the serving tanks was less than absolutely bright. An hour or so later, meeting friends over at Big Time, I had to remind the confused bartender just coming on shift why the beer he was pouring was cloudy.

So, here you have it: the most complete accounting to date of what's gone on in the Washington brewing scene from then until now, which itself is a moving target. From the rivalries, the buyouts and bankruptcies, the difficulties of Prohibition and the resurgence and flowering of the past thirty years, Mike has tracked it all down. Rainier, it turns out, was a San Francisco–based brand for many years. Good thing we got that one back, however briefly. We also had some of the earliest craft IPAs in the country in Grant's, Big Time Bhagwan's Best and at Pike Place. And something tells me that we're not done yet—there are further appendices yet to come, in books like Mike's and on street corners throughout our state and beyond.

Dick Cantwell
Co-founder Elysian Brewing Company

INTRODUCTION

Beer in the United States is and has almost always been thought of simply as a drink. The alcoholic content in early beers was often lower than that of many beers today. When fighting the temperance movement and prohibitionists in the late 1800s and early 1900s, they often touted the ill effects of hard liquor such as whiskey, but usually not beer. As an example of how things change, a petit jury in 1859 in Steilacoom, Washington, asked for a meal while deliberating:

One Ham;
Twelve dozen eggs;
Two pounds butter;
Six loaves of bread;
Three cans of oysters;
Three do. pears;
Three do. peaches;
One gallon whisky (Scotch);
Five gallons of lager.

I'm pretty sure most courts would not approve of a keg of beer in a jury deliberation room today.

The Pacific Northwest has a unique place in the brewing world. Hoppy beers of nearly every style are produced, even if that style does not call for it. India pale ales (IPAs) could be what many people associate with the area.

Most modern breweries can't seem to survive without brewing at least one, but some are trying to differentiate themselves and that will help to provide the needed variety to help sustain this ever-growing industry. Just when you think that another brewery could not open in Washington, another one does. Just when you think that you've heard or tried every possible variation of beer style, another combination is released.

The sheer number of breweries in Washington (and my need to be doing something at all times) was the impetus to start a weekly audio podcast on the Washington brewing industry, *Northwest Brew Talk*, in January 2015. Together with my wife, Michelle, we have met dozens of brewers, tasted dozens of Washington beers and continually pushed to expand our knowledge and let the world know about the great breweries in our state.

There have been hundreds of breweries in Washington, most within the past ten years. Some very small breweries have been left out, as they were open just a short time or left little footprint. Sometimes I had to make a judgment call based on information I could find. This is not intended to be the definitive book on brewing in Washington, but it is pretty close.

Because of the number of breweries in the state, it has been quite the task keeping up with openings, closings, mergers, expansions and more. Up until the day I submitted the final manuscript, I was still making changes to the current brewery scene. Of course, there could be a mistake or two. Dealing with 160 years of information and hundreds of breweries and people, there tends to be a mistake now and then. I'll apologize for that now.

I have written a number of history books, and one thing I try my best to do is either corroborate facts or dismiss them. This book is no different. There were several things often touted as "facts" in books or on websites, copied from website to website and even repeated in some books. If I could not find an original source, an old book or newspaper article, I usually discount it. If I could not verify it by census records or city directories, it may not have been true and I did not include it.

Since there are so many cities mentioned in Washington, I only specify the state if the city is not in Washington.

Also, remember that dollar amounts are from that time period: $5,000 in 1890 is $134,000 in today's dollars. If you want to compare dollar values to today, this site is very useful: www.measuringworth.com/calculators/uscompare/relativevalue.php.

Special thanks goes to the Washington Beer Commission, Charles and Rose Ann Finkel, Mari and Will Kemper, Steve Acord and the many

breweries and individuals who contributed information and photos for this project. All photos are credited.

And as always, thank you to my wonderful wife, Michelle (who was pregnant while I wrote); son, Gerlando; and my baby girl, Isabella. Michelle did a tremendous amount of research for the modern breweries that saved me hundreds of hours of work and could really be considered my co-author. I love you all more than these words express.

Stay hoppy, my friends!

Chapter 1

THE BEGINNING

When Beer Came to Washington

Temperance movement–minded people were constantly trying to have alcohol outlawed. In 1866, the Department of Agriculture in Washington, D.C., stated, "The intemperate use of beer is like the intemperate use of anything detrimental to health, but a moderate use of pure beer will aid digestion, quicken the powers of life, and give elasticity to the body and mind and will not produce any of the terrible results named by fanatics and ignorant people."

We may not exactly know who built the first brewery in Washington State, but there were several pioneer brewers across the state who led the way. Most early breweries were attached to the homes of the owner and often were also saloons—not much different from today's brewpubs.

One of those early pioneers in Washington was Henry Weinhard, who was born on February 18, 1830, in Lindenbronn, Württemberg, Germany. He moved to Stuttgart, Germany, where he became a brewer's apprentice. Weinhard came to America in 1852, settled in the German-populated city of Cincinnati, Ohio, and worked in a brewery there for several years before moving to Portland, Oregon. He began working in John Meunch's brewery near Fort Vancouver, "which catered primarily to the soldiers garrisoned there." Weinhard lasted six months before heading back to Portland, where he partnered with brewer George Bottler. Weinhard went back to Vancouver in early 1857 and returned to work at Muench's brewery. In 1859, Henry Weinhard purchased the brewery and renamed it Vancouver Brewery.

Emil Meyer was born in Germany in 1833. "He served in the U.S. Army, escorting immigrant wagon trains to Oregon. Meyer may have worked as an Army concessionaire to provide the troops at Fort Walla Walla with beer before 1859." Just when Meyer started a brewery is not exactly known, but he and his neighbor, Joseph Hellmuth, advertised their breweries in the *Walla Walla Statesman* newspaper in 1861. In 1862, Meyer built City Brewery on Second Street.

John U. Hofstetter started a brewery in Fort Colville in about 1860 after leaving Oregon. The brewery suffered a major fire in 1873, so he moved the brewery to his homestead, where his Colville Brewery (1874) was erected. In 1878, he sold 126 barrels of beer and 186 barrels in 1879. In 1889, the town was incorporated, taking land from Hofstetter and another man, and Hofstetter became the first chairman of the council.

In 1862, Charles Wood, a cooper (someone who builds barrels), opened what is believed to be the first brewery in Olympia next to his cooper shop. He was said to have the first cream ale in the territory, and the *Washington Standard* newspaper reported, "We had the pleasure of examining this new feature of our town this week. The lager from this beer is pronounced to be the best quality." He later sent hop roots to Jacob R. Meeker in Steilacoom, leading to the beginning of the hop business in Washington.

Brewers were important in their communities, from organizing churches and social organizations to helping fund public projects. A case in point was in June 1862, when brewer Joseph Hellmuth campaigned to organize a fire department and purchase the first fire engine in Walla Walla. "He raised $1,600 and contributed $500 himself toward purchase of a Hunneman 'tub' engine."

Washington Brewery was manufacturing porter, beer and cream ale in Seattle before the spring of 1864. Started by A.B. Rabbeson & Company, Rabbeson was a businessman and involved in numerous enterprises, but his obituary does not mention a brewery. By 1865, the brewery had moved and was operated by McLoon & Sherman, until it sold it in 1872 to Stewart Crichton & Company, which renamed it Seattle Brewery. It would create Rainier Beer as early as 1878.

It was 1862 when Henry Weinhard, operating Vancouver Brewery since 1859, decided to return to Portland, Oregon. He purchased a brewery and in 1864 sold the Vancouver Brewery to Anton Young.

On February 1, 1865, Martin Schmieg and Joseph Butterfield announced their new brewery, the North Pacific Brewery, in Seattle. Butterfield later sold his share, and Schmieg partnered with Amos Brown. For a time, the

Brown family lived on the second floor of the brewery. By 1867, they were advertising that they were manufacturing porter, ale and lager beer. Brown, born in New Hampshire in about 1835, was listed as a brewer in 1870, with his real estate valued at $7,525. That same year, John Locke was operating a distillery and brewery in Steilacoom.

On June 24, 1865, Ludwell J. Rector signed an agreement with Emil Meyer (of City Brewery) allowing Meyer the right to construct a mash mill on what today would be 345 South Second Avenue, Walla Walla, and use water from Robert's Creek (Lincoln Creek) for the next five years. Meyer died in 1868 at the age of thirty-five. On June 4, 1870, A.B. Roberts sold Meyer's water rights and a ten-foot alley to brewer Joseph Hellmuth.

John H. Stahl was born in 1825 in Germany. He was a sailor and employed as a ship's carpenter. It is believed that he was in California during the gold rush, where he met his future wife. After marrying Catherine Rehorn, sometime after 1858, they moved to Canyon City, Oregon, where Catherine ran a grocery store and John opened City Brewery with Mr. Salori. In 1870, a "disastrous" fire, producing $275,000 in damages, struck Canyon City, Oregon. The City Brewery was destroyed, so the Stahl family packed up and moved to Walla Walla. There John Stahl purchased the former City Brewery of Emil Meyer. The brewery manufactured only steam beer until 1888, when it began brewing lager beer. The origin of steam beer is not fully known, but it is believed to be beer brewed with lager yeast without the use of refrigeration. The Stahl brewery was located across the street from Emil Meyer's mill, and Joseph Hellmuth had a business interest in the Stahl property. John Stahl contracted tuberculosis in about 1872, and Catherine Stahl took over brewery operations. She successfully ran it for twelve years until her husband's death in 1884. The brewery sold 851 barrels of beer in 1878 and 811 in 1879.

The year 1872 was the first that Puget Sound had a directory listing businesses, as well as their addresses and advertisements. J.C. and J.R. Wood, brewers in Olympia, sold 175 barrels of beer in 1878 and 24 in 1879.

In 1869, Gustav Joseph opened a brewery in Walla Walla, which he sold in 1872 to George Seisser. Jacob Betz, a German immigrant, arrived from San Francisco, California, as plant superintendent, purchased the brewery in 1875 and renamed it Star Brewery. The brewery sold 216 barrels of beer in 1878 and 222 barrels in 1879.

Morris H. Frost and Jacob D. Fowler, New York natives, were the founders of Mukilteo in about 1857. There are differing accounts as to who started the first brewery in Mukilteo, but Joseph Butterfield from Seattle may have

been back in business as Joseph Butterfield & Company as early as 1867. Butterfield incorporated the Eagle Brewery, with a capacity of 500 barrels per year, in 1875, and the following year, he sold it to Frost & Fowler. There was a financial panic after one of the Northern Pacific Railroad's financiers defaulted, and Frost & Fowler went into receivership. George Cantrini (various spellings) took over the Eagle Brewery in 1878 with partners Theodore H. Boehme and Herman Klausman. They sold 240 barrels of beer in 1878 and 432 barrels in 1879.

In 1870, Jacob Barth, forty-eight, from England, was a brewer in Mukilteo. The following year, Jacob Ripstein of Switzerland was a brewer in Mukilteo.

In about 1875, Slorah (Andrew) & King (A.H.) purchased Washington Brewery in Seattle from Stewart Crichton & Company. Slorah was born in 1841, and an 1877 article noted that "nothing stronger than Slorah & Co.'s beer" was allowed to be sold in Coupeville because it was low alcohol. King retired not long after, and Slorah continued the business. He sold 1,652 barrels of beer in 1878 and 1,111 barrels in 1879. He sold Superior Lager Beer, extra fine ale, porter and lager beer.

In about 1876, the partners at North Pacific Brewery in Seattle split when Amos Brown sold to Martin Schmieg, and shortly thereafter, Schmieg's wife died. Schmieg went to Germany for a visit and left the brewery in the care of August Mehlhorn. Mehlhorn was born in Saxony, Germany, on March 20, 1842, and in 1867 he came to America and landed in Chicago, Illinois. In 1870, he moved to Gray's Harbor and cut wood for a brewery. He moved to Seattle in 1873 and worked on farms. In 1875, he began driving a beer wagon for North Pacific Brewery.

After several months, Schmieg did not return from Germany, so Mehlhorn brought a judgment against the brewery for back wages. The sheriff put the brewery up for auction, and no bids came. He did so a second time, and Mehlhorn reluctantly purchased the brewery to satisfy his own judgment. He took Mr. Picht on as a partner, and Picht and Mehlhorn are listed as proprietors of the brewery in 1876. They manufactured steam beer, ale, porter and lager beer for eight years, selling 1,804 barrels in 1878 and 868 in 1879.

Wolf Schaefer started a brewery in Steilacoom in 1873. Schaefer and Dennis K. Howard became partners in 1878. Schaefer & Howard sold 1,810 barrels of beer in 1878 and 1,559 in 1879, making it the largest brewery in the state at the time.

In 1878, Peter Rumpf & Dunkel began business in Dayton and sold eighty-even barrels of beer that year. In 1879, it only sold sixty barrels.

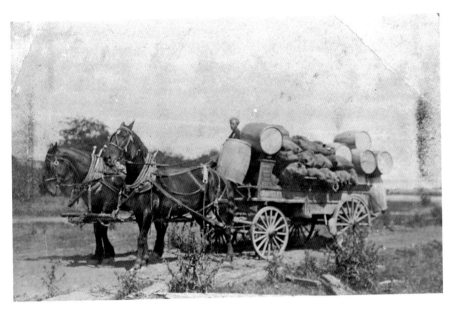

Horses played a large role in the delivery of beer up until the early twentieth century. This photo with horses and a wagon with barrels for Angeles Brewery on Tumwater Creek shows how they would be delivered. *Bert Kellogg Collection of the North Olympic Library System.*

The Scholl brothers, Emil and Ernst, were running a brewery in Pomeroy in 1878. They had come from Germany before working for John H. Stahl at his brewery in Oregon, and then they moved with him to Walla Walla when he opened his new brewery. Columbia Brewery had no sales in 1878 but sold thirty-six barrels in 1879. It was in business until 1884, when they sold the brewery to John Rehorn, who closed it in 1892.

Anton Young's Vancouver Brewery in Vancouver began delivering its "famous bottled lager beer" in mid-July 1879. Sales generally increased for the brewery, as it sold 218 barrels in 1878 and 243 in 1879.

On July 31, 1879, Louis Damphoffer, of the Columbia River Brewery, Vancouver, announced that he was "making an excellent quality of beer" and would deliver for free "bottled beer, or lager beer, in kegs." That was his second year, and he sold thirty barrels, possibly making it the smallest brewery in the state.

THE HOP INDUSTRY: WASHINGTON'S CASH CROP

No story about Washington brewing history would be complete without a brief history of the hop industry. It became tremendously profitable in the 1800s and then again in the twenty-first century. It is an extremely important crop and an essential ingredient in beer. Ask a lover of a hoppy India pale ale, synonymous with the Northwest, and many could tell you the hop flavor they prefer.

Ezra Meeker was born in Ohio in 1830. In April 1852, Meeker, living in Iowa since he was nine, joined thousands making the trek to Oregon Territory. He and his family arrived five months later in Portland and began running a boardinghouse in St. Helens. They then moved to McNeil Island and then Fern Hill, south of Tacoma. They ran general stores and a farm, which was also a failure, so they moved to Puyallup Valley in 1862. In about March 1865, brewer Charles Wood of Olympia sent "three peck of hop roots" to Ezra's father, Jacob R. Meeker, in Steilacoom. Ezra planted "six hills of hops," and his father planted the rest. The following September, they harvested a bale of hops and sold it to Wood for $150. According to Ezra, "This was the beginning of the hop business in the Puyallup Valley, and the Territory of Washington."

In 1869, his father died, and Ezra ended up meeting Henry Weinhard in Portland, Oregon. He told Ezra, "I want your hops next year" and said that they were the finest hops he had ever used. He purchased Ezra's hops for fourteen years. Other farmers began to grow hops, and Meeker added to his fields for "twenty-six successive years" until there were more than five hundred acres, which produced four hundred tons per year. He developed techniques for curing and baling that produced "a hop that would compete with any product in the world."

In 1882, there were crop failures across the world, and the Puyallup Valley crop sold for record prices. Meeker began exporting to England and opened an office there, selling about $500,000 per year—said to be the largest hop export business in the country. In 1892, hop lice struck the hop fields across the West Coast, and his crop sold for a fraction of what it usually did. Meeker quit the business—or, as he said, "the business quit me." In later life, Meeker wrote books and worked to memorialize the Oregon Trail. He was also the first mayor of Puyallup.

Charles Carpenter was another farmer to plant hop rootstock. His family were hop farmers in New York, where hop farming became a major crop in about 1830. By 1849, "New York had attained the national leadership in the

Hops are an important component of beer, providing flavor and aroma, and Washington State produces 70 percent of the world's hops. Ezra Meeker built a hops empire in western Washington, in the Puyallup Valley, beginning in 1865. *Library of Congress.*

production of hops," and "by the Civil War, nearly 90 percent of the total hop crop of the United States was raised in New York."

Between 1868 and 1872, Carpenter moved west and planted hop root cuttings in Moxee. This was the beginning of the hop industry in Yakima Valley. The climate and soil in eastern Washington proved to be perfect for hop growing. By the early 1900s, New York had lost its crown as the hop leader, as Washington farms yielded more per acre. Prices fell, and many New York farmers changed crops. Hops from the Carpenter family are still grown in Washington. By 1930, Moxee City was known as the "hops capital of the world."

There are three distinct growing areas in Washington: the Moxee Valley, the Yakama Indian Reservation and the Lower Yakima Valley. Hops were harvested by hand. Native American women and children often picked hops. "They would come in with horses. And they would stand on the backs of the horses and actually harvest hops by hand. They would pick berry by berry." They would work the fields from sunrise to sunset.

Ezra Meeker spoke of using Indian labor: "They were of all conditions, the old and young, the blind and maimed, the workers and idlers, making a motley mess curious to look upon…[2,500 people] came into the Puyallup valley during the hop harvest of 1882."

In 1992, worldwide hop acreage hit an all-time maximum at 236,067 acres, creating an excess of hops. Much of that was converted to hop extract, which lasts for years. As the cans of extract were sold off over the years, sometimes at a loss, hops prices stayed low. Farmers began converting their land to other crops or selling to developers. By 2006, worldwide hop acreage was down to 113,417 acres.

A series of events caused that to change. In 2006, a massive fire at the S.S. Steiner hop warehouse in Yakima and a poor crop yield in Europe in 2007

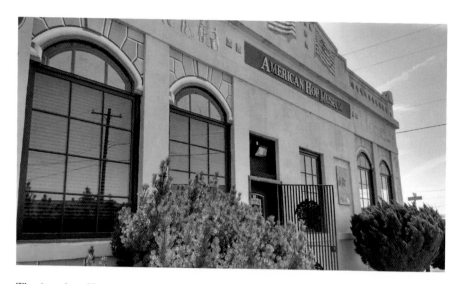

The American Hop Museum in Toppenish, south of Yakima, is the only museum in the country dedicated to the history of the hop plant. It has a lot of great old machinery, tap handles and history that pertains to beer; it is definitely worth the trip if you are in the area. *Author's collection.*

helped to create a worldwide hop shortage. Some hops rose 400 percent in cost, creating pressure on all breweries. Brewers like Rob Hall at Ice Harbor Brewing Company in Kennewick had to make changes to still produce beer: "You know, we kind of mess around. We think we can get some better flavors at a certain temperature and not have to use all the hops as we did before. And we want to save the company some money as well but still produce the best beer in the world." The shortage created a boom in Yakima Valley farmlands, where 26 percent more hops were planted in the spring of 2008.

In 2014, hop acreage was increased by 10 percent in the United States, but low yields led to record acreage in 2015. As of June 2015, Washington had 32,205 acres of hops strung for harvest. Together with Oregon and Idaho, this was a 16 percent increase in the number of acres from 2014. Washington's hop farms accounted for 73 percent of the total acreage in the United States and 20 percent of the world's hop production. There are two types of hops: aromatic varieties grown in Washington that provide good aroma, including Willamette, Cascade and Mount Hood; and alpha varieties grown in Washington that are used to extract bitterness, including Columbus, Tomahawk, Zeus, Nugget and Galena. In 2015, a drought emergency was declared by Washington's governor that could affect the price of hops in the future.

Chapter 2
THE 1880s AND 1890s

The Territory Grows as the Century Ends

By 1880, there were twenty breweries operating in Washington; the largest, producing 1,559 barrels in 1879, was Schaefer & Howard in Steilacoom. Two interesting patterns come from this information. First off, Walla Walla had the most breweries of any city in the state, but the volume was not as high as that of Seattle. Also, it is unknown why there was a sharp drop in sales from 1878 to 1879 in almost every city across the state.

The City Brewery, owned by John and Catherine Stahl in Walla Walla, built a new brick brewery on the same site.

In 1881, Peter Rumpf, who was running a brewery with Mr. Dunkel in Dayton, took Jacob Weinhard on as a partner. Just two years later, Weinhard became sole owner of the brewery. Weinhard came to Dayton in 1880 after an apprenticeship with his uncle Henry Weinhard in Portland, Oregon.

Seattle purchased its second steam fire engine in July 1882. Shortly afterward, a fire broke out in August Mehlhorn's brewery, and "No. 2 was put into action." The engine proved to be too heavy for the incline on Columbia Street, and it ended up sliding downhill into the water. The brewery was dismantled after 1883, and Mehlhorn ran a saloon on Front Street before retiring in 1889.

George Cantrini's brewery in Mukilteo was destroyed by fire in the early 1880s. S.N. Snyder rebuilt the brewery and opened in 1882, operating it until 1884.

Erford & Palmtag started a brewery in Colfax in 1878 and sold 159 barrels of beer in 1879. A severe fire in Colfax destroyed twenty-five

buildings in 1882, including the brewery. With new partner Wolford, the brewery was rebuilt that year.

Sprague Brewery was opened in Sprague by Rudolph O. Porak in about 1882. Porak was born in Germany in about 1845 and had been running a brewery in Dalles, Oregon. The brewery was still in business as late as 1889.

Andrew Hemrich was born in Alma, Wisconsin, on October 31, 1856. He attended the public schools and then spent about twelve years in various states, working mines and establishing a brewery in Glendale, Montana. After several years, he sold the plant and became manager-superintendent of the Bozeman Brewing Company in Bozeman, Montana. After two years, he resigned and left for Seattle, arriving in February 1883, whereupon he met John Kopp and established a steam beer brewery under the name Kopp & Hemrich. In their first year in business, they brewed 2,658 barrels of beer.

On July 17, 1883, the Weinhard Brewery in Dayton was destroyed by a fire, two years after Jacob Weinhard took possession of the plant. He rebuilt, adding a malt house and an outdoor German beer garden.

Edward F. Sweeney was born in San Francisco, California, on May 10, 1860. He was educated at St. Mary's College in San Francisco and at seventeen began working at a bank. Soon after, he started working at the M. Nunan Brewery in that city and stayed for two years. In 1884, Sweeney and W.J. Rule established Puget Sound Brewery, in what is the Georgetown neighborhood in Seattle, to manufacture steam beer. The partners were in business for about eighteen months before Rule sold out and Sweeney became sole owner.

The Bavaria Brewery was opened in Cheney in 1884 by Joseph Weber and operated until 1907. Also in 1884 in Cheney, Frank Locher and Charles Jensen founded the City Brewery. This brewery only survived four years.

Ignatz Fuerst established the New Tacoma Brewery in Tacoma in 1884. That same year, Diederich Stegmann established a brewery at the same address. Stegmann took on a partner in 1886, Harry Lusthoff, and formed United States Brewing & Ice Company.

The Seattle brewery landscape changed in 1884 after John Kopp sold his interest in Kopp & Hemrich brewery to Andrew Hemrich's father, John Hemrich, from Wisconsin, and they renamed the business Hemrich & Company. The following year, Andrew's brother-in-law, Frederick Kirschner, joined the renamed Bay View Brewery.

Brothers Theodore and Charles Henco formed the Henco Brewery in Spokane in 1886.

Rudolph Gorkow was brewmaster for Jacob Ruppert in New York before moving to Spokane in 1886. There he established the New York Brewery.

As labor unions grew in power and popularity, it was only a matter of time before they found their way into the breweries, where safety was always an issue. They became involved in the brewery business in 1886 when the Brewery Workers' Union was formed.

On March 9, 1887, a fire destroyed Main Street between Third and Fourth Streets in Walla Walla. One of the biggest losses, at $15,000, was dealt to the building and Depot Saloon owned by Adolph Schwarz. He was John Stahl's son-in-law and ran the saloon for the City Brewery, owned by Stahl. It was later known as Schwarz's Saloon.

Although all the brewers in Washington were not of German origin, Anton Huth was, being born in Germany in 1854. There he learned the trades of brewer and maltster at a young age. His father died about 1871, and with his mother and family, they moved to America that fall. They settled in Louisville, Kentucky, where the young brewer secured a position in a brewery that he held for fourteen years. In about 1885, Huth and his mother moved to Portland, Oregon, where he secured a foreman position at City Brewery, owned by Henry Weinhard. He stayed there about two years and then found his way to Vancouver, just nine miles north. By this time, Huth had gained a wealth of brewery experience and had saved enough money to become a partner in the Star Brewery in Vancouver with Anton Young and George H. Mockel, who had joined the firm in 1880.

The Bay View Brewery in Seattle was rebuilt in 1887 and began manufacturing lager beer, said to be the first on the Puget Sound, with a capacity of eighty thousand barrels per year.

The Erford & Wolford brewery in Colfax was sold in 1888 to Hans and John Michaelson, who operated as Michaelson Bros. & Company. They sold the business in 1890 to Charles and Mary Bourgardes, who ran it as M.E. Bourgardes & Company. In 1892, Alvin Schmidt purchased M.E. Bourgardes & Company. Charles Bourgardes became a horse thief and was arrested in August 1893 for poisoning eleven horses.

Edward F. Sweeney had been manufacturing steam beer since 1882 at Puget Sound Brewery in Seattle. In January 1889, he incorporated the brewery with Hans J. Claussen as Claussen-Sweeney Brewing Company. With capital stock of $80,000, Sweeney was president and Claussen was brewmaster and secretary-treasurer. The brewery was rebuilt with modern machinery, and afterward, they began to manufacture lager beer with an

annual output of thirty-six thousand barrels of beer. Business grew fast, and the capital stock was soon increased to $140,000.

Anton Huth of the Star Brewery in Vancouver moved to Tacoma and partnered with John D. Scholl Brothers to form the Puget Sound Brewery in 1888. The four-story building was eighty by eighty feet, but the businessmen added another forty square feet. The brewery had a steam boiler and could produce 260 barrels per day. In 1889, they advertised as the "Largest Brewery in Washington Territory." Their brands included Walhalla Beer and Der Goetten Trank Beer.

Bernhardt Bockemuehl founded a plant, known as Fort Spokane Brewery, to manufacture lager beer in 1888 in Miles. The facility had a malt house and bottling works attached to it.

Wolf Schaefer, who had run a brewery in Steilacoom since 1873, died in 1889. Northern Pacific Railroad took over the brewery and closed it two years later.

On February 22, 1889, the United States Congress passed an act enabling the territories of Washington, North Dakota, South Dakota and Montana to seek statehood. This was the first enabling act passed by Congress since

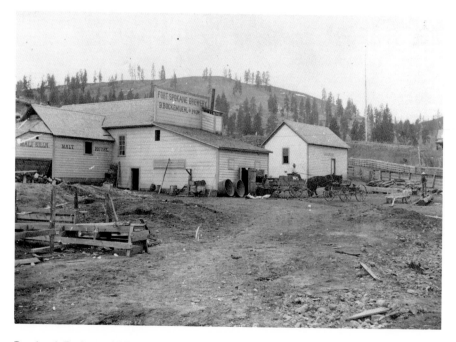

Bernhardt Bockemuehl founded a plant to manufacture lager beer in 1888 in Miles, known as Fort Spokane Brewery. The facility had a malt house and bottling works attached to it. *Lincoln County Historical Society.*

Colorado became the thirty-eighth state in 1876. On November 11, 1889, Washington became the forty-second state of the United States of America.

Washington hadn't been a state for long when the first vote for statewide alcohol prohibition was taken in 1889, but luckily for the many people involved in the brewing industry, the voters turned it down.

The Old Tacoma Brewery opened in Tacoma in 1889 at 2118–22 North Thirtieth Street. Tacoma added another new brewery in 1889 when the Donau Brewing Company was opened at 1001–23 East Twenty-sixth Street by Simon Donau, president, and James H. Barry.

In 1889, William Dewitt and Frank Groger started a brewery in Roslyn, and that first year, they produced about five hundred barrels of lager beer.

The Albert Braun Brewing Association was formed in Seattle with $250,000 capital in June 1890, with Albert Braun as president, G.B. Kittinger as vice-president, D. Baxter as secretary and Herman Chapin as treasurer.

John G.F. Hieber started a malting business in Spokane in 1889. In 1890, he added a brewery, and the combined business was named Hieber Brewing and Malting Company, with lager beer being his specialty.

In 1890, Jacob Weinhard in Dayton constructed the Weinhard Hotel to house the Weinhard Saloon and Weinhard Lodge, called "perhaps the finest in the state of Washington."

The United States Brewing & Ice Company in Tacoma added two additional partners in 1890, Zacharias Zimmerman and George Harrel, who owned United States Brewing Company in Portland, Oregon. The newly organized business had Diederich Stegmann as president and Mathies Karasek as secretary-treasurer.

In 1890, Colville founder and mayor John U. Hofstetter decided to concentrate on his ranch and sold his brewery to Andrew Schipps. Schipps only held the brewery for two years before selling it to Joseph Pohle of J. Pohle & Company.

In April 1891, Bay View Brewing Company in Seattle (formerly Bay View Brewery) was incorporated with capital stock of $300,000. John Hemrich was treasurer, Frederick Kirschner was secretary and Andrew Hemrich was superintendent and president.

Puget Sound Brewery in Tacoma incorporated in August 1891 as Puget Sound Brewing Company, with John D. Scholl as president, Anton Huth as treasurer and Peter A. Kalenborn as secretary. In about 1891, Puget Sound Brewery and Seattle Brewing & Malting Company entered into an agreement to keep beer priced at eight dollars per barrel and not to enter each others territory. That year, the United States Brewing & Ice

Company in Tacoma was purchased by liquor dealers Samuel S. Loeb and Albert Weinberg, with other Jewish businessmen from the community, and renamed Milwaukee Brewing Company. They were brewing 50 barrels per day. The new owners enlarged the brewery, increasing capacity to 125 barrels per day. By the end of 1891, it had a capacity of 60,000 barrels per year and employed twenty-three men.

In May 1891, Hans J. Claussen, co-founder and secretary-treasurer of Claussen-Sweeney Brewing Company of Seattle, sold his share in the corporation to George F. Gund, the son of John Gund, who owned a brewery in La Crosse, Wisconsin. George had worked for six years as secretary-treasurer of John Gund Brewing Company before moving to Seattle and joining Sweeney. Claussen then purchased an interest in Seattle Automatic Refrigerating Company and renamed it Diamond Ice and Cold Storage Company, of which he was vice-president.

By June 1891, Donau Brewing Company in Tacoma was insolvent. One of the creditors ran the brewery for several months as security for payment.

In late August 1891, Pabst Brewing Company of Milwaukee, Wisconsin, took action against Claussen-Sweeney Brewing Company, claiming that it used a label very similar to its Pabst Select Beer brand. It sought an injunction and damages, but the outcome is unknown.

The Roslyn Brewing Company in Roslyn, run by William Dewitt and Frank Groger, was sold to Rachor & Duerrwaechter in 1892. The following year, the Roslyn Brewing Company was re-formed by the Schlotfeldt brothers (John, Herman and Hans Detlaf), Adolf F. Kuhl and Ernest and Charles Duerrwaechter. All of the men were born in Germany, and Ernest Duerrwaechter was the brewmaster. The brewery had a capacity of five thousand barrels per year, and "their private sales are quite large."

Brothers Julius, Adolph and Samuel Galland were born in Oregon. They were involved in numerous businesses and opened a general mercantile business in Palouse in 1888. In the fall of 1891, they moved to Spokane and began construction on a five-story brewery they called the Galland Brothers–Burke Brewing Company. Julius was president and Adolph was secretary.

The Friend-Degginger Improvements Company opened a brewery in Auburn in 1893. It suffered a fire in July 1897, with a loss of $25,000, which was covered by insurance, but it did not reopen.

Chewelah had its first brewery in 1886 when Loaker & Delva opened. Joseph Fox purchased the brewery in 1890, and Otto Mengert took over the brewery in 1897. He did not hold it long before Engelbert Leible purchased it and held it until the next century.

Seattle Brewing & Malting Company was formed when three Seattle breweries were combined in 1893. Andrew Hemrich was one of the masterminds behind the merger and was the company's first president. They were the creators of Rainier Beer. *Sloan Foundation via Library of Congress.*

In the spring of 1893, the Hemrich family created a new brewing powerhouse when they consolidated three Seattle breweries—Claussen-Sweeney Brewing Company, Bay View Brewing Company and the Albert Braun Brewing Association—to form the Seattle Brewing & Malting Company. Andrew Hemrich was elected president, Albert Braun vice-president, Edward F. Sweeney secretary and Hemrich's brother-in-law, Frederick Kirschner, treasurer. The new company was capitalized with $1 million and had a capacity of 150,000 barrels per year. The Braun plant was closed shortly after the merger.

Louis Gerlinger was born on January 24, 1853, in Weitersswiller, Bas-Rhin, Alsace, France. He came to America at sixteen and lived in Chicago. In 1894, he moved to Portland, Oregon, and in 1899, he settled in Vancouver after he purchased the Star Brewery in Vancouver from Anton Young.

In 1894, the Puget Sound Brewing Company of Tacoma was divided when druggist William Virges bought out John D. Scholl, who then moved to Chico, California, where he purchased another brewery. Anton Huth continued to run the brewery as president, and Peter A. Kalenborn was vice-president.

In about 1894, the Milwaukee Brewing Company in Tacoma bucked the trend and lowered the price of its beer from eight dollars a barrel to seven. It set up a sales office in Seattle and started selling its products. This was in direct opposition of the agreement the Puget Sound Brewing Company in Tacoma and Seattle Brewing & Malting Company in Seattle had made in 1891.

The St. Louis Brewing Company was organized in Ellensburg in 1895. It was founded by Casper Hoffmier and his stepson, Frank Groger (of the Roslyn Brewing Company), who was secretary-treasurer and manager. The following year, 1896, it began malt production at the facility.

Changes continued at Seattle Brewing & Malting Company in 1895, as former secretary Edward F. Sweeney replaced Andrew Hemrich as president, W.J. Grambs replaced Albert Braun as vice-president and W.H. Murray became secretary. The following year, George F. Gund, who had been with Claussen-Sweeney Brewing Company before the merger, became president. Andrew Hemrich became vice-president, A.F. Metzger became secretary and Frederick Kirschner continued as treasurer. In 1897, Andrew Hemrich was named president, and his brother, Louis, became secretary and treasurer. George F. Gund left Seattle and purchased a brewery in Cleveland, where he would live out his life.

By 1896, the Star Brewery in Walla Walla was producing ten thousand barrels of beer per year. Run by Jacob Betz, his Betz Beer was said to be one of the finest in the nation.

On July 7, 1896, Rudolph Gorkow, sixty-four and owner of the New York Brewery in Spokane, died from heart disease. After his death, his estate found $11,755, in mostly $20 gold coins, hidden in a tin box. His estate ran the brewery from July 1896 to July 1900.

On August 25, 1896, John Hemrich Sr. of the Seattle Brewing & Malting Company died of appendicitis.

Leopold F. Schmidt was born in Germany on January 23, 1846. He was educated in the local schools and then set out to sea at a young age. In 1886, he moved to Montana and began working in mines. He returned to Germany and attended a brewing school, and after graduating, he returned and built the Centennial Brewery in Butte, Montana. Schmidt was a member of the Montana legislature when Washington and Montana were drafting state constitutions, so he traveled to Olympia, where he discovered the artesian waters in Tumwater; he had them tested and decided that the water was perfect for brewing. In 1896, Schmidt moved to Tumwater, on the outskirts of Olympia, where he bought land at lower

Tumwater Falls, secured water rights and built the Capital Brewing Company, capable of brewing four thousand barrels per year. He kegged the first beer on October 1, 1896. The following year, he sold Centennial Brewery.

Charles Henco of the Henco Brewery retired in 1896, leaving elder brother Theodore Henco in charge.

Job H. West was born in England in 1874. His grandfather was a brewer, and his father may have also been one. West came to America in 1895, and in 1896, he was living in Seattle, where he started West & Company, proprietors of Britannia Brewing, brewers and bottlers of English ales and porters. Unfortunately, in 1899, Britannia Brewing went into receivership. Coincidentally, West's grandfather had also gone bankrupt while running a brewery in 1832 in England.

Leopold F. Schmidt built his first brewery in Montana. In 1896, he moved to Tumwater, on the outskirts of Olympia, where he bought land at lower Tumwater Falls, secured water rights and built the Capital Brewing Company, capable of brewing four thousand barrels per year. He kegged the first beer on October 1, 1896.

The beer war was still brewing after Milwaukee Brewing Company of Tacoma started selling its beer for a dollar less a barrel than the Seattle breweries. It probably made some sales inroads in Seattle until those breweries decided to fire back. In early March 1897, Seattle Brewing & Malting Company announced that it was cutting the price of its beer in half, to only four dollars a barrel. It sent sales agents to Tacoma and began offering year-long contracts to saloon owners.

On March 21, 1897, Samuel Loeb of the Milwaukee Brewing Company told the press, "We are prepared for anything that may come. I want to say that our people have never cut the price of beer. We made the price of Milwaukee beer $7 per barrel." He went on to discount accusations that they were selling beer at a lower rate, and he knew Seattle Brewing & Malting Company was trying to knock him out of the Seattle market. He countered, "We will not give this up without a struggle."

Seattle Brewing & Malting Company hired attorney James O'Brien from Tacoma to watch over its interests while it slowly eliminated Milwaukee Brewing Company from the Seattle market. O'Brien was then supposed to negotiate the purchase of a controlling interest in the brewery by Edward

F. Sweeney, vice-president and general manager of Seattle. At one point, O'Brien said, a deal was reached for $15,000, but Sweeney decided to hold out for a better price. O'Brien later had to sue for his fee.

In August 1897, the Northport Brewing Company in Northport was formed by Jacob Hook, S.A. Barstow, R. Asimus and J.W. Boyd. In 1898, Asimus purchased Barstow's interest in Northport Brewing, and in 1899, he purchased Hook's interest. M.E. Stansell bought into the firm in 1898.

The Milwaukee Brewing Company, struggling after the price war with Seattle Brewing & Malting Company, was sold on August 27, 1897, but not to Edward F. Sweeney, as he had hoped. Instead, Anton Huth, who was running the Puget Sound Brewing Company in Tacoma (and not involved in the beer price war), and his new partner, William Virges (of the Bonney Drug Company), purchased Milwaukee and merged it with Puget Sound Brewing Company. The renamed Pacific Brewing & Malting Company, with $500,000 capital stock, would continue to operate both breweries under the new name, with Huth as president, Samuel Loeb of Milwaukee Brewing as vice-president and Virges as treasurer.

In 1897, Switzer's Opera House in North Yakima was sold at sheriff's auction to North Yakima Brewing and Malting Company, which survived until Prohibition.

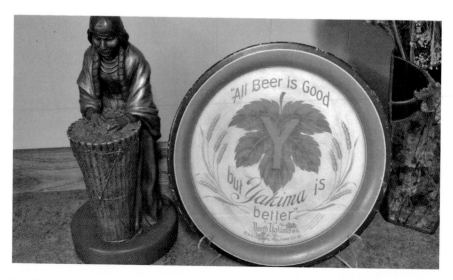

Brewing memorabilia, or breweriana, is very popular with collectors and includes everything from coasters to matches to bottles and signs. This is a fun way to collect items about your favorite breweries. This is a tray from North Yakima Brewing & Malting Company, which survived until Prohibition. *Photo by author at American Hop Museum.*

Alvin Hemrich helped to solidify Seattle Brewing & Malting Company as the biggest brewery in Seattle in 1906 when, with brothers Andrew and Louis, they bought out other shareholders and controlling interest in the Claussen Brewing Association. *Sloan Foundation via Library of Congress.*

Andrew Slorah was about to abandon his North Pacific Brewery in Seattle when Alvin M. Hemrich, of the Bay View Brewing Company branch of Seattle Brewing & Malting Company, purchased it in 1897 and renamed it Alvin Hemrich Brewing Company, "Brewers of Steam Beer and Porter." Hemrich was born in Alma, Wisconsin, on February 14, 1870. His father was in the brewing business, and after attending public schools, he joined his father and later established a brewery in Durand, Wisconsin. Hemrich moved in 1890 to Victoria, British Columbia, where he managed the Victoria Brewing Company for two years. He then moved to Seattle, where he became foreman at the Albert Braun Brewing Association for a year, and then spent about four years at the Bay View Brewing branch of Seattle Brewing & Malting Company as foreman before setting out on his own.

His brother, Louis Hemrich, was born in Alma, Wisconsin, on May 20, 1872. After attending school in Wisconsin and Seattle, he joined the Seattle Brewing & Malting Company, Bay View Brewing branch, in 1893 as bookkeeper. It was about 1897 when Louis joined his brother Alvin, and Julius Damus, just six months after Alvin had started Alvin Hemrich Brewing Company, and they renamed it Hemrich Brothers Brewing.

The Colville Indian Reservation was opened to settlement in the 1890s. George Falligan and Joseph Winker came to the area to mine but instead started a small lager brewery. Their first beer was available in January 1899. They were able to turn out twenty-five barrels per day, with Winker running the brewery and Falligan a saloon in the nearby town of Republic.

Henco Brewery in Spokane was sold to Reinhard Martin on January 26, 1899, by Theodore Henco, just three years after Charles Henco retired.

The Pacific Brewing & Malting Company in Tacoma closed its Milwaukee Brewing Company location in 1899 and purchased the former Donau Brewing Company plant, both in Tacoma. To the north, it built the Washington Brewing Company in Everett in July 1899. By the end of the century, it was distributing throughout Washington, Alaska, China and the Philippines.

After owning and operating the Star Brewery in Vancouver for just about six years, Louis Gerlinger sold controlling interest in the brewery in November 1899 to Gustav G. Freiwald, who had been brewmaster, and to William Young and Adam Mueller, other employees. Freiwald immediately began updating the machinery and modernizing the concern. He was president, Mueller was vice-president and Young was secretary-treasurer of the firm, which manufactured lager beer.

Job H. West, determined to make a go of brewing, started the Seattle Ale and Porter Company in Seattle in October 1899 after his Britannia Brewing had failed. It wouldn't take him long to fail again.

In 1899, Hemrich Brothers Brewing of Seattle increased its capacity to an output of up to eighteen thousand barrels of porter and lager beer per year.

Chapter 3

1900

Dawn of a New Century

As the Victorian era and the nineteenth century came to an end, the twentieth century promised more. The United States' population would exceed 75 million for the first time. President William McKinley would be assassinated in 1901, and nature lover Theodore Roosevelt would become the youngest president. Industrial companies U.S. Steel and Ford Motor Company would be born, forever changing the world. In Washington, the brewing industry continued to contort, expand and contract as prohibition lurked in the near future.

Charles Theis was born in 1866 in Missouri. His father was Prussian, and his mother was from Bohemia. He arrived in Spokane in 1889 as a "representative of eastern capitalists" to purchase municipal bonds. "He arranged for the financing of the Spokane water department," and with his help, many buildings were constructed with money from the East Coast.

Theis later formed a brokerage firm that he operated until July 1900. The Henco Brewery and New York Brewery, both of Spokane, were purchased at that time when Theis organized a group of stockholders to found the Spokane Brewing & Malting Company. Reinhard Martin, owner of Henco Brewery, was retained as a trustee and manager, Peter Larsen as president and W.J.C. Wakefield as secretary-treasurer.

In mid-1900, the St. Louis Brewing Company of Ellensburg was renamed St. Louis Brewing & Malting Company, noting the added malting it was doing.

Emil Kliese was a brewmaster born in Naugard, Germany, in 1860. Unable to find work as a brewmaster when moving to Washington, he joined

The St. Louis Brewing Company was organized in Ellensburg in 1895 by Frank Groger of Roslyn Brewery and his stepfather, Casper Hoffmier. The brewery was sold in 1906, and the building was operated as a dairy until 1932. *Ellensburg Public Library.*

with William C. Kiltz in Tacoma in February 1900 to form the Columbia Brewing Company with $50,000 startup capital. Although Kliese was president and brewmaster, and Kiltz secretary-treasurer, the Pacific Brewing & Malting Company was a major shareholder in the brewery. The five-story building was built over an artesian well, pumping sixty-six thousand gallons per day. Its original brands were Columbia Beer, Golden Drops Beer, Golden Foam Beer and Old Pilsner Beer.

In March 1900, the Seattle Ale and Porter Company in Seattle was taken over by W.H. Armstrong, also receiver for West & Company, after apparent financial difficulties plagued the business. The fledgling brewery was sold by the receiver in June 1900 to Joseph May, Cornelius F. Schmidt and Alvin M. Hemrich.

The Seattle Brewing & Malting Company began construction on a "colossal new brick structure" in Georgetown that would become its main plant.

The Galland Brothers–Burke Brewing & Malting Company of Spokane realized that the river water it was using developed a bad taste when the river was low and decided to blast a hole in the side of the hill just below the brewery. In early 1900, it found spring water that was plentiful and suitable for brewing its beer.

In 1900, the Hieber Brewing and Malting Company of Spokane rebuilt its malt house and brewery at a cost of $65,000. It now had the capacity to produce 110,000 barrels of beer per year.

Some breweries came and went quickly in the early part of the twentieth century. Charles Langendorf and R.A. Garrett started Langendorf & Garrett in Loomis in 1900. The plant was open a few years at most before closing.

One of Washington's first malt houses at the turn of the century was owned by Jacob Weinhard, who ran Weinhard Brewery in Dayton. In January 1901, Jacob converted the brewery to a malt house with a capacity of 175,000 bushels per year.

By early 1901, the Washington Brewing Company in Everett may have changed hands, as Adam Mueller was now manager and Mr. Weigand was brewer. They upgraded the brewery at a cost of $17,000 to bring the capacity of the plant up to twelve thousand barrels per year. Then, in 1902, William C. Kiltz of Columbia Brewing Company was running the brewery.

Frank Dreyer was born in Hamburg, Germany, in 1855. He attended brewers' school, and when he was twenty-five, he came to America and

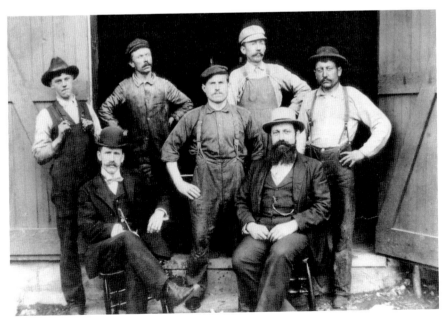

Here is a great photo of the founders and early employees of Columbia Brewing Company, taken in 1900 in Tacoma. Seated to the left is William Kiltz, and founder and brewmaster Emil Kliese is seated to the right. *Tacoma Public Library, Richards Studio Collection Series: C87485-72.*

worked at a Salt Lake City, Utah brewery for a short time before heading to Sacramento, California, where he worked as a brewery foreman. After two years, Dreyer moved to Tacoma, where he invested heavily in real estate. In 1893, the second-worst depression struck the country, and Dreyer lost $75,000. With a small sum of money, Dryer went to British Columbia, Canada, and opened a brewery that proved successful. He returned to Tacoma in 1901, and at the "suggestion and with the cooperation" of Anton Huth, president of Pacific Brewing & Malting Company, he started the Puget Sound Malting Company in the former Donau Brewing Company buildings. Dreyer was president and manager.

James S. Coolican was a Port Angeles businessman and president of the Washington Immigration Society interested in bringing more people to the Port Angeles area. His organization helped bring one hundred families from other cities by 1898. Coolican helped organize the Port Angeles Brewing Company, and in early 1902, Charles Hirsch and Frederick Jensen of Chicago built the brewery. Jensen was also vice-president of Angeles Telephone & Telegraph Company. Adolph Oettinger was a new brewing graduate whom they brought from Chicago, Illinois, to be their first brewmaster. He was in an unfamiliar city, but "with his first toast he had the good will of the captains, the lumbermen, the loggers and the trappers."

A weiss (wheat) beer brewery was constructed in Seattle during the winter of 1901 by the Standard Brewing Company. In March 1901, before a barrel had been brewed, the plant was sold to the newly formed Claussen Brewing Association. Hans J. Claussen, brewmaster and formerly of Claussen-Sweeney Brewing Company, was president, and William de Curtin was vice-president and secretary. In October 1901, they began sales of their beer, and in July 1902, they began bottling their beer.

John J. and Hans Henry Schlotfeldt admitted Rudolph C. Oppenlander as manager to their partnership at the brewery they ran in Roslyn in 1901 and formed Roslyn Brewing Company. The brewery was producing six thousand barrels per year by this time.

In November 1901, construction began on the Gray's Harbor Brewing Company plant in Aberdeen. Before it was completed, Alvin M. Hemrich of Hemrich Brothers Brewing in Seattle purchased the unfinished plant and formed the Aberdeen Brewing Company on January 1, 1902. Alvin was president and treasurer, Louis Hemrich was secretary and Ernst Block was manager. The plant was completed in April 1902, and beer was flowing the following month. The plant had a capacity of six hundred barrels per week and employed twenty-five people. Their beer brand was known as the

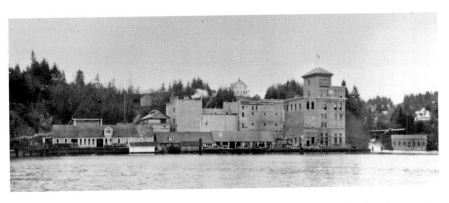

Capital Brewing Company, founded by Leopold F. Schmidt, was reorganized and renamed Olympia Brewing Company in 1902. Leopold was president, Louis B. Schmidt was vice-president and Henry Schupp was secretary. Business had increased from five thousand to forty thousand barrels per year in just six years. *Washington State Archives.*

Aberdeen Prima Beer, and bulk quantities were shipped to San Francisco, California, where they maintained a bottling plant for local distribution.

In 1902, the Capital Brewing Company in Tumwater was reorganized and renamed Olympia Brewing Company. Leopold F. Schmidt was president and treasurer, Louis B. Schmidt was vice-president and Henry Schupp was secretary. Business had increased from five thousand to forty thousand barrels per year in just six years. Olympia's slogan, "It's the Water," would become synonymous with, but not unique to, its beer.

The former owners of the Milwaukee Brewing Company started a new brewery in August 1902, the aptly named Independent Brewing Company. Samuel Loeb and Benjamin Moyses had completed construction of their new brewery in south Seattle when, just a few short weeks later, on August 25, fire engine companies raced to a fire at the brewery. It was destroyed by the fire at a loss of $55,000, about one-third covered by insurance. Principal stockholder Moyses said that the brewery would be rebuilt.

Mr. Schmidt had run a brewery in Colville since 1892. In 1902, he sold it to Henry Schultz, who operated as Schultz Brewing Company until he sold it to brewmaster Max Hoefle from Buffalo, New York, in 1911 for $65,000. Hoefle operated as Colfax Brewing and Malting Company. The company ran the only ice plant in Colfax, supplying the brewery, all the town residents and shipping to outside towns. They had ten employees by 1910 but were forced to close with the start of Prohibition.

Charles A. Schindler traveled to Seattle around early 1901 searching for a suitable location to build a brewery. He purchased a plot of land in

Chelan Falls and then returned to Seattle. In November 1901, he returned to Chelan Falls to build his brewery, citing the fine water for brewing. With his father, they opened Schindler & Son Brewing and Malting Company in 1902. The brewery had a capacity of two thousand barrels per year but was only open until 1910.

In 1902, the Spokane Brewing & Malting Company of Spokane, presumably under the direction of Charles Theis, purchased the Galland Brothers–Burke Brewing & Malting Company in Spokane. The company now had three branches, including the former Henco and New York breweries. Julius Galland was vice-president and manager, and Reinhard Martin was superintendent. The company added a new bottling department in 1902, and its capacity was about 100,000 barrels per year, with Gold Top Beer its best seller.

The Galland brothers still owned a brewery in Wallace, Idaho, and had an interest in the Gambrinus Brewing plant in Portland, Oregon. Soon they focused their attention on other projects. In 1906, they formed the Northwest Loan & Trust Company, and in 1909, they had two buildings constructed in Spokane, spending $400,000 on one alone, still standing as the Delaney Apartments.

Bernhardt Schade, once brewmaster of Spokane's New York Brewery, started construction on the Schade Brewery near the Riverpoint campus in Spokane in 1902. It was designed to replicate a European brewery with a capacity of thirty-five thousand to forty thousand barrels per year.

Leopold F. Schmidt of the Olympia Brewing Company set his sights north in 1900 when he started the Bellingham Bay Brewery in Bellingham. This was only the third brewery in North America to use a closed system whereby from the time the beer was brewed until it was kegged, it never came in contact with the air, making it completely sterile. The brewery was completed in December 1902 after spending $150,000. Schmidt was president of the brewery, with a capacity of 100,000 barrels per year. Just a year after opening, it added a $50,000 bottling house. Along with Leopold, his son, Peter G. Schmidt, was treasurer, and Henry Schupp was secretary, manager and brewmaster.

The Whatcom Brewing & Malting Company was started in Whatcom (now Bellingham) in 1899 by Fritz Grathwohl. He operated the brewery until 1903, when Whatcom Brewing & Malting Company was merged with Bellingham Bay Brewery. After Grathwohl sold Whatcom Brewing, he headed over the mountains to Oroville, where he joined partner E.J. Stretlau of Seattle to build Oroville Brewing Company.

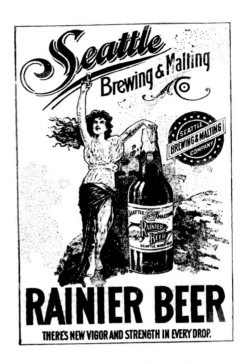

Left: Beer bottles are highly sought by collectors, especially rare or unusual ones. The Microbrewery Museum in Pike Brewing in Seattle has a great collection of bottles. Curator Charles Finkel has been collecting for years and is still adding to the collection. This bottle is from Schade Brewing in Spokane. *Author's collection.*

Right: This ad for Rainier Beer from Seattle Brewing & Malting Company shows how times have changed. Beer was often considered a healthy drink, unlike hard liquor, and this ad touts the fact that "there is vigor and strength in every drop." *From the* Pacific Commercial Advertiser.

The Seattle Brewing & Malting Company's new plant in Georgetown was completed in 1903 after three years of construction. The company now had a capacity of 300,000 barrels per year. Its most popular brand, Rainier Beer, was known along the West Coast. Officers were Andrew Hemrich as president, Edward F. Sweeney as vice-president, J.G. Fox as secretary and John T. Campion as treasurer. Its slogan, "Rainier Beer: There's New Vigor and Strength in Every Drop," seems less legitimate today.

Job H. West was not good at selling his English ales and porters, having failed twice. However, he was good at finding new financial backers, and in 1902, he convinced lawyer George H. Spellmire to join him. They started Spellmire-West Brewing Company in Seattle. By 1903, West's previous venture, the Seattle Ale and Porter Company in Seattle, was shuttered.

American Brewing Company took over the brewery but operated just a short time before it was in receivership in 1903.

Several national brands had tried to make headway in the Washington market by this time. American Brewing Company of St. Louis and Anheuser-Busch Brewing Association both had offices in Seattle in the early 1900s. Although both seemed to spend a considerable amount on newspaper advertisements, neither was able to make a significant headway against strong Washington brands.

Another union battle came up in Seattle in 1903 during construction of Hotel Butler, which was using non-union labor. This time, it was discovered that one of the stockholders of Seattle Brewing & Malting Company was also a stockholder in the hotel, so all the building trades and labor unions boycotted Seattle Brewing and its beer. This outraged the Northwest Brewers' Association, but the boycott continued.

Joseph Pohle & Company ran the Colville Brewery until 1904, when it was sold to Arnold Krueger.

The brewery owned by Engelbert Leible in Chewelah since 1898 was sold to Frank Ernst in 1904. The brewery was small, with a capacity of three hundred barrels per year. In 1906, it became Ernst & Ernst until Joseph Pohle, former owner of the Colville Brewery, became his partner; it was renamed Pohle & Ernst in 1907. The brewery closed in 1912.

In early October 1902, Jacob Betz began demolition of his Star Brewery in Walla Walla so he could build a new five-story brewery. On November 29, 1903, his eldest son, Jacob Betz Jr., died at nineteen years old of pneumonia. On April 1, 1904, the Star Brewery became Jacob Betz Brewing & Malting Company after founder Betz sold half his interest in the brewery and retired to Tacoma later that year. The new officers were Betz as president, John Bachtold as vice-president, George Retzer as secretary-treasurer and Rudolph Gorsulowski as general superintendent.

The other major brewery in Walla Walla, the City Brewery, had been run by Catherine Stahl since 1872, when her husband, John Stahl, became ill. Although he died in 1884, she proved to be a wise businesswoman and continued to operate the brewery until it had grown to the point where she incorporated in October 1904 as Stahl Brewing and Malting Company. With capital stock of $100,000, the officers were Stahl as president, Adolph Schwarz (her son-in-law) as vice-president and Woldemar Stockder as secretary, treasurer and general superintendent, as well as brewmaster. The plant had a capacity of thirty thousand barrels of beer per year.

Bernard Hochstadter purchased the Washington Brewing Company in Everett from William C. Kiltz and formed Everett Brewing Company in 1904 with J.E. Horan and J.D. Eveland, with $100,000 capital stock. Capacity would be thirty-five thousand barrels annually. They operated the Washington plant until the new one was completed.

Republic Brewing Company in Republic was formed when Joseph Winker's partner, Arnold Maschka, purchased the brewery started by George Falligan and Winker in Colville.

Gustav Freiwald, who had been brewmaster of the Vancouver Brewery since 1894 and owner since 1899, decided in 1905 that it was time to sell. The Northern Brewing Company purchased the brewery and installed new and modern machinery, spending more than $165,000 in the process. The brewery would have a capacity of 100,000 barrels per year and by 1909 had a payroll of $4,000 per month and fifty employees.

In 1905, Charles Theis, W.J.C. Wakefield, James Cronin, William Huntley, John Lang, George R. Dodson and A. Ross incorporated the Idaho Brewing & Malting Company of Boise, Idaho, with a capital stock of $200,000. In early October 1905, Theis negotiated to purchase controlling interest in the Hieber Brewing and Malting Company in Spokane for $300,000 from founder John G.F. Hieber. As a stockholder of Spokane Brewing & Malting Company, Theis had signed an agreement not to enter into a competitive business within 150 miles of Spokane for a period of ten years. The other stockholders filed a restraining order and injunction to prevent him from the purchase, but it went through and the company was renamed Inland Brewing & Malting Company. John Lang was president, William Huntley was secretary-treasurer, Hieber was vice-president and J.A. Velton was general superintendent.

On May 1, 1905, 292 brewery workers from five different unions went on strike against eleven different plants of the Northwest Brewers' Association across the state. The main point of contention was the use of new employees whom the union wanted to call in order from union rolls, while the employers wanted to choose who they wanted. The strike lingered on until November 12, 1905, when a preliminary deal was reached between the union and Northwest Brewers' Association. The agreement was signed on April 3, 1906, with brewers' minimum pay set at twenty dollars per week. Neither side won the strike, as the employees lost wages and the employers used inexperienced workers and their products were boycotted.

The Northport Brewing Company in Northport, open since 1897, closed in late 1905.

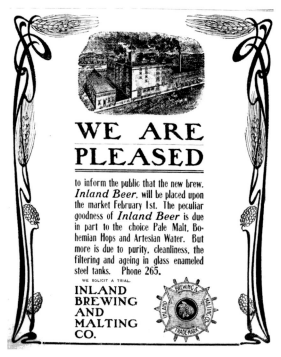

WE ARE PLEASED

to inform the public that the new brew. *Inland Beer*, will be placed upon the market February 1st. The peculiar goodness of *Inland Beer* is due in part to the choice Pale Malt, Bohemian Hops and Artesian Water. But more is due to purity, cleanliness, the filtering and ageing in glass enameled steel tanks. Phone 265.

WE SOLICIT A TRIAL.

INLAND BREWING AND MALTING CO.

Left: Inland Brewing & Malting Company in Spokane was formed when a group of investors led by Charles Theis purchased the Hieber Brewing and Malting Company in 1905. Theis became president in 1910. *From the* Spokane Press.

Below: Pacific Brewing & Company in Tacoma was the second-largest brewing company in the state by 1909, with output of 200,000 barrels per year. *Library of Congress.*

Pacific Brewing & Malting Company completed its expansion in 1905, and by 1909, it was the second-largest brewing company in the state, with output of 200,000 barrels per year of its Tacoma and Pacific Beer brands. "But shareholders weren't happy." Samuel Loeb, owner of Independent Brewing Company of Seattle and a minority shareholder in Pacific, sued the company for larger dividends and demanded that it sell its interests in the Washington Brewing Company in Everett and the Columbia Brewing Company and the Puget Sound Malting Company, both in Tacoma, and convert the proceeds into dividends.

A major consolidation of Seattle-area breweries took place in 1906 by Andrew Hemrich of Seattle Brewing & Malting Company in Seattle. With his brothers Alvin and Louis, they arranged a buyout of majority shareholder Edward F. Sweeney to the tune of $500,000. They then purchased controlling interest in the Claussen Brewing Association in Seattle with Samuel Loeb, Benjamin Moyses and Albert Weinberg of the Independent Brewing Company, who sold their interest in the Pacific Brewing & Malting Company in Tacoma to finance the investment. Seattle Brewing & Malting Company now had an annual capacity of 600,000 barrels.

The new two-story office building in Georgetown for the Seattle Brewing & Malting Company was completed in early 1906. The total cost, including furnishings, was $40,000. Olympia Brewing Company in Tumwater Falls also built a new brick brewery in 1906.

S.S. Bailey (treasurer) and Hans Claussen (president and general manager) were left without control of the Claussen Brewing Association after it was taken over by the new Seattle Brewing & Malting Company. They had to decide whether they wanted to get involved in a new brewery to fight the growing Seattle "syndicate" or remain minority owners.

By February 1906, Inland Brewing & Malting Company in Spokane had begun a $50,000 expansion, adding a new stock cellar and bottling works and a one-hundred-ton refrigeration system, as well as an additional twenty-five-thousand-barrel capacity.

That year, there was also a major earthquake in San Francisco, California. The city was left with few operating breweries and thirsty citizens. According to one story, a $1 million order was placed with Bellingham Bay Brewery and probably Olympia Brewing Company. Owner Leopold F. Schmidt saw this as an opportunity and started construction on a new brewery in San Francisco in early 1907, Acme Brewing Company, which brewed its first beer in mid-May 1907.

Hans J. Claussen (pictured) and Edward F. Sweeney incorporated Claussen-Sweeney Brewing Company in Seattle in January 1889. Sweeney was president, and Claussen was brewmaster and secretary-treasurer. The brewery manufactured lager beer with an annual output of thirty-six thousand barrels.

In 1906, Arnold Krueger of Colville Brewery was charged with "selling intoxicating liquors to minors." He pleaded guilty and was fined but also lost his license. In May 1907, the business was taken over by A.E. Veatch (who served as president) and others and renamed Colville Brewing and Bottling Company Limited. The business was apparently mismanaged, and within a few months, most of its customers were lost. The brewery closed in 1909, and the property was auctioned off in 1911.

Seattle Brewing & Malting Company purchased land in Lewiston, Idaho, in early 1906 for a new $10,000 cold storage, refrigeration and bottling facility. In March, it announced an addition to the bottling plant in San Jose, California, at a cost of $3,000.

By 1905, Job H. West was no longer involved in the brewery he had started. The Spellmire Brewing Company was now operating in its place, and in early 1906, Spellmire Brewing Company was incorporated with $100,000 capital stock by brothers George H. and Edward D. Spellmire. West left town almost immediately and moved to California, where he became a steamfitter.

In late 1906, Jacob Weinhard of Dayton announced that he was retiring and sold his malt house to Max Dunlap and A.P. Cahill.

The St. Louis Brewing & Malting Company in Ellensburg was producing about 2,400 barrels of lager beer per year by 1902. In January 1907, the brewery was sold and renamed Ellensburg Brewing & Malting Company, and the capital stock was raised from $20,000 to $75,000. Frank Groger (previously a partner in the Roslyn Brewing Company) was secretary-treasurer and manager, and James Clark was president. The company had just completed construction of its new plant when the building was destroyed by fire on July 5, 1907. The loss was $50,000 and there was only $7,000 in insurance, but the plant was rebuilt.

Seattle Brewing & Malting Company registered the trademark and logo for Rainier Beer on May 21, 1907.

The Brewery Workers' Union lost its charter in 1907 after it refused to "surrender" to other craft unions, including Teamsters' Union and coopers union.

The Schade Brewery in Spokane expanded its capacity to 100,000 barrels in 1907 and built a bottling plant.

Bavaria Brewery, open since 1884 in Cheney, was sold in 1907 to Alois Schmidt, who operated the brewery until Prohibition forced the closure. Afterward, he remodeled the brewery and converted it into a lodging house, where he moved with his wife. Schmidt died there in late July 1916.

Catherine Stahl of Walla Walla, who rivaled any man by running Stahl Brewing and Malting Company, died on April 1, 1908, leaving an estate of $102,825. After her death, her son, Frank H. Stahl, became president, Adolph Schwarz became vice-president and Woldemar Stockder became secretary-treasurer.

The temperance movement never really went away, and in 1909, it heated up again. "A wide-ranging local-option bill passed the legislature in 1909 in which 30 percent of registered voters in towns, cities, and unincorporated county areas could petition for an election to vote dry." In November 1910, seventy of these measures were held across the state, but the 1911 legislature did not enact any laws.

The Northern Brewing Company of Vancouver installed a new bottling department in early 1909 capable of bottling eight thousand bottles per day. Along with an ice plant capable of producing thirty tons per day, the plant, managed by Vice-President Adam Mueller from Portland, Oregon, was one of the larger breweries in Washington at the time. The president was Henry Boehmke of Cleveland Brewing Association in Cleveland, Ohio. Allen Smart of Chicago, Illinois, was secretary and treasurer.

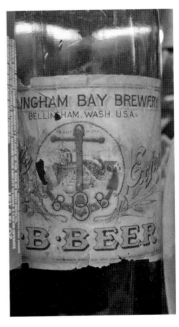

In 1902, Leopold Schmidt of Olympia Brewing opened the Bellingham Bay Brewery in Bellingham. It was sold in 1909 to Edward L. Stowe, who continued selling beer under the 3-B Beer brand until the onset of Prohibition. This 3-B Beer bottle is located in the Microbrewery Museum in Pike Brewing in Seattle. *Joe Mabel.*

By 1909, the Seattle Brewing & Malting Company employed more than four hundred people in Seattle and was the largest industrial business in Washington by 1914 and the sixth-largest brewery in the country. The Olympia Brewing Company in Tumwater was that city's largest employer, with 110 employees and a payroll of more than $100,000 per year.

The Bellingham Bay Brewery was sold in 1909 to Edward L. Stowe. He continued selling under the 3-B Beer brand until Prohibition.

Chapter 4

FROM THE 1910s TO THE 1930s

Prohibition Comes to Washington

Two major issues were at play when the first decade was coming to an end: women's suffrage and, entangled with that, the temperance movement's desire to ban alcohol. At the time, no one really expected the cries of the temperance movement to develop into anything meaningful. But while activists worked in their churches, in the press and in the streets, they slowly developed a following that would carry nearly the entire state. Through the hard work of dedicated women, Washington was the first state in the twentieth century to enact women's suffrage, in 1910.

In April 1910, two Walla Walla competitors became one as the Jacob Betz Brewing Company merged with the Stahl Brewing and Malting Company. The new company was renamed Walla Walla Brewing Company, with $300,000 capital stock. John Bachtold was president, Adolph Schwarz was vice-president and George Retzer was secretary-treasurer. Both breweries stayed open until a new $150,000 brewery could be built.

Andrew Hemrich, who founded what would become the Seattle Brewing & Malting Company and its famous Rainier Beer brand, died at sixty-six years of age on May 2, 1910. He was a lifelong Republican, one of the organizers and vice-president of Seattle and Lake Washington Water-Way Company and in 1898 was elected a state senator. In 1892, he helped organize the Victoria Brewing & Ice Company, owned mines and was president of Eureka Coal Company. His sons did not follow him into the business, and his estate controlled his ownership.

Charles Theis had been a stockholder in Spokane Brewing & Malting Company and attempted to purchase Inland Brewing & Malting Company in 1905 but was rebuffed by a court order. In 1910, he became president of Inland, and John Lang, who had been president since 1905, was made vice-president; William Huntley continued as secretary and treasurer.

In about 1910, the health of Leopold F. Schmidt, of Olympia Brewing Company, began to decline. He added a conference room wing to his house so he could have business meetings with his sons without having to walk down the hill to the brewery. Schmidt then moved north to Bellingham, where he purchased the Byron Hotel and made his residence there. He made Henry Schupp manager of the hotel.

Almost anticipating Prohibition, Oroville Brewing Company in Oroville released Malt Tea, a "non-intoxicating beverage." The company was incorporated in September 1912 as the Oroville Brewing and Malting Company, with a capital stock of $15,000. The incorporators were Fritz Grathwohl, E.J. Stretlau of Seattle and George Bruder of Vancouver. The brewery operated until Prohibition started in 1916.

The founder of the Jacob Betz Brewing Company in Walla Walla died in 1912 at his home in Tacoma, where he had lived since 1904. Betz had been a councilman in Walla Walla, as well as the city's fifteenth mayor, from 1896 to 1900.

In 1912, Seattle Brewing & Malting Company was forced to defend its Rainier Beer brand. It offered $10,000 if anyone could prove that it used corn, sugar, honey, glucose, salicylic acid or any drugs in its beer. It did admit that Rainier Beer was "made from the choicest Barley malt, Rice and Hops."

Just a week later, it again defended its business, stating that it employed "nearly 700 men" and spent $500,000 annually on payroll, $500,000 annually purchasing Washington barley and hops and brought the city of Seattle $1.4 million in sales from outside the state. The company was producing 1 million barrels of beer per year and selling not just in Washington but also in California, where its San Francisco distributor, John Rapp & Son, was doing tremendous business.

In 1913, the Spellmire Brewing Company of Seattle was renamed Washington Brewing Company. George Spellmire was president, and his brother, Edward, was secretary.

In June 1913, Angeles Brewing & Malting Company in Port Angeles was purchased after a long receivership. The company was bought by Andrew Blackistone, general manager of Seattle Brewing & Malting Company; Harry Levin; the Burnett brothers; and capitalists from the East. The

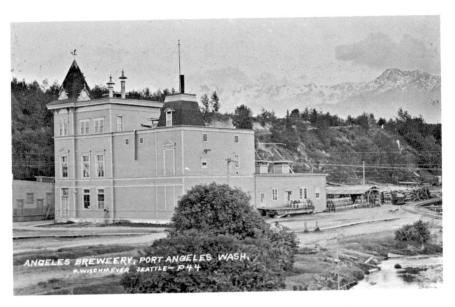

Angeles Brewing & Malting Company in Port Angeles was purchased after a long receivership in 1913 by Andrew Blackistone, general manager of Seattle Brewing & Malting Company; Harry Levin; the Burnett brothers; and capitalists from the East. The company was renamed Port Angeles Brewing Company. *Bert Kellogg Collection of the North Olympic Library System.*

company was renamed Port Angeles Brewing Company. Blackistone was vice-president and general manager and would manage the business from Seattle. He had been comptroller of the city of Seattle in the early 1890s. On May 16, 1893, he "pummeled with a cane" the editor of *Seattle Evening Press-Times,* whose paper had assailed his character over the years.

In July 1914, a fire broke out in the Ellensburg Brewing & Malting Company. It was confined to the boiler room, and insurance covered the loss.

Leopold F. Schmidt, founder of Olympia Brewing Company, died on September 24, 1914, in Bellingham at his Byron Hotel. His son, Peter, took over the brewery. Henry Schupp, as a tribute to his longtime boss, renamed the hotel Hotel Leopold.

The Independent Brewing Company, brewer of Old German Lager, changed its name to Old German Lager Brewing Company in 1914. In an effort to stay in business, in 1916 Samuel Loeb and Otto I. Wise formed Old German Lager Brewing Company in San Francisco, California, with $25,000 capital stock and then relocated there.

By 1914, the temperance movement was gaining steam, and enough signatures were circulated across the state by the Anti-Saloon League,

churches, the Grange and backers of women's suffrage to get a measure on the 1914 ballot to ban alcohol in Washington. Almost 95 percent of registered voters turned out for the election, and the measure was passed by 18,632 votes. Breweries had one year to sell off their remaining stock, several years ahead of national Prohibition.

Northern Brewing Company of Vancouver was granted a restraining order in November 1914 after the City of Vancouver voted to become dry as of January 1, 1915, whereas the state law did not become effective until January 1, 1916. The brewery claimed that it had a legal right to continue to manufacture until the state law was enacted. The case was argued in May 1915, but Northern eventually lost.

With the writing on the wall, Anton Huth and William Virges of Pacific Brewing & Malting Company in Tacoma took big steps to stay in business. They purchased land in San Francisco, California, and constructed a new brewery. The plant would be ready before the end of 1915, just in time for Prohibition to begin in Washington.

The Hemrich family was looking for additional ways to make money after Prohibition was enacted, so they started Surf Packing Company in Aberdeen, which opened in March 1915. The company, owned by Alvin and his son, Elmer E. Hemrich, packed clams at the factory. The company would open the largest clam cannery in the world in Alaska in 1919. Elmer ran the Alaska factory, but after a series of events, he returned to Washington to brew "near beer," which is real beer with 0.5 percent or less alcohol that was brewed by many breweries during Prohibition. The cannery burned in 1936.

On January 1, 1916, statewide prohibition went into effect that closed saloons and stopped breweries from beer production but allowed individuals to possess two quarts of liquor or twelve quarts of beer every twenty days. That was still too much for the temperance movement, and the law was amended in 1917 to make the state completely dry.

No one knew how long Prohibition would last or if it would ever end. That didn't stop the availability of alcohol, though, as beer and hard alcohol were available through various illegal means. Roy Olmstead was a former Seattle police lieutenant who became one of the biggest bootleggers in the West, importing alcohol from British Columbia, Canada. Henry Reifel was a Canadian distiller and bootlegger also involved in the highly profitable business.

Republic Brewing Company, not seeing any options, decided to close in mid-1916.

The Roslyn Brewing Company announced that it would manufacture near beer and reorganized as Cascade Manufacturing Company, with Richard Muzatko as manager and Adolf F. Kuhl as secretary.

With Prohibition arriving in Washington earlier than California, the Seattle Brewing & Malting Company took a page from Pacific Brewing & Malting Company and built a new plant in San Francisco, California, and started Rainier Brewing Company. It shipped 2,797 casks and 719 cases of beer from Seattle to the new plant, and by October 1915, it was brewing beer. The Seattle police raided a scow in the bay near Seattle belonging to the Rainier Brewing Company in May 1916 and dumped twelve thousand quarts of beer in the water.

Other breweries tried to stay afloat by producing other products. The Schade Brewery in Spokane produced near beer and soda. Olympia Brewing Company and Peter G. Schmidt filed a trademark application in May 1915 for Fruju beverage. They reorganized the company, renamed it Olympia Beverage Company and brewed soft drinks and juice drinks, including Appleju (apple "champagne") and Loju (a loganberry variation). When World War I rationing caused sugar shortages, Schmidt went into the fruit business and sold the brewery to a paper company.

In 1916, Hemrich Brothers Brewing was renamed Hemrich Staff Products, with Alvin M. Hemrich as president and treasurer, Louis Hemrich as vice-president, Paul F. Glaser as secretary and general manager and William Koch as brewmaster. They brewed near beer at their plant, which was on Airport Way, right next to the former Bay View Brewing Company plant of Seattle Brewing & Malting Company.

By April 1916, nearly every brewery in Washington had closed or gone out of business. Most would not reopen after Prohibition was repealed due to the costs to restart the plants. The Yakima Brewing Company dismantled its plant and put it in storage, while the Spokane Brewing & Malting Company erected a new three-story brick storehouse.

In early 1916, Dennis K. Howard, seventy, and a former partner in the Schaefer & Howard Brewery in Steilacomm, died at his home in Seattle.

Three hundred saloons were closed due to Prohibition, but thirty drugstores opened in their place, supplying legal liquor by prescription. Rents in Seattle dropped 25 percent in 1916, causing property values to drop considerably—all blamed on Prohibition.

On April 24, 1916, Benjamin Moyses, secretary-treasurer of Independent Brewing Company in Seattle, died after undergoing treatment in a Chicago hospital. He was fifty-three years old. Moyses was "recognized as a prominent

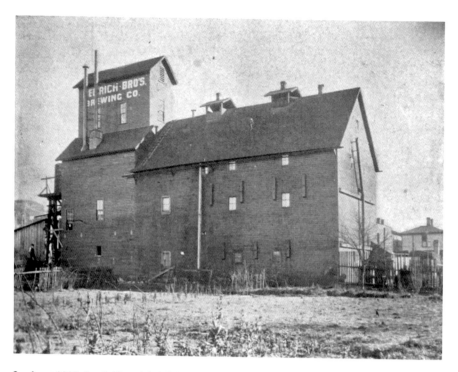

In about 1897, Louis Hemrich left Seattle Brewing & Malting Company to join his brother Alvin at his new brewery, which they renamed Hemrich Brothers Brewing. In 1916, Prohibition began in Washington State, and the business was renamed Hemrich Staff Products; it brewed near beer. *Sloan Foundation, via Library of Congress.*

factor in the business world of the Northwest and Alaska" and was active in civic affairs in the community.

George F. Gund, who had a role in the formation of Seattle Brewing & Malting Company and was a onetime president, died in Cleveland on March 11, 1916, at sixty years old. While living in Seattle, Gund was a director of many businesses, including Puget Sound National Bank, National Bank of Commerce, Rambler-Caribou Mining Company and Gund Gold Mining Company. In 1897, he moved to Cleveland, purchased the Jacob Hall Brewing Company and renamed it Gund Brewing Company. He was president and treasurer of the brewery at the time of his death.

Anton Huth, Tacoma capitalist and president of Pacific Brewing & Malting Company, died on September 5, 1916, just months after Washington went dry, after suffering heart failure. Huth was married to Agnes Muehler, whose family had a five-hundred-acre hop farm in nearby South Hill. After his estate was probated, it was valued at $1,413,348. Upon his death, Agnes

and her three children formed Huth Estate Inc. to manage his real estate and joined his partner, William Virges, to run National Cocoanut Butter Company and National Soap Company in their former former brewery.

The Ellensburg Brewing & Malting Company reorganized in mid-1916. James Clark and former brewmaster August Sold Jr. decided to manufacture near beer, cider and other similar products. Sold Jr. was brewmaster and president, and Clark was secretary-treasurer and general manager. Frank Groger, who was the minority owner of the business, did not participate in the new venture, so Clark leased his shares for one year. In the summer of 1916, Groger started to buy outstanding shares of stock, including Sold's, and by the time the lease expired, he had amassed majority ownership of the business. Groger's wife, Emma, and son, Casper, also owned shares.

At a special meeting in January 1917, Emma and Casper were elected to seats on the board, and at a subsequent meeting, they terminated the current business and decided to make soft drinks, ordering James Clark to remove his property from the premises. Clark, in turn, sued them, claiming that they would be violating their articles of incorporation to manufacture beer. A receiver was appointed, and at trial, the jury found against Groger for $5,000; in 1918, though, it was reversed on appeal.

In 1905, Harry L. Crosby joined Inland Brewing & Malting Company in Spokane as a bookkeeper, moving from Tacoma with his family. The company was good to its employees, and the Crosbys were offered a way to purchase a home in Spokane. The company purchased the land and, after the house was built, took payroll deductions from the Crosbys.

When Prohibition went into effect on January 1, 1916, Crosby, like many workers in the industry, was unsure whether he would have a job. He took a "drastically reduced salary" to remain employed. To stay open and try to weather the storm, Inland Brewing & Malting Company began manufacturing near beer, ice and sweet cider. The public was not interested in the products, and Crosby's salary was further reduced.

In 1917, after World War I commenced, the company was reorganized as Inland Products Company, and Harry L. Crosby was elected secretary. It authorized spending $175,000 to erect a cold storage warehouse and converted the brewery into a pickle factory. Inland contracted with a distributor that supplied the Jewish Orthodox community of New York with pickles, and a rabbi visited the plant to certify that its pickles were kosher.

Harry's son, Harry "Bing" Crosby, worked in the brewery as a teenager during Prohibition, rolling barrels of cucumbers and dumping them into the brining vats to make pickles. He quit after two weeks and never liked pickles

after that. In 1923, Inland Products Company's senior partner, Charles Theis, appointed his son as secretary, and Harry was bumped down to a shipping clerk. Several years later, "Bing" Crosby would move the family to California, where he would reach fame and fortune.

Columbia Brewing Company reorganized in 1917 as Columbia Bottling Company and brewed soft drinks such as birch beer, Chocolate Soldier, Blue Jay and Green River.

In April 1917, foreclosure proceedings against the Northern Brewing Company, Vancouver, were begun after it defaulted on a first and second mortgage totaling almost $300,000.

Emil Kliese, the founder and brewmaster of Columbia Brewing Company in Tacoma, ran the brewery until the onset of Prohibition. Kliese died on March 27, 1919. Otto Birkmaier took over as brewmaster until his death in 1946.

Congress, in 1917, voted to make the Eighteenth Amendment to the Constitution, the law of the land. Three-quarters of the states needed to ratify the amendment in seven years in order for it to become law. It took just thirteen months, enabling the Volstead Act, which enforced the national prohibition of alcohol. The Volstead Act defined an alcoholic beverage as one containing one half of 1 percent of alcohol, which eliminated even light beers and wines. President Woodrow Wilson, though, would have none of it and vetoed the Volstead Act; his veto was overridden by Congress on October 28, 1919.

Pacific Brewing & Malting Company in Tacoma, already brewing soda pop, added a near beer in 1919 called Colo.

In late 1919, Walla Walla Brewing Company formed Crystal Beverage Company to sell a cereal beverage, a line of soda water, fruit drinks and apple cider. The same officers were in place, including brewmaster Woldemar Stockder, who brewed Ex-Cel near beer.

At midnight on January 17, 1920, national prohibition went into effect. Washington had already spent four years without legal alcohol, so this was no special day.

With Prohibition rambling on, Schade Brewery in Spokane tried to survive by making near beer and soda. With no end in sight, Bernhardt Schade, the brewery's founder, died in 1921. A 1997 article suggested that Schade committed suicide because of illness and his brewery losing money. The brewery was closed after his death. During the Depression years, it was known as the Hotel de Gink, a place for homeless men to stay.

The officers of Aberdeen Brewing Company, run by Alvin M. Hemrich and Elmer Hemrich, finally succumbed to the long drought of Prohibition and closed in 1923.

Like many of the breweries that tried to stay open during Prohibition, Inland Products Company of Spokane was on life support as the years wore on. Almost every year it operated at a loss, and by 1924, it had to float a bond issue for $150,000 to stay operational.

Peter Marinoff was born in Austria, and by the time Prohibition arrived, he was a bootlegger operating out of Tacoma. His history is a bit murky, but he was said to be known as "Legitimate Pete" because he only ran illegal liquor and was not involved in any other illegal activities.

According to Dr. Lorraine McConaghy, historian at Seattle's Museum of History and Industry, Marinoff "emerged from obscurity to give Roy Olmstead a run for his money as king of the rumrunners in central Puget Sound. The *592-M* rumrunner was built at Schertzer shipyard at the foot of Stone Way, designed and powered to be fast, lean and mean. The *592-M* smuggled liquor from Canada to Puget Sound cities during Prohibition. Pursued by the Coast Guard boats, *592-M* led law enforcement on a merry chase through the San Juan Islands, racing through the dark without running lights, to hide in coves."

In 1921, Peter Marinoff was hijacked by another rumrunner, but his political influence helped convict that man. Marinoff's illegal businesses must have been profitable, as in 1925 he purchased the Walla Walla Brewing Company and Crystal Beverage Company, which he then renamed Washington Brewing Company, known as brewers of near beer brand Olympic Club Special.

Orange Kist soft drink became the newest product available in 1925 from Tacoma's Pacific Brewing & Malting Company. Pacific went all out, sponsoring big events and giving thousands of cases away to promote the new drink.

Columbia Brewing Company did what it could to stay open during Prohibition, including brewing Columbia Brew, a near beer.

THE 1930s: GETTING BACK IN THE BREWING GAME

Although the 1930s brought about the Great Depression, the end of Prohibition seemed to grow closer, and Washington breweries were angling to get permits, update their factories and prepare for the onslaught of demand.

Around 1930, Louis Hemrich suggested to his friend Joe Goldie that they buy the former Seattle Brewing & Malting Company property in Seattle.

After repeal, Louis Hemrich and others tried to get the Rainier plant in Georgetown operational and nearly merged with Century Brewing Association in 1935, but it didn't materialize. *Sloan Foundation via Library of Congress.*

Goldie had been the manager of the Rainier Brewing Company in San Francisco, California, making near beer and soft drinks. With some financial backers, they made a deal with the estate of Louis' brother, Andrew, to pay $1.1 million to buy the Georgetown brewery in Seattle and the San Francisco brewery. They also purchased the Pacific Brewing & Malting Company plant in San Francisco.

Bootlegger Peter Marinoff was also ready to make a stake in the legitimate beer market and renamed Washington Brewing Company in Walla Walla the Northwest Brewing Company—Walla Walla and purchased a former meat factory in Tacoma to open another plant in early 1931. The Olympic Club Company was listed at the same address as Washington Brewing Company, and Robert T. Knight was secretary of both companies.

A creditor of Olympic Club Company tried to get the company declared insolvent and into receivership in August 1930. That application was granted on February 5, 1931. What effect that had on the Marinoff enterprises is not known, but he stayed in business.

After Prohibition ended, Elmer E. Hemrich purchased Columbia Brewing Company in Tacoma and renamed it Columbia Breweries Inc.

Bohemian Breweries Inc. of Spokane was the first brewery in the Northwest ready for the thirsty mouths of its customers. In 1933, the company made a net profit of $155,000. Company president Charles Theis was earning $9,000 a year, and in just a few years, they retired the bond they took out in 1924 and were able to pay a dividend.

Morris Rosauer (or Rosair) of Golden Age Breweries Inc. purchased the former Schade Brewery in Spokane that had been closed. The new owners upgraded the thirty-year-old brewery and doubled its capacity to 200,000 barrels per year.

The Sick family, headed by Fritz Sick and his son, Emil G. Sick, were well-known Canadian brewers and owners of Associated Breweries of Canada Limited, with plants in several Canadian provinces. In 1933, they purchased two former breweries in Montana and consolidated them into one, forming Great Falls Breweries Inc., with $400,000 capital stock. Associated owned 75 percent of the new concern and the previous owners 25 percent. As they were getting their license, they found out that "aliens," or those not born in the United States, could not own land. To avoid the problem, they created American Brewery Engineers Inc. and put controlling stock in that company, with Emil Sick as president.

Emil Sick was looking for bottling equipment and leased the Henco Brewery in Spokane, buying the equipment for $60,000 cash. It had been owned by Reinhard Martin, who was friends with Fritz Sick. During Prohibition, the Pioneer Educational Society (owned by a Gonzaga University holding company) funded the plant to manufacture near beer and soft drinks. It hired Harry Goetz and "put together a little syndicate" run as Goetz Breweries Inc.

With Prohibition ending, the Rainier Brewing Company of San Francisco, California, was ready for production well before Seattle, so it began brewing Rainier Beer and shipping it to Seattle, where it was distributed. Emil Sick, "fully aware of the fine record the old Rainier name had in Seattle," was interested in buying the brand and contacted the San Francisco brewery to see if it was interested in selling, but it wasn't.

The Olympia Brewing Company was restarted in 1933, and instead of buying back and updating its old plant, it built a new plant upriver from its original plant in Tumwater. The new plant, when completed, would be modern and serve it well for many years, but it would delay its opening. Brothers Peter and Adolph Schmidt approached Emil G. Sick to invest in their brewery, and he did. His company purchased $111,111 worth of stock in Olympia Brewing Company, and with their large

The Olympia Brewing Company was able to survive Prohibition and was the last Washington-born brewery to remain open despite ownership changes, until the plant finally closed in 2003. This vintage wood crate was used to carry fresh bottles of Olympia Beer. *Author's collection.*

investment, Sick and Robbie Ker were named to the Olympia Brewing board of directors.

The Sicks knew that they wanted a brewery in Seattle and looked at several locations before settling on the former Bay View Brewing Company. During Prohibition, it had been a feed mill; the owner had died, so they ended up leasing the building from the widow for $250 per month for the first four years and $200 per month thereafter, with the option to purchase at any time for $50,000. They equipped the brewery with equipment from a brewery in Regina, Saskatchewan, and created Century Brewing Association, with $320,000 capital stock, which included the stock they invested in the Olympia Brewing Company in Tumwater.

The Aberdeen Brewing Company in Aberdeen had closed during Prohibition, but in 1933, the Hemrich family reactivated the brewery and renamed it Pioneer Brewing Company. They would brew under the Aberdeen Beer and Pioneer Beer brands.

The former Ellensburg Brewing & Malting Company was another to be restarted in 1933, renamed Ellensburg Brewing Company. It claimed to only use water from artesian wells in its Edel Brau Beer. Howard J. Williams was president; his brother, Elmer G. Williams, was secretary-treasurer; Harry R. Breede was vice-president; and John F. Pooler was manager. The Williams brothers would purchase several breweries over the years.

George F. Horluck ran a sizable creamery business in Seattle, Horluck Creameries Inc. When Prohibition was ending, he saw a new opportunity and started the George F. Horluck Brewery in 1933, adding the necessary buildings. The next year, it was renamed Horluck Brewing Company, with Horluck as president and Wilma L. Lepisto as secretary.

The Kitsap Brewing Company was formed in 1933, with the six-story brewery built on Bay Street at one point the tallest building in Kitsap County. Its initial beer, though, was not well received, and the company struggled until 1934; that year, there was a change in ownership, and the brewery was renamed Silver Springs Brewing Company.

Investors thought that with a few dollars they could start a brewery and become wealthy. Pilsener Brewing Company was started in 1933 in Seattle. Centralia resident and logging salesman R. Harry Fischnaller was president, Charles H. Schwellenbach was vice-president and F.H. Furey was secretary-treasurer.

Henry Reifel was a German immigrant who became a brewmaster before starting Canadian Brewing & Malting Company in Vancouver, Canada, with his brothers and sons. Over time, they built a network of four breweries and two distilleries that was used by smugglers during Prohibition. As Prohibition was ending, Reifel went to Seattle to complete a deal with Alvin M. Hemrich, who had struggled financially during Prohibition.

Hemrich's plant was small, so they decided to open a second plant on the waterfront, forming Hemrich Brewing Company. After a while, the arrangement did not work out, and the partners split, with Hemrich taking his old brewery back and renaming it Apex Brewing Company and Reifel keeping the new plant and the Hemrich Brewing Company name.

In July 1934, Henry Reifel and his son crossed the United States border from Canada to go to Seattle and check on their brewery. They were arrested on smuggling charges dating back to Prohibition. They did not return to Seattle and forfeited bonds, later agreeing to pay back taxes to the United States; they also resigned from the board of their Canadian companies. After this, the Reifels were unable to return to Seattle to monitor their brewery.

During Prohibition, the Brewery Workers' Union had lost members and power after so many breweries closed. Those that stayed open to make near beer or soft drinks needed smaller staffs, and the union insisted that the teamsters (truck drivers) who worked in the breweries remain in their union.

After Prohibition, the American Federation of Labor (AFL) awarded jurisdiction over beer truck drivers to the Teamsters' Union. The Brewery

Workers' Union refused to accept the decision, and "trouble began immediately, particularly in the Pacific Northwest." The Teamsters' negotiated with twenty-seven breweries and distributors in the area, and in retaliation, the Brewery Workers' Union called a strike against Hemrich Brewing Company in Seattle in October 1933. The Teamsters' supplied men to the brewery to replace the strikers. Vancouver and Spokane, as well as Portland and Salem, Oregon, also saw similar action.

Peter Marinoff's Northwest Brewing Company was selling Olympic Club Beer and using the slogan, "It's the water." The Olympia Brewing Company was not too happy with the similarity, especially since that was its pre-Prohibition slogan, and sought an injunction to stop Northwest from using the name. On October 30, 1933, Northwest was barred from using the name and slogan, so it started selling Marinoff brand beer instead.

Emil G. Sick, although loyal to the Brewery Workers' Union for many years, saw Teamsters' Union leader Dave Beck as a challenge he did not want to face and turned Century Brewing Association over to the Teamsters.

The union fight, though, would center on Peter Marinoff. He had signed an agreement with the Teamsters' Union in 1933 but could not reach a new agreement in 1934 and switched to the Brewery Workers' Union. After fighting with the Northwest Brewers' Association, Marinoff resigned from the organization and cut the price of his beer by two dollars a barrel. "A number of brewers were beaten while driving [his] trucks," and damage was done to establishments selling his beer, ostensibly done by Teamsters' members. "If you take delivery on this Marinoff beer, you'll be sorry!" was yelled at one restaurant owner in Seattle—he took the delivery and had his windows and sign smashed. After the Northwest Brewing Company was placed on the unfair labor list, Marinoff signed with the Teamsters' Union, but trouble would find its way back to him soon enough.

General Brewing Corporation was formed in San Francisco, California, after Prohibition was repealed in 1934. The company renamed itself Lucky Lager Brewing to better describe the beer it was brewing. That same year, Interstate Brewing Company took over the former Star Brewery in Vancouver.

The Spokane Brewing & Malting Company had gotten back into business after Prohibition. Ted Galland sold stock through a Calgary, Alberta broker to fund the business. The company opened but struggled, and the stock broker suggested a merger between Goetz Breweries Inc. and Spokane Brewing & Malting Company. The board of Spokane declined, but not for long.

Malt is an integral part of the brewing process, and the malt industry was as important as the beer. So, in 1934, a group of businessmen started Great Western Malting in Vancouver: Arnold Blitz and William Einzig of Blitz-Weinhard Brewing Company, Oregon; J.R. Bowles and Phillip Polsky of Star Brewing Company, Vancouver; Henry Collins of Pacific Continental Grain Company; Peter Schmidt of Olympia Brewing Company, Tumwater; and Emil Sick of Century Brewing Association, Seattle.

The Pilsener Brewing Company in Seattle was open less than a year when it was forced into involuntary bankruptcy on May 10, 1934. August Weiffenbach of Seattle Cornice Works filed a claim for $20,795.73 for barrels sold to the brewery, saying that they were obtained fraudulently. A receiver was appointed, and the following month, it filed for reorganization and was reorganized.

By the time Century Brewing Association and Olympia Brewing Company were ready to open in January 1935, six other breweries had beat them to the gate. Century began brewing Rheinlander Beer, whose name, according to Emil Sick, "we pretty much took out of thin air." Its first brewmaster was Karl Heigenmooser, who had been a master brewer in Havana, Cuba, and Century's early advertising touted this fact.

In February 1935, Alvin M. Hemrich of Apex Brewing Company in Seattle died at sixty-five years old. Dick Lang had controlling interest in the brewery, so he had his manager run the brewery. Lang sought out Emil G. Sick, since the Century Brewing Association plant was right next door, to see if he was interested in purchasing it. He was, and for $100,000, which included assuming a $50,000 mortgage, it was bought.

Whether gimmick or not, in 1935 Olympia Brewing Company introduced the eleven-ounce "stubby" bottle to the West Coast. The bottle was sturdy, broke less and could be refilled at the brewery. A twelve-pack was also one beer less than a standard twelve-pack, since they were only eleven ounces.

Emil G. Sick made several trips to San Francisco, California, trying to negotiate a deal with the Rainier Brewing Company, but he always left empty-handed. At the same time in Seattle, Louis Hemrich and Joe Goldie had not yet opened their Rainier Beer plant in Seattle. Sick said that they nearly merged in early 1935, but he broke off the negotiations for unknown reasons. Through all this, George Allen, who worked at the San Francisco plant, had become friends with Sick; when Sick offered him a job in Seattle, he took it.

This alarmed management at the California plant, who thought with Allen leaving they would lose their Seattle business, so they contacted Sick and made him a deal. On April 23, 1935, Sick purchased the former Rainier

Beer brewery in Seattle for $250,000 cash. They also negotiated a royalty deal to sell Rainier Beer and Tacoma Beer brands in Washington and Alaska. The deal was good until July 1, 1940, at which time Sick could terminate the deal. He also renamed the company Seattle Brewing & Malting Company. The former Apex Brewing Company plant was the new Rheinlander Beer brewery, so it could concentrate on producing Rainier Beer in the larger plant. Rheinlander sales eventually declined until it discontinued the brand.

Later that year, Emil Sick was sued by the widow who owned the Bay View Brewing Company building they were leasing over a contract they had never signed. After she lost the court case, Sick made a deal to buy the brewery for $14,000 cash and assumption of a $25,000 mortgage, which was $11,000 less than the original deal of $50,000.

In 1935, Elmer E. Hemrich sold his interest in Columbia Breweries Inc. of Tacoma to Joseph F. Lanser, who then constructed a new $120,000 bottling shop. Hemrich did not leave the beer business; instead, he started Elmer E. Hemrich's Brewery Inc. at 2601 Holgate in Tacoma. Elmer was president, and his wife, Nina, was vice-president. They sold beer under the Gold Seal Beer brand, which was brewed by several different breweries, including Apex Brewing Company of Seattle, Silver Springs Brewing Company of Tacoma and Mutual Brewing Company of Ellensburg. In 1936, Hemrich renamed the brewery Gold Seal Breweries Inc.

The Northwest Brewing Company in Tacoma found more union trouble in 1935 after the Teamsters' accused company president Peter Marinoff of contract violations, including using Brewery Workers' Union drivers to make deliveries through Teamsters' Union picket lines. A strike was called against the brewery. With sales being hurt by the constant union troubles, the Brewery Workers' Union loaned the brewery $150,000. When the Teamsters' discovered the loan, the Seattle Central Trades Council expelled the Brewery Workers' Union local from its membership.

Marinoff was forced to hire armed guards to ride with his delivery drivers, and on May 24, 1935, "a Teamster picket was fatally wounded by an armed guard" working with a driver in Seattle. Marinoff was charged with second-degree murder on June 1, 1935, in that case because he was "behind the action that resulted in the death."

Peter Marinoff and several others were convicted of manslaughter and sentenced to twenty years in prison. The verdict was later overturned in Washington State Supreme Court, and he was released in August 1936.

The pressure from the Teamsters' Union and Marinoff's conviction forced Northwest Brewing Company out of business. It was closed for several

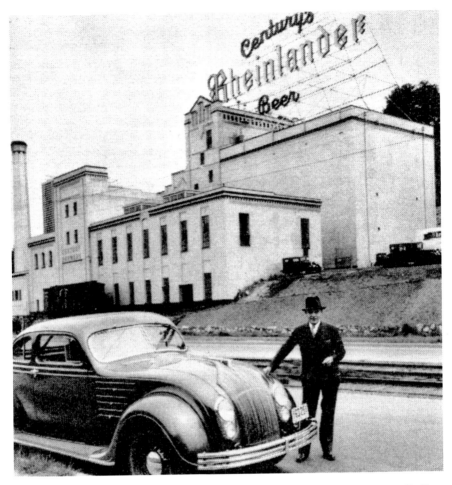

Century Brewery in Seattle began brewing Rheinlander Beer in 1935; according to Emil Sick, the name was "pretty much took out of thin air." In this photo, Emil Sick is standing in front of brewery. *Author's collection.*

months before the Brewery Workers' Union purchased the Walla Walla and Tacoma breweries from the receivers in 1936 and operated them as United Union Breweries Inc. The Walla Walla plant was reopened in April 1937 after being shut down for several months.

By 1936, the Teamsters' Union controlled the brewing industry in Washington and Oregon. Emil Sick said it was "never our policy to sell beer under pressure," but Local 566 Teamsters' Union president Dave Beck (who lived in Seattle) believed that he was doing the brewery workers good. At one point, though, fliers were handed out during a city election that read, "Emil

Emil G. Sick came from a well-known Canadian brewing family. In 1933, he purchased two breweries in Montana to begin his own brewing empire. He knew that before Prohibition Rainier Beer had been a prominent brand in Washington and wanted to secure the rights to it. That didn't happen right away, but he did invest in the Olympia Brewing Company as it was restarting after repeal. *Author's collection.*

Sick paid off Dave Beck." An article written in *Time* magazine in 1957 nearly said that Sick and Beck colluded during the boycott in the 1930s and that Sick benefited from it. He flatly denied that. In 1973, all was mended, as the parent union of the Brewery Workers' Union merged with the Teamsters' Union.

The struggling Spokane Brewing & Malting Company decided to accept the offer to merge with Goetz Breweries Inc. in 1936. Owned by American Brewery Engineers Inc., which was primarily the Sick family, the new company was called Spokane Breweries Inc. The Goetz brewery was closed "after a little while," but it continued to produce the Goetz and Gilt Top beer brands at the Spokane plant. Personnel trouble eventually affected the business.

Elmer E. Hemrich (son of Alvin), president of the Surf Cannery and president of Elmer E. Hemrich Inc., died of a heart attack on January 21, 1937.

In 1937, Ellensburg Brewing Company ran into financial trouble when it could not make payments on a second mortgage owned by J. Justin Bourquin. In September, the assets were sold at auction. The new owners—William H. Biner, president, and John F. Pooler, secretary and office manager—renamed the brewery Mutual Brewing Company. Elmer G. and Howard J. Williams owned the first mortgage and may have been additional partners.

By November 1, 1937, Bohemian Breweries Inc. of Spokane had a net value of more than $800,000, or $160 per share. Company president Charles Theis owned 1,266 shares, worth $202,560.

Bernard Hochstadter was brewmaster for the Horluck Brewing Company in Seattle. He had run Everett Brewing Company in Everett prior to Prohibition, but by 1938, he could see that the business was not very profitable, so he advised owner George F. Horluck to sell the business. Hochstadter approached Emil G. Sick to lease the plant and run it as a competitor. After negotiations, Sick agreed, and for more than $9,000 per year, they leased the business and the property. It was later renamed Sicks'

Century Brewery and was a branch of Seattle Brewing & Malting Company. Another Sick competitor was now out of the way, leaving it as the largest brewery in Seattle.

Yakima Valley Brewing Company opened in 1938 in Selah, selling Selah Spings Beer. Fred Martin purchased the brewery and sold his Martin's Beer, made from "Martin's Formula," until the brewery closed in 1954.

Hemrich Brewing Company in Seattle was not doing so well with the owners banished to Canada. This affected its business, along with "bad policy decisions" to the point that it lost substantial market share. It was around 1939 that Emil Sick was approached to buy the business. He said, "I am not buying any more breweries." Rudi Samet was running the operation for the Henry Reifel family and was desperate, so Sick offered him $30,000 for every piece of equipment in the building but not the lease ("including the typewriters, because I want a typewriter for my daughter"). Samet agreed, and Seattle Brewing & Malting Company took over the Hemrich Brewing Company, trying to save "all of the Hemrich business possible."

Chapter 5

FROM THE 1940s TO THE 1970s

Juggling for Market Share

By the time 1940 began, World War II was in its infancy and the United States was staying neutral. The ensuing years would force many changes, with more brewery consolidation, war rationing and changing tastes affecting the market. In addition, large out-of-state breweries were starting to encroach and make it more difficult for the small brewer to stay in business.

Emil G. Sick desperately wanted Rainier Beer back in Seattle—not out of love for the brand but because it was a smart financial decision. He was rebuffed numerous times during the five years of his royalty agreement because there were five owners "who never saw exactly alike." At one point, he offered them $5 million for their California brewery, but they could not agree.

The United States was teetering on the verge of entering the Second World War, and Sick decided to convert the contract he had with Rainier Brewing Company in San Francisco, California, to buy the brand. One of his board members was against it, but he convinced the rest to approve the purchase. On June 25, 1940, Seattle Brewing & Malting Company issued the first $200,000 of $1 million to the Rainier Brewing Company as part of its original deal to purchase the brand. To make up for the purchase, it sold an additional 500,000 shares of stock.

In 1940, sister company Spokane Breweries Inc. discontinued the Goetz Beer brand and started brewing Rainier Beer, which helped its bottom line over time.

Jacob Weinhard, who built the brewery and malt house bearing his name in Dayton, died on May 18, 1941. Weinhard took great interest in his adopted community, building an opera house in 1904, the Weinhard Hotel to house the Weinhard Saloon and the Weinhard Lodge and a Victorian home in 1907 that is on the National Register of Historic Places. Weinhard Lodge was in use until 1963, and in 1994, the Weinhard Hotel was reopened.

John G.F. Hieber, founder of Hieber Brewing and Malting Company and Inland Brewing & Malting Company in Spokane, died on December 25, 1941.

Joseph F. Lanser, president and manager of Columbia Brewing Company in Tacoma for eight years, bid $140,000 for Arizona Brewing Company in Phoenix, Arizona, in August 1942. The company had gone into bankruptcy, and on September 12, the deal was finalized; Lanser, with 51 percent of the stock, became the company's president and majority shareholder.

William D. Bryan was a truck driver for Mutual Brewing Company in Ellensburg when he purchased stock in the company from the Williams brothers of Tacoma. The Williams brothers were beer distributors with interests in breweries, including Mutual. By 1943, Bryan owned one-third of the company stock, with Joe K. Hart and Clarence J. Coleman owning the other two-thirds. At the time, the United States government was running a secret wartime program, now known as the Hanford Site, where it was working on nuclear weapons. "One of the difficulties being experienced in carrying out the project was to get a sufficient supply of beer for the employees." Mutual Brewing Company was supplying beer, but not nearly enough. Bryan was advised that United Union Breweries Inc. in Spokane was for sale, so he purchased it to increase Mutual's beer supply for the Hanford Site.

The purchase was completed in November 1943, with Bryan owning one-third and Joe Hart the other two-thirds. Bryan was elected president, C.G. Uran secretary and J.A. Norway treasurer. The latter two were officials from First National Bank of Everett, which had supplied a $110,000 loan. In December 1943, Williams brothers became distributor for United Union Breweries Inc., as it was already distributing Mutual Brewing's beer.

By August 1944, William Bryan and Joe Hart were starting to not see eye to eye, so Howard J. Williams purchased Hart's interest in both Mutual Brewing and United Union Breweries, thereby becoming secretary-treasurer. Mutual Brewing Company was renamed Pioneer Distributing Company and in 1946 was renamed Pioneer-Tacoma Inc.

"During World War II the brewing industry suffered from both labor and grain shortages." With the United States involved in the war effort, it

was difficult for most breweries to get supplies and ingredients. The Pioneer Brewing Company in Aberdeen was not making enough money and brewed its last beer in 1943. It began doing business as Ice Delivery Company, and the buildings were sold to a frozen food concern.

The supply shortage led to the Sick family purchasing the controlling stock in a brewery in Salem, Oregon, in 1943 that became Sicks' Brewing Company. The Seattle company was renamed Sicks' Seattle Brewing & Malting Company at this time also. After the war, sales declined at the Oregon plant, and it was merged with Sicks' Seattle Brewing & Malting Company in August 1952; the brewery was closed in 1953. The company also took another step to cover itself after a hop merchant was unable to deliver product in 1944. It went into partnership with a hop farmer in Yakima Valley, and its seedless Sicks' Select hops exceeded average production; while supplying its own breweries, it also sold some to other breweries.

In 1944, the canning of beer in olive drab cans (made so they would not reflect on the battlefield) for military use began. Thirty-five breweries across the country were chosen to can beer for the military. In Washington, Sicks' Select Beer and Golden Age Beer were canned in olive drab cans and possibly others.

When the war ended in 1946, breweries were once again allowed to begin packaging their beer in cans. Columbia Brewing Company in Tacoma brought back the long-neck twelve-ounce brown bottles and was selling about 140,000 barrels per year.

In 1944, Associated Breweries of Canada Limited changed its name to Sicks' Breweries Limited. It was also during this period that the Canadian company, which was the primary owner of the Seattle subsidiary, sold its interest to a new holding company, Washmont Corporation. It used the sale to retire outstanding stock.

Sicks' Seattle Brewing & Malting Company had been operating with used equipment since reopening in 1934. It needed storage for an additional twenty thousand barrels and a bigger brewhouse, so it spent more than $1 million to upgrade the brewery. In 1948, it used the former Hemrich Brewing Company, located next door, to start a laboratory.

Bohemian Breweries Inc. of Spokane, run by Charles Theis, purchased the Golden Age Breweries Inc. plant in Spokane in 1948.

Columbia Brewing Company in Tacoma survived Prohibition only to see the post-Prohibition landscape much different. In 1949, Heidelberg Brewing Company purchased the business. The brewery continued to operate as

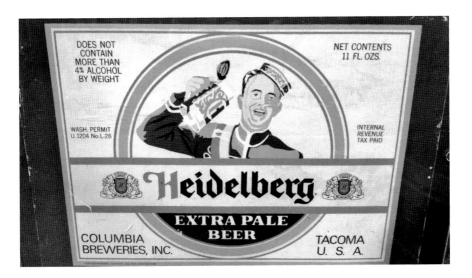

Emil Kliese and William C. Kiltz formed Columbia Brewing Company in February 1900 in Tacoma. Kliese was president and brewmaster, and their most popular brand was Heidelberg. This item is on display at the Microbrewery Museum in Pike Brewing in Seattle. *Author's collection.*

Columbia, and Alt Heidelberg Beer was its most popular seller. It added a twenty-thousand-square-foot bottle shop.

Many breweries sponsored sports teams, radio and television shows, parades and more. Columbia Brewing Company sponsored sports teams, including a football team, in the 1930s. For eight years starting in 1949, Columbia Breweries Inc. sponsored Raye & O'Dare, known as the "Heidelberg Harmonaires," heard on more than thirty-one radio stations in Washington, Oregon, Idaho and Alaska. They entertained with songs, jokes and piano and signed off each show with, "Your Tacoma Neighbor, the Columbia Breweries." Columbia also sponsored Clay Huntington, who broadcast *Baseball by Heidelberg*; Bob Field and *Hockey by Heidelberg* from the Tacoma Ice Arena; and Bill O'Mara, who covered *Wrestling by Heidelberg.*

The Pioneer Brewing Company of Tacoma and Silver Springs Brewing Company of Port Orchard merged to become Silver Springs Brewing Company in Tacoma in 1950. It purchased the former Northwest Brewing Company site and added a three-story bottling plant. It brewed beer using artesian water and was known as "Home of Oldstyle Pilsener Beer," but it also produced Pilsener Beer and Hartz Beer brands.

In 1950, Lucky Lager Brewing of San Francisco, California, purchased Interstate Brewing Company in Vancouver, which became a Lucky Lager Beer plant.

Olympia Brewing Company in Tumwater began canning its beer for the first time in 1950.

In 1952, to commemorate the seventy-fifth anniversary of Rainier Beer, Sicks' Seattle Brewing & Malting Company issued a special set of cans. The result was the Rainier Jubilee set, which was the largest of all 1950s can sets and issued between 1952 and 1964.

Owned by Heidelberg Brewing Company since 1949, on July 15, 1953, Columbia Brewing Company was officially renamed Heidelberg Brewing Company. With the name change, a major $800,000 expansion was announced. A new brewhouse with new barrel tanks would bring the brewery's capacity to 750,000 barrels per year. Its brands Alt Pilsener and Columbia Ale would be popular in the Northwest. It employed 350 people and had an annual payroll of $1,750,000.

In 1953, Sicks' Seattle Brewing & Malting Company finally made a deal with Rainier Brewing Company of San Francisco, California. The San Francisco brewery had lost millions of dollars due to mismanagement and agreed to sell the company for $1,809,937.50. After the sale, Seattle Brewing immediately sold the San Francisco brewery and other California properties to Theodore Hamm Brewing Company. Seattle Brewing kept the Rainier Beer brands, including a strong ale it sold in California. It then merged all of its American operations together, including Sicks' Spokane Brewery Inc. and the Seattle Rainiers Baseball Club. It took eighteen years, but Emil G. Sick had brought the Rainier Beer brand back to Washington.

Charles Theis, chairman of the board and principal stockholder of Bohemian Breweries Inc. in Spokane, died at eighty-seven years old on December 31, 1953, after a long illness. Theis was worth about $250,000 in 1938. He was also a builder and was involved in other businesses, including organizing and building Boise Gas, Light and Coke Company.

With Theis no longer controlling the brewery in Spokane, it was sold in 1956, along with a plant in Boise, Idaho, to Atlantic Brewing Company of Chicago, as part of its expansion plan. Atlantic's business model was to spend little on advertising and sell cheap beer. Emil G. Sick was not a fan of this tactic, saying, "This method of operating marks a new departure in the conduct of the industry in the Northwest."

Heidelberg Brewing Company in Tacoma installed a second brewing line in the summer of 1954, doubling its brewhouse capacity. In 1959, the

Bernhardt Schade began construction on this brewery in 1902. The Schade Brewery was open and run by the founder until 1921, when he died. This photo is the Spokane building in 2015. *Linda Miller Sheets.*

brewery was sold to Carling Brewing Company, which began brewing its Black Label Beer at the plant.

At the end of 1956, Sicks' Century Brewery in Seattle was closed, and its manufacturing moved to the larger Sicks' Seattle Brewing & Malting Company plant. "There was no longer much room for a small brewery to compete with our big plant in Seattle, or the large plants in Tacoma and Olympia," said Emil Sick. Small as it was, the Century plant paid more than $1 million in profits to its parent company over time and never lost money. In 1957, the parent corporation was renamed Sicks' Rainier Brewing Company.

By 1959, the former Schade brewery in Spokane had been sold to Inland Metal, which used it as a warehouse until 1977.

THE 1960s AND 1970s: BEER WARS

By 1960, Olympia Beer, or "Oly," was the "National Beer of Montana." It had a 24 percent market share in California, and in 1962, Olympia Brewing Company sold 1.742 million barrels of beer. For comparison, Anheuser-Busch sold 9.035 million barrels during the same period. The company was the number-one seller in its home of Washington State, beating out rival Rainier Beer.

Great Western Malting in Vancouver and California Malting merged in 1960, creating a new company called Great Western Malting Company, with malt plants in Vancouver, and Los Angeles, California.

The Atlantic Brewing Company of Chicago had been running two former plants of Bohemian Breweries Inc. in Spokane and Boise, Idaho, since 1956. Its plans to expand nationally backfired, and in 1959, it closed the Boise plant. In 1963, it closed the Spokane plant, the last brewery left in town, and sold the Bohemian Club Beer brand to Blitz-Weinhard Brewing Company in Portland, Oregon. The Spokane plant was razed in 1964.

The Lucky Lager Brewing company went through many name changes over the years. In 1964, the Vancouver site was renamed the Northern Division of the General Brewing Corporation after it reverted to its original name. Regional breweries like General were fighting the megabrands in the 1960s. To save money and stay competitive, it sold some of its properties but kept the Vancouver site.

Born in Tacoma and raised in Canada, Emil G. Sick took after his father and built a brewery empire in the United States, primarily in the Northwest. In February 1958, he dictated his memoirs to his personal secretary. He planned to add a final chapter but died on November 10, 1964, at seventy years old, before it was completed. Sick was a shrewd businessman, buying up nearly every small brewery in Seattle as well as other cities. His breweries, under various names, made a variety of brands that became well known, but when he finally secured the Rainier Beer brand, that was the icing on the cake.

Sick also saved the losing Seattle Indians baseball team in the Pacific Coast League, built a new stadium with his own funds and renamed the team the Seattle Rainiers. The team won multiple championships under his ownership, and he sold it in 1960 after several East Coast Major League Baseball teams moved to the West Coast and the Pacific Coast League was relegated to minor-league status.

Emil G. Sick was a generous benefactor and gave back to the community. He served on the Seattle Chamber of Commerce, raised funds for the first blood bank and raised funds to pay off St. Mark's Cathedral mortgage and another for the Seattle Historical Society. He served as chairman of the Washington Brewers Institute. Sick believed that brewers should work "with a view toward the elevation of our product in public esteem and good will." But even more so, he believed that brewers were more than just businessmen: "The successful brewer is not a small figure in his community. His industrial prominence brings him to the forefront and imposes upon him the obligation to take a keen and helpful interest in civic and national affairs." Emil G. Sick did that and more, and the city is better off because of him.

The Schmidt family, who started Olympia Brewing Company, purchased back their original 1906 plant in 1965 and used it as a storage facility.

In 1970, the Carling Brewing Company plant in Tacoma had a new addition completed. But by 1979, Carling was struggling, and the plant in Tacoma was closed after Carling was bought by G. Heileman Brewing Company of La Crosse, Wisconsin.

Sicks' Rainier Brewing Company was renamed Rainier Brewing Company in 1970.

In 1969, General Brewing Corporation was once again renamed Lucky Breweries Inc., and then again in 1972, it was General Brewing Inc.

This photo, taken in Sedro-Woolley in Skagit County, is of what appears to be a former Rainier Beer delivery truck from the 1970s. During that time, Rainier and Olympia Beer were fighting for market share in the state. *Author's collection.*

In 1974, a new Schmidt took the helm of Olympia Brewing Company as Leopold F. "Rick" Schmidt became the new president.

Paul Knight was made brewmaster at Olympia Brewing Company in 1974. "I was amazed by the correlation by what we were doing in the 1970s and what the original brewmasters were doing in the 1800s," Knight said. "We were making very much the same beer as they made in 1896."

By the late 1960s, the mega beer brands had started to diversify and buy regional breweries. They started to increase their presence in Washington, so Olympia Brewing Company purchased Theodore Hamm Brewing Company in St. Paul, Minnesota, for $13.4 million on March 1, 1975. Hamm's had been owned by several Hamm's Beer distributors. Sales of Olympia Beer had grown every year since 1962 except 1971. After this purchase, Olympia Brewing sold 5.574 million barrels of beer in 1975.

For the first six weeks after the sale, Olympia Brewing Company continued to distribute Hamm's Beer through the previous Hamm's distributors, which were also the previous owners. Olympia sent a letter dated April 12, 1975, to two of the distributors, terminating them. On April 30, 1975, they sued Olympia. The case took two years, and Olympia eventually won successive appeals. But did it win? As one writer noted, "The fight with old Hamm distributors cost millions of dollars in legal fees that could have gone other places, like developing a new brew, or pushing advertising."

In 1975, General Brewing Inc. was acquired by S&P Holdings, owned by Paul Kalmanovitz, which included Falstaff Brewing Corporation. Its original Los Angeles, California brewery and one in Pueblo, Colorado, were closed, leaving the Vancouver location the only one left to produce Lucky Lager Beer.

On December 29, 1976, Olympia Brewing Company, still on a buying spree as it sought to stay relevant in the shrinking beer market, purchased Lone Star Brewing Company in San Antonio, Texas. Its sales had been steadily increasing, and after this purchase, it sold 7.163 million barrels of beer in 1976. Former brewmaster Paul Knight said, "They had to get bigger or get a lot smaller. Each time Olympia Brewing Company bought a new brand, it would give them a boost." By trying to keep up with the megabrands, it cost money the Schmidt family didn't have.

By the early 1970s, Rainier Beer lagged behind Olympia Beer in the state, but the mega beers were starting to encroach. To combat this, Rainier Brewing Company hired a young advertising firm, Bowker, Heckler, to craft a new image. Composed of artist Terry Heckler and writer Gordon Bowker, their first client had been ski company K2, based on Vashon

The massive Rainier brewery in Seattle. It was the largest brewery in the state before Prohibition. After repeal, it took some years before Emil Sick was able to purchase the brewery and resume producing Rainier Beer in the plant. *Washington State Archives.*

Island. After executives at Rainier saw their K2 ads, they called them. Bowker, Heckler came up with a series of television ads, the first of which, called "Frogs," gained them national attention. The frogs were croaking "Rainier," and mosquitoes said, "Beer." This was two decades before Budweiser made frogs famous.

These ads won fans over, and Rainier Beer went from sixth place in sales in Washington to number one, "even though Budweiser spent eight times what we did," Heckler said. "I won't say how much Rainier Beer I drank over the years; that was not sustainable either."

Other memorable commercials were "Rainier Deer"; a motorcycle revving "Rainier Beer"; and a series of commercials with actor Mickey Rooney, who was at a low point in his career. He was acting in a play in Seattle when they contacted him. They told him they would pay him $2,500 for the first commercial, and Rooney said, "Rooney will only

accept $3,000." They agreed, and as soon as he was through shooting the commercial, he asked to be driven to a used car lot on Aurora Avenue in Seattle, where he bought a station wagon for $3,000 and drove home to California. Gordon Bowker left Bowker, Heckler in about 1973 and went on to co-found Starbucks Coffee and Redhook Ale Brewery. Heckler Associates did the labels and packaging for Redhook from the start until it merged with Widmer Brothers Brewing in 2008.

Emil Sick's adopted son, Alan B. Ferguson, took over operations at Rainier Brewing Company after his death in 1964. By the 1970s, there was changes to the company's corporate structure and another name change. Molson Breweries Ltd. of Canada came to own the majority of Rainier's stock.

So, was it a complete surprise when, in 1977, Rainier Brewing Company was sold to G. Heileman Brewing Company of La Crosse, Wisconsin, and one of Washington's iconic brands was no longer locally owned? This left Olympia Brewing Company as the last major brand in the state, with a large target on its back.

Chapter 6
THE 1980s AND 1990s

The Birth of Craft Beer

The term "craft beer" was not in the American dialogue in 1980. Watered down, bland beer was the staple, and no one was interested in starting a brewery. A recession began in January, tightening the belts of Americans. But there were some pioneers, people who saw what others didn't—that beer could be good, that it could taste good and have flavor. These people were, unbeknownst to them at the time, at the beginning of the craft beer movement, when they were often called micro beers. Today, they are our history, and without them, who knows where we'd be.

By 1980, sales at Olympia Brewing Company had dipped from their high in 1976 to 6.091 million barrels. It had 2,164 total employees, including 374 in a leasing business. Its total sales in 1980 was $391,974,000. For years, the brewery was the largest employer in Olympia.

But in February 1980, Olympia Brewing Company president Leopold F. "Rick" Schmidt was arrested in a sting operation and resigned from his position the next day. His uncle, Robert A. Schmidt, replaced him.

That year, it hired Chiat/Day to create a new advertising campaign to try and win back the beer drinkers who had either gone to mega beer or rival Rainier Beer in Seattle. Not wanting to copy the highly successful Rainier Beer ads of the time, it created the Artesians, based on the artesian water it used to brew its beer. "The campaign was a resounding success. The brewery began to get hundreds of letters a month. The Artesians entered the popular culture locally, and both awareness of the Olympia Beer brand and trial rates for the beer soared." There was even a game for the Apple II computer.

"But ultimately, the campaign failed." According to a Chiat/Day employee, Olympia Brewing had chosen to reformulate the beer, which "was a clear winner in double-blind taste tests against all the major American beers." But it claimed that it was different than the brand it was selling, and it became known as a bad light beer. But according to former Olympia brewmaster Paul Knight, they never changed the recipe—the ad campaign just didn't work. Whatever the real reason, in a short time it wouldn't matter.

In 1981, Peter Marinoff sued former Teamsters' Union president Dave Beck for libel after Beck was quoted in a 1978 biography in which he accused Marinoff of murder. Marinoff, then a successful insurance executive, sued for $500,000 and was later awarded $10,000. Both men were eighty-six years old at the time.

The times were starting to change in the beer world. Bert Grant was a pioneer in an industry no one wanted to enter. He was born in Scotland and grew up in Toronto, where his first job at sixteen was a brewery taster. He worked in other breweries, including Stroh Brewing Company as research director. Grant planned to start the first brewpub in the United States since Prohibition. By December 23, 1981, when he filed papers to incorporate Yakima Brewing & Malting Company, he was a successful hop farmer. Washington State had passed a bill making it legal to transport homemade wine for exhibitions and tastings, and that was all the leeway he needed.

In early 1982, Bert Grant opened Grant's Pub in the former Switzer's Opera House and North Yakima Brewing and Malting Company in Yakima, brewing four barrels at a time. His first beer was Grant's Scottish Ale, which he made more hoppy than the typical malty style for Scotch ales. It took second place in the consumer's preference poll at the Great American Beer Festival in 1984. He also took first place for his Russian imperial stout. The beer movement's early authority, Michael Jackson (the beer expert), "was one of the operation's biggest" supporters. Jackson eventually declared Grant's India pale ale "the hoppiest beer in America." While Washington's Rainier Beer and Olympia Beer were losing their appeal, Bert Grant was able to create something different and fresh, opening consumers eyes to the flavor possibilities.

By 1982, Olympia Beer was sold in thirty-three states, but in mid-July 1982 Pabst Brewing Company bought 49 percent of the outstanding shares of Olympia Brewing Company stock in an obvious takeover attempt. Through a subsidiary, Olympia tried to purchase 49 percent of Pabst stock to "preserve the business combination," but it never transpired.

In 1983, the Schmidt family, out of time and money, gave in and sold Olympia Brewing Company to Pabst Brewing Company. Lone Star Brewing Company was sold to G. Heileman Brewing Company of La Crosse, Wisconsin. Heileman also owned Rainier Beer and Weinhard Beer at this time. The only good to come out of the closing was that several employees went on to start their own craft breweries in Washington. Pabst gifted the Schmidt House to the Olympia Tumwater Foundation along with $700,000 for perpetual care of the home and grounds.

In 1982, the people who began the craft beer movement could not have known at the time that they were on the cusp of history. That's why it is interesting that twenty investors contributed $500,000 to a new brewery opening in the Fremont neighborhood of Seattle that summer. Independent Ale Brewing Company opened in a former transmission shop and was started by Paul Shipman and Gordon Bowker. Shipman was marketing and sales manager and a former wine salesman who discovered a strain of Belgian yeast they used in their beer.

The brewery was Gordon Bowker's idea, and he would serve as vice-president. He was previously with the Bowker, Heckler advertising agency that was behind the famous Rainier Beer ads in the 1970s, would help start *Seattle Weekly* and was co-founder of Starbucks Coffee and Peet's Coffee.

Charles McElevey was an assistant brewmaster at Rainier Brewing Company in 1969, rising to brewmaster. He left the company in 1978 and, in 1982, became Independent Ale Brewing Company's first brewmaster. It modeled its first beer after an English ale, but by using that Belgian strain of yeast, it created a spicy, fruity beer that locals called "banana beer." That first beer was Redhook Ale, and Independent produced fewer than one thousand barrels its first year, possibly because early quality was inconsistent. It released a porter in 1983 and an IPA in 1984, and Independent Ale Brewing Company was on its way.

In the summer of 1981, Mike Hale traveled to England, where he spent eleven months learning the art of brewing during an apprenticeship at a small British brewery. In the summer of 1983, Hale, an electrician and Colville city councilman, brewed his first batch of beer in his apartment. After discussing his idea for a brewery with friends, some invested in his vision. He spent many hours and $100,000 until, on July 4, 1984, Hale opened Hale's Ales in a warehouse in Colville. He was just the third microbrewery in the state at the time. Hale brewed English-style draft ales—the first was Hale's Pale American Ale, which he called a "training brau." He said, "My goal from the beginning was to brew the best beer I could possibly produce."

The problem he faced was that only two of the town's taverns would carry the beer, "so it's not like the whole town embraces us," Hale said. They hauled 70 percent of their kegs south to Spokane for distribution, and it worked. They were selling two hundred barrels per month from Idaho to Seattle. One person was quoted in a newspaper article saying that comparing Hale's to mass-market beer was like comparing Monet to a starving artist.

Kufnerbrau Brewery opened in Monroe in 1984, started by German brewmaster Robert Kufner (who had brewed in Germany and for Anheuser-Busch) and his wife, Kathy. Unlike most breweries at the time, they bottled 95 percent of their beer and capped and labeled it themselves. Known for Old Bavarian Style Beer, it closed sometime after 1990.

Around the same time, another brewery was getting started along the Columbia River. Beth Hartwell and her husband, Tom Baune, started Hart Brewing Inc. in 1984 in the logging town of Kalama. They built the brewery by hand in an old store, and their first beer was Pyramid Pale Ale, a precursor to what their future would hold.

Meanwhile, Will Kemper (a chemical engineer) was "conducting experiments" in his kitchen in 1984 on Bainbridge Island. With his friend Andy Thomas (an environmental scientist), they started the Thomas Kemper Brewery. The original brewery started in an industrial park, where they crafted German-style lagers. In January 1985, they poured their first beer at Roanoke Park Place Tavern in Seattle, and as their following grew, they moved in 1986 to a larger facility in Poulsbo.

In 1985, S&P Holdings bought Pabst Brewing Company and, with it, the Olympia Beer brand and the rights of 6.56 million gallons of artesian water per day. Hamm's Beer was now brewed in the plant in Tumwater. The Vancouver Lucky Lager Brewing plant owned by S&P Holdings was closed in 1985, dismantled and shipped to Zhouging, China, where it was reassembled. "Under Kalmanovitz and the new business model, advertising was slashed and only the minimum of brewery maintenance was done."

Lucky Lager Beer survived after the Vancouver plant closed by contract brewing, and it became the house brand for the unrelated Lucky grocery store chain. When the grocery chain was purchased by Albertsons in 1999, the Lucky brand beer was discontinued.

Hart Brewing Inc. in Kalama introduced a second beer in 1986, Pyramid Wheaten Ale, the first year-round wheat beer produced in America since Prohibition. It also added a bottling line.

In September 1986, Bert Grant's beer was available in bottles, and the brewpub in Yakima was producing three thousand barrels of beer annually.

Will and Mari Kemper are pioneers in the craft beer world. From co-founding Thomas Kemper Brewery in 1984, they have traveled the world to help others open breweries. Their Chuckanut Brewery and Kitchen in Bellingham holds numerous awards for their beer and brewery. This photo is of the couple accepting their first World Beer Cup award. *Mari and Will Kemper.*

Hale's Ales brewery in Colville was at capacity by mid-1986, producing 2,500 barrels per year. Sales in Colville were not what Mike Hale expected, so he opened a second location in Kirkland in western Washington on July 4, 1987, and shifted half the production there. "The Seattle operation pays the bills, while we get to do the avocation in Eastern Washington." By 1989, it was producing 4,305 barrels of beer.

Spinnaker's Brewpub from Victoria, British Columbia, made its way to Seattle in 1988. It opened what it said was the state's first "authentic" brewpub, serving fish and chips, shepherd's pie and other English food. Known as Noggins Brewpub, it was one of the original tenants in the new Westlake Center. The following year, it opened a second location in the University District in a remodeled church.

Big Time Brewery opened in Seattle in December 1988, just a few minutes' walk from Noggins Brewpub. The brewery had a 14-barrel brewhouse, and the pub had a novel idea at the time: a non-smoking

section. Owned by Reid Martin, who had started brewpubs in California, Big Time had a 1,500-barrel-per-year capacity. Ed Tringali , from Berkeley, California, was head brewer and said that the brewery sold 935 barrels of beer in 1989.

By July 1988, four investors had permits to open a new brewery in Spokane. Fort Spokane Brewery Inc. was started by James Bockemeuhl (descendant of Bernhardt Bockemuehl, who started Fort Spokane Brewery in the 1880s), John W. Eyre, John Key Jr. and Gary Schroeder. They had no definitive beer recipes or location at the time but were hoping for sales of 2,000 barrels per year.

In 1989, Hart Brewing Inc., five years into the beginning of craft beer history, sold the brewery to five investors from Seattle who had no previous beer experience: George Hancock (president), John Stoddard (previously owned Paul Thomas Winery), Don Burdick (vice-president and secretary-treasurer) and John and Peter Morse (who owned the popular Fratelli Brothers ice cream in Seattle).

That same year, Thomas Kemper Brewery held its first Oktoberfest, the beginning of an annual tradition. According to one report, it was a small affair that eventually grew to draw thousands of people to Poulsbo. Co-founder Will Kemper left the company in 1989 to start a brewery consulting business.

Richard Wrigley was an English entrepreneur with a grand plan to open brewpubs across the country. He started in Manhattan, New York, and by 1989, he was looking at Seattle. The outcome was Pacific Northwest Brewing Company in Pioneer Square. The area was still being redeveloped, and customers would call to see if it was safe to visit. Pacific Northwest featured cask-conditioned English-style ales, but complaints of expensive beer (gasp, $2.75 for ten to fourteen ounces) and food and beer that wasn't great prompted speculation that it would not be open long.

There is a husband-and-wife team that may not get as much recognition as it should for helping to foster the new wave of craft breweries. Charles and Rose Ann Finkel, owners of a wine importing company, started a beer importing business in 1978 to "satisfy their taste for authentic beers." They began marketing great European beers and helped introduce a new generation of Americans to forgotten styles like oatmeal stout, Scotch ale, imperial stout and porter; they were also the first company to offer a range of Belgian beers, now all very common.

While the old Washington brands, Rainier Beer and Olympia Beer, were being bought and sold, Charles and Rose Ann Finkel decided to open their

own brewery in downtown Seattle. In 1989, they bought Liberty Malt Supply Company in the Pike Place Farmers' Market and created the Pike Place Brewery. The brewery was located in what had been the LaSalle Hotel, made infamous by Nellie Curtis, a madam who ran the hotel as possibly the biggest brothel in Seattle.

The Finkels installed a four-barrel kettle with the goal of brewing beers "equal or better, and in better condition than any that they represented from Europe." Their first head brewer was Jason Parker, and the first beer was Pike Pale Beer, followed by XXXXX Stout. Charles, a designer, created the bottle labels, and the beer was featured that year in *Beer: A Connoisseur's Guide to the World's Best Beer*, by Christopher Finch. In 1991, beer expert Michael Jackson chose Pike Pale Beer as one of the eight beers he would take to a desert island. In 1990, Fal Allen, who started in 1988 at Redhook Ale Brewery, became head brewer and stayed for eight years. In 1999,

Charles and Rose Ann Finkel started a beer importing business in 1978 to "satisfy their taste for authentic beers." In 1989, they opened Pike Place Brewery, which has become an award-winning brewery that gave many brewers a start. This is Charles Finkel with the author's baby, in September 2015. *Author's collection.*

Allen was awarded the Brewers Association's Russell Schehrer Award for Innovation and Achievement in Craft Brewing.

Roslyn Brewing Company was started by Roger and Lea Beardsley and brother-in-law Dino Enrico in 1990 in Roslyn. The town is best known for being the setting for the television show *Northern Exposure*. Starting the brewery was "kind of a way to make work that would allow us to live in the area," said Roger. It did work, and their beer was popular. In 2003, their priorities changed, and they put the business up for sale. Kent Larimer, Paul Angelos and Mike Payne purchased the business in 2004 from the founders.

Kent is the current brewer, and his elder brother knew Paul; Mike arranged the financing. They learned how to brew after the sale.

Noggins Brewpub in Seattle was not doing well and laid off brewer Craig Skelton and other staff on January 17, 1990. Cost overruns during the construction put it behind from the start. It filed for chapter 11 bankruptcy protection due to $300,000 in debts. The brewer at the time was Larry Rock, and he hoped that it could bring in investors to jump-start the brewery.

Maritime Pacific Brewing Company was the first brewery to call the Ballard neighborhood in Seattle its home. Opened in 1990 by George and Jane Hancock, it is a pioneer in the neighborhood. "Hancock has seen some lean times. He's survived by brewing simple beers; beers he knows will sell far and wide in restaurants and grocery stores." In 1997, it opened a taproom adjoining the brewery and named it the Jolly Roger in honor of its most popular holiday brew. In 2011, it took the adults-only restriction off the taproom.

Phil Rogers was a chef in Napa Valley, California. He found that his customers liked good beer, and eventually he started brewing it and started a brewery along with a restaurant. He sold the business in early 1990 and moved to Seattle, where he started Seattle Brewing Company & Duwamps Café Inc. In October 1990, he and his wife, Susan Benz, opened their business in Seattle a few blocks from the Space Needle, bringing their chef from California with them. Although they tried, the business struggled to stay profitable, and they closed in 1991.

One good thing came out of Seattle Brewing Company, though: Dick Cantwell. While caring for his young daughter, he started to homebrew. "It was something that was creative, but I was able to be with her," he said in a 2007 interview. After moving to Seattle, he brought samples of his homebrew to brewpubs, and Phil Rogers hired him. After Seattle Brewing Company closed, Dick found a job at Pike Place Brewery, where he stayed for two and a half years.

Independent Ale Brewing Company (renamed Redhook Ale Brewery) in Seattle sold an estimated fifteen thousand barrels of beer in 1989 (but had a capacity for forty thousand). In 1991, it took home a bronze medal at the Great American Beer Festival for its Redhook Extra Special Bitter (ESB).

G. Heileman Brewing Company of La Crosse, Wisconsin, the owner of Rainier Beer and Weinhard Beer brands, among others, filed for bankruptcy protection in January 1991. It survived that, and in 1996, Heileman was purchased by Stroh Brewing Company, which itself would soon be struggling for survival.

In the fall of 1990, Hale's Ales was given an eviction notice at its original brewery in Colville. In October 1991, it closed the Colville location and moved all its equipment to a new location in Spokane Valley. The new location would allow five times the production of the first location, but construction delays forced the brewery to withhold the opening until the end of the year. It was producing 6,350 barrels per year by this time.

It was during one of its Oktoberfest festivals that Thomas Kemper Brewery introduced a hand-crafted root beer that was an instant hit. It did so well that in the early 1990s it formed the Thomas Kemper Soda Company to develop and market a line of sodas.

Charles McElevey, Redhook Ale Brewery's first brewmaster, left in October 1991 to start West Seattle Brewing Company in Seattle. The small, nine-hundred-barrel-per-year brewery was renamed California & Alaska Street Brewery in 1991. It closed in early 1997.

Dave Moorehead began homebrewing in about 1969, and the brew bug bit him. He later became friends with Tom Baune, one of the founders of Hart Brewing Inc., and picked his brain about running a brewery. In 1987, he began constructing a mechanic's shop behind his home in Onalaska and then converted it to a brewery. The first bottle of beer from Onalaska Brewing Company rolled off the line in December 1991. "At one point, I was brewing every weekend and experimenting with recipes," Moorehead said. He brewed 275 homebrew batches before coming up with his signature ale, with medium body and amber color.

In 1992, Scott Hansen started Leavenworth Brewery in a building he built in the Bavaria-themed town of Leavenworth, brewing German-style beers.

Winthrop Brewing Company was formed in 1992 in Winthrop by Dan S. Yingling and Paul Brown. They opened with an eight-barrel brewhouse in June 1993. "Coasters are glued or stapled all over the place, and each has a girl's name, phone number, and a lipstick kiss. This tradition stems from a woman who didn't have enough money to leave a tip, so she left her own 'special' tip, and it just caught like wildfire."

In 1990, Hart Brewing Inc. brewed 9,300 barrels of beer, and gross sales were growing at a rate of 88 percent per year. The new owners of Hart Brewing saw the potential in the growing industry, so in 1992 they purchased Thomas Kemper Brewery and the soda company, which had previously been separated. Not long after, Hart Brewing opened a new eleven-thousand-square-foot brewery in Kalama in 1992 as the company continued to grow.

The San Juan Brewing Company—Front Street Ale House was formed in October 1992 in Friday Harbor. Oren Combs was the brewmaster and

general manager of the brewpub when it opened in April 1993. Combs is credited with being the first person to infuse bacon in beer. "Someone suggested I could make a bacon beer, and people laughed at the idea." In 2008, he put his bacon beer on tap and put a sign in the window. "We did it as a complete novelty; I had no idea what the reaction would be to something like a bacon beer. During the peak tourist season, we sometimes had one hundred people a day taking photos of the bacon beer sign." A flood in January 2010 forced the brewery to close, and it did not reopen.

On November 25, 1992, brewer Jerry Ceis founded Seattle Brewers in Seattle. The brewery had a capacity of eight hundred barrels per year. His beer was distributed to local bars and at his own pub called Jerry's Jungle. It closed in 1999.

Noggins Brewpub had two brewpub locations in Seattle, but in 1992, parent company Spinnaker's Brewpub shut down both locations.

Hart Brewing Inc. and Thomas Kemper Brewery, although under the same ownership, still operated independently. In 1993, they both released new products: Thomas Kemper released Weizen Wheat, a German raspberry wheat beer, and Hart introduced an unfiltered wheat beer it called Hefeweizen. Both became very popular in the Northwest.

Paul Shipman laid out a plan in early 1992 to expand Redhook Ale Brewery. He planned to build another, larger brewery in King County, another on the East Coast and, eventually, a string of regional breweries across the country. The company was profitable, and the board was eager to follow his lead. It constructed a plant in Woodinville that resembled Andechs Brewery in Germany. The company was also planning to take the company public.

In 1993 Shipman was asked how he would secure distribution for Redhook's products. The distributors who worked for Anheuser-Busch (A-B) were hard-pressed to disrupt their guaranteed cash flow and reluctant to take on small breweries. Shipman suggested a deal with Anheuser-Busch that would solve that problem, but no American brewery had ever tried it. When an executive from A-B wanted to visit Redhook Ale Brewery, she was given the red carpet treatment and agreed to meet Shipman. Over several visits to Anheuser-Busch headquarters in late 1993, Shipman explained: "I would like A-B to invest in Redhook so we're partners. I was thinking that Anheuser-Busch should have a minority stake in Redhook—maybe about 5 percent." They wanted 49 percent.

In June 1994, Redhook Ale Brewery announced that Anheuser-Busch had purchased a 25 percent stake in the company. It would use the money

to finish the Woodinville brewery and start another in Portsmouth, New Hampshire. The reaction to the news was mixed, but the biggest critic was Jim Koch, founder of Boston Beer Company, who called the alliance "Budhook." Paul Shipman admitted that they should have come out with a message that Redhook Ale Brewery wasn't changing. "I was so proud to be associated with Anheuser-Busch that I naïvely failed to look at all the possible consequences."

Mark Irvin fell in love with beer in the 1980s after living with his family in Germany and began homebrewing. He went to Eastern Washington University and then worked at Coeur d'Alene Brewing in Idaho before joining Hale's Ales, working at its Kirkland, Colville and Spokane locations. In October 1993, he opened Northern Lights Brewing Company in Airway Heights, a suburb of Spokane, distributing beer out of the back of his pickup truck. He purchased the original twelve-barrel electric brew kettle from Hale's Ales. "I could have brewed in Seattle, but I never could have passed up the chance to brew in my hometown and create my own independent style," he said. In 2002, it moved to a new location on the Spokane River and opened a pub.

On October 31, 1993, Crayne and Mary Horton (and few dozen local investors) founded Fish Brewing Company in Olympia. With a fifteen-barrel brewhouse, Tom Chase was head brewer, and Tom Munoz later apprenticed under him. The brewery would become known for its "super-hop beers" and English-style ales, with double-digit sales propelling the brewery for several years.

Kelley Creek Brewing in Bonney Lake was opened on the Kelley Farm, owned by Michael Svinth, a descendant of the Kelleys, in 1993. He ran the brewery until 1999.

The first modern commercial craft brewery in Vancouver since the closing of Lucky Lager in 1985 was started in 1993 by Phil Stein, as Vancouver Brewing Company Inc., Hazel Dell Brewery, in Hazel Dell. "I've lived here all my life, and we used to have to go to Portland all the time to get good beer," Stein said. "So we decided to start our own brewpub in Vancouver." The company lost its license in 2012.

In 1993, Dick Cantwell left Pike Brewing Company in Seattle to take over for brewer Ed Tringali at Big Time Brewery in Seattle. During his stay, Dick hired Bill Jenkins, another Pike brewer alumni, who became his replacement.

Malcolm "Mac" Rankin began homebrewing in February 1991. Over the next year and a half, he worked on recipes and wrote a business plan. In 1993, he asked Jack Schropp to join him, and they began Mac & Jack's

Brewery in Jack's garage in Redmond, producing one to two kegs daily. They hand-built a new brew system capable of brewing twenty-six kegs per day and made their first sale in April 1994. Their first employee, in 1995, was Manny Chao, who helped market and sell the beer on commission. In 1996, they moved out of the garage to a new production brewery. The company sold only growlers and kegs until 2015. African Amber Ale is its flagship, accounting for 95 percent of its sales by 2009. By 2010, it was the top-selling draft beer in Washington. A disagreement with Chao in 2000 led to his leaving and starting Georgetown Brewing Company.

Issaquah Brewhouse in Issaquah was started in 1994 by a group of friends who made their fortunes in the tech industry. In March 2000, Rogue Ales of Oregon acquired the company. It continues to brew its own specialty beers, including Bullfrog Ale and a selection of specialty and Rogue beers.

Larry and Ana Pratt opened Salmon Creek Brewery & Pub, the first brewpub in Vancouver, in 1994. Larry and a friend started brewing in Woodland after rent for a space in Salmon Creek suddenly increased at the last minute. "Neither of us had ever brewed beer before. The first batch we made was awful." They stayed in Woodland until 1997, when they found a spot in Vancouver.

Rick Star and Allen Rhoades started Anacortes Brewery—Rockfish Grill in Anacortes in 1994. Star began homebrewing in 1987 and joined a homebrew club in his hometown in Southern California. His uncle was a brewmaster in Bavaria, and he always wanted to own a brewery. "It was fascinating to me, and I always had a very positive association with the smell of fermentation." They have a seven-barrel brewhouse and have a "cold room specially designed for lagering to provide our beers with a traditional character and complexity." They produce about 1,100 barrels per year, and he used one of his uncle's recipes for their first beer, Klosterbier.

NW Sausage & Deli was established in Centrailia in 1983 by Dick Young. His vision was to create a place where everyone could enjoy Old World–style smoked sausage. In 1984, Dick "poured his passion and interest into homebrewing" and built a three-barrel brewhouse from scratch. Eventually, his popular beer was exceeding homebrewer limits, and in 1994, Dick's Brewing Company was founded. He built a brewery adjacent to the deli and brewed two hundred barrels, growing to more than three thousand barrels per year by 2009.

After moving to Spokane to open a coffee bar, James Gimurtu took the brewing course at University of California–Davis and decided to open a brewery. In June 1994, he filed corporation papers for Birkebeiner Brewing

Company. Gimurtu was an avid skier and named the brewery after "a legendary group of hardy Norwegian skiers who rescued the infant King Haakon V." Set up in an old warehouse in a run-down part of town, Gimurtu had a restaurant and twelve-barrel brewhouse with twelve beers on tap at any given time. He brewed a different selection of beers, including a malty chili beer. Tom Taylor was head brewer in 1995.

By the mid-1990s, Hart Brewing Inc. was the fourth-largest craft brewer in the United States, and Thomas Kemper Brewery saw sales double from 1994 to 1995, making it one of the top three brands in Washington. People were starting to notice the different takes that Northwest brewers were having on beer. In a 1995 article in the *Seattle Times*, there was talk about fruits being added to beers by Thomas Kemper and Hart, espresso stout from Hart and the first bottled rye beer in eight years from Redhook Ale Brewery. "The whole industry looks to the Northwest as the bellwether of their market," said Larry Baush, editor and publisher of the *Pint Post*, the official magazine of the Microbrew Appreciation Society, published in Seattle.

There were some who thought that the market might have peaked for new breweries by 1995, including Paul Shipman, co-founder of Redhook Ale Brewery. "The golden age is passing," he said, "but in many ways it's even better now. The talent that is coming here because of what we do is great. They want to participate in what's new. But it's definitely tougher to start up."

In 1995, real estate investor Tom Leavitt invested in Pike Place Brewery and took over as president. His first task was to search for a larger location. It ended up moving next store to a building adjoining the market, and the brewery name was changed to Pike Brewing Company. It also started contract-brewing its beer in Vermont and Minnesota. In 1996, the Seattle Microbrewery Museum was created downstairs from Liberty Malt Supply Company, and to this day, it is curated by Charles Finkel. In 1996, Pike Brewing Company won three gold medals at the World Beer Championships, and the brewery was definitely on the map.

As the craft beer wave started to hit Washington, Hart Brewing Inc., in March 1995, opened a second brewery, with a 250-seat alehouse, in downtown Seattle, near the Kingdome. By 1994, it had an annual capacity of 87,000 barrels, and 72,100 barrels were shipped. For the first three quarters of 1995, capacity was 152,300 barrels, but only 89,100 were shipped. Three weeks before its fourth quarter, the company conducted an Initial Public Offering. The stock was priced at $19, raising $34.2 million for the company.

Not long after, sales declined, the stock lost value and it was sued by one investor. The company prevailed.

Kelly Taylor started homebrewing in his dorm in 1989 and then apprenticed at Karl Strauss Breweries in San Diego, California, while attending college. In 1994, Taylor designed and built the seven-barrel brewing system for Eagle Brewing Company in his hometown of Mukilteo. Started by Mayor Brian Sullivan, the brewery was in the basement of his pizza joint. "He has a homemade mash-lauter tun and uses the hot water heater for a hot liquor tank."

James M. Jones (president), Tom Bannister (vice-president of restaurant operations) and Homer Allen began Glacier Peak Brewing Company in 1994. Jones was a homebrewer and asked Tom Munoz from Fish Brewing Company to be head brewer and vice-president of brewery operations. In November 1994, they offered ninety-eight thousand shares of stock to raise funds and become the first brewpub in Everett. The brewery featured a fifteen-barrel system and opened in 1995. Munoz used his skills from University of California–Davis "in brewery design and procedures, recipe development and quality assurance." The brewery only lasted a year before it closed.

Offering stock to start a brewery became popular for a while after Redhook Ale Brewery and Hart Brewing Inc. went public. Charles Sullivan started in the brewing business at Redhook Ale Brewery's Trolleyman Pub in Seattle. He then moved to Oregon and worked at McMenamins Inc. for three years. In 1995, Sullivan helped found Skagit River Brewery in Mount Vernon. It sold shares in the business, with a minimum of fifty shares at only five dollars each. As head brewer, Sullivan saw the business grow, but the brewery lagged the growth of the attached restaurant, which grew faster than the brewery. In 2010, the Sullivan family sold their ownership in the business to employee Eric Lint, who took over as president. In 2014, former head brewer Charles Sullivan was named executive director of the Washington Brewers Guild.

Hale's Ales announced in early 1995 that it would be moving from its Kirkland location to a new, larger location in the Fremont neighborhood of Seattle, the home of Redhook Ale Brewery. The new seventeen-thousand-square-foot brewery would include its first brewpub and allow three times the production capacity of the Kirkland location.

Ed Bennett was poised to enter the wine industry after receiving a master's in finance and wine chemistry. Then he discovered beer and decided to open a brewery. That was in 1992, when he began looking for the right

location. He finally found it and started Boundary Bay Brewery and Bistro in Bellingham in September 1995 in a historic 1922 warehouse.

Win Anderson and Bob Lane purchased and restored Tacoma's Engine House No. 9, which was built in 1907 and closed in 1965. They converted the first floor to a tavern and the second story into an apartment, opening in 1972. In 1995, Tacoma architect Dusty Trail purchased the business and converted it to Tacoma's first brewpub with Douglas McDonnell, the grandnephew of the founders of Columbia Brewing Company. Brewmaster Karl Ockert was hired to design and help open the brewery. They created Tacoma Brew, a beer based on similar Tacoma-style beers of yesteryear. "Tacoma was a serious brewing town before Prohibition," said Trail. The new Engine House No. 9 Tacoma Brew kind of nurtures and keeps that old history alive."

In June 1995, Tapps Brewing Company opened in Sumner, founded by Jay Fuchs. The first brewmaster was Stacy Tyler.

Sweetwater Brewing Company was one of the pioneers in the craft beer movement when it was opened in Spokane in 1995 by William Bassett. One report noted, "Some of these beers were hit or miss. Some were solid, and others were unbalanced or bland." The brewery was open until 2002, when it shut its doors.

Dusty Trail purchased the Puyallup Substation in Puyallup in 1994. Originally constructed in 1907 for the Puget Sound Electric Railroad, the building was renovated and the Powerhouse Restaurant & Brewery opened inside in August 1995. The interior was an electrical museum and included a brewery. Trail, once again, hired brewmaster Karl Ockert to design and help open the brewery. In 2013, homebrewer Dan Tweten purchased the brewery.

Homebrewer and Ferndale city council member Lloyd Zimmerman started Whatcom Brewery Incorporated in November 1994 in his Ferndale home. He brewed on a five-barrel system while he looked for a permanent location. He found it in downtown Ferndale, where he opened Frank-n-Stein (hot dogs and beer) and brewed on a half-barrel system. Housed in a small, former barbershop, on brew day he assembled and disassembled the brewing equipment to fit in the space. In early 2012, Zimmerman closed the business after not having enough time to run it. In its place, Maggie's Pub opened, serving craft beer and becoming a popular local spot.

In late 1994, 4,300 investors spent $2.7 million to fund Seattle Brewing Inc. (under the Aviator Ales brand), a new brewery that opened in Woodinville in September 1995. It was founded by James Bernau of Willamette Valley Inc.

of Portland, Oregon, with plans to open ten breweries across the country. It hired consultant (and co-founder of Thomas Kemper Brewery) Will Kemper to develop its recipes.

The Bellweather Brewhouse, run by Wind River Brewing Company, opened in late 1995 in Vancouver. It was open until late 2002, when the business was dissolved.

Also in 1995, Gallagher's Where-U-Brew opened in Edmonds. It was a brew-on-premises microbrewery, where you used its equipment to make your own beer. Started by Dennis and Sandy Gallagher, "It is not about keeping people brewing batches of beer for years," Dennis Gallagher said. "It is about creating a memory that customers tell their friends about. That is how to build a business. It is slow and arduous, but it works." The company grew into a local place to drink a pint and in 2010 moved and expanded. In December 2014, Marcie and Tom Kretzler purchased the company.

Rick Buchanan was a plumber who started working for Redhook Ale Brewery in Seattle before it first opened. When brewmaster Charles McElevey quit in 1985, Buchanan became the new brewmaster. In late 1988, he resigned from Redhook and took a position outside the United States. Buchanan later contacted Bart Traubeck, whom he worked with setting up the Redhook brewery, and asked for his help in starting a new brewery. Traubeck found a thirty-five-barrel copper brewhouse in a closed brewery in Bavaria and had it shipped to Oroville, where they opened Buchanan Brewing Company in 1995. The business, with full restaurant, lasted just over a year, finally closing in 1997.

La Conner Brewing Company was founded in 1995 by brewer Scott Abrahmson and his wife, Cindy, in La Conner. In 2002, they sold the business to Pamela Larson, while longtime brewer Arlen Harris continued in the brewhouse. After a few years, Harris became head brewer at Issaquah Brewhouse and in 2005 was named executive director of the Washington Brewers Guild.

On August 17, 1995, Redhook Ale Brewery went public. The initial stock price was $19 per share, but it immediately started trading at $25 per share. Within two weeks, it had shot up to $35 per share. The company would stay profitable for months, until December 1996, when its stock plunged to $9.625 per share after it announced flat sales. The craft beer industry had grown 33 percent in ten months, and Redhook was no longer the only choice available.

Elysian Brewing Company was founded in Seattle in 1995 by former spirits wholesaler Dave Buhler, Seafirst Bank vice-president Joe Bisacca

and Big Time Brewery head brewer Dick Cantwell. Their first location was opened in 1996 in the Capitol Hill neighborhood.

Christian Krogstad was a homebrewer and moved in 1991 from Seattle to Portland, Oregon, finding a job at McMenamins Inc. He started at its Edgefield location cleaning kegs and training as a brewer. He then moved to its Hillsdale location before returning to Edgefield. Afterward, he attended Siebel Institute of Technology brewing school and returned to Edgefield as head brewer. In 1995, he and Donal McKenzie started Orchard Street Brewery in Bellingham, which included a brewery and restaurant. The brewery bottled and kegged its beer, sending it across the state and across state lines. Between 1998 and 2003, Orchard Street Brewery had a change in management, lost a large account and closed its restaurant. It survived for a while, still brewing through the end of April 2004. Neighbors said that it suddenly left, taking all the equipment from the property. It was evicted, and Christian Krogstad moved to Oregon and into the wine business.

Opened in May 1996 in Prosser, Whitstran Brewing Company Inc. was run by partners John-Paul Estery and Brad Elliot. By 1997, they were self-distributing 200 barrels, and in June 1998, they started bottling. In 2012, they produced 185 barrels of beer, but it was down to 95 barrels in 2014.

The Tumwater plant of Pabst Brewing Company was its most modern and capable of producing 4.5 million barrels of beer per year. In 1996, it produced 2.4 million barrels, most of which was exported to China.

Sales and growth was increasing at Hart Brewing Inc., and by early 1996, revenues had hit $25.3 million. With the proceeds from its stock sale, it increased production at both its breweries, and by the end of 1996, its Kalama facility could produce ninety-five thousand barrels per year and the Seattle facility ninety-eight thousand barrels per year. This prompted the closing of its sister company, Thomas Kemper Brewery in Poulsbo, and it moved production to the Seattle location. This year was a time of great change for Hart Brewing. Its bestselling beers were all named Pyramid, so in 1996, it renamed the company Pyramid Breweries Inc. and began distributing outside the Northwest. The Thomas Kemper brands were still marketed under their own name.

Restauranteurs and brothers Scott and Steve Houmes were living in the Kitsap area and wanted to create a brewpub experience similar to their home back in Oregon. They looked to Thomas Kemper Brewery and asked head brewer (and founder of the West Sound Brewers Club) Don Spencer to become their brewer. They opened Silver City Brewery in Silverdale in 1996. Spencer said, "There's a history of brewing in Kitsap County, and I

think we should recognize it." In 2008, Spencer was challenged to recreate DeLuxe Beer, a beer originally brewed by Silver Springs Brewing Company in Kitsap, and he did. Demand would outgrow production capacity for the brewery, and in May 2010, it moved production to a new facility in Bremerton. In 2012, it opened a taproom at the brewery, kept the restaurant in Silverdale and expanded production.

Don Wyatt had been homebrewing for five years before he went to work at Thomas Kemper Brewery in Poulsbo. When Thomas Kemper closed its doors, he opened Hood Canal Brewing in September 1996 in an eight-hundred-square-foot building on his property just north of Poulsbo. He personally distributed to bars, pubs and grocery stores in Kitsap and surrounding counties. Former boss Will Kemper was proud of his former brewers: "You plant some seeds, and so it's great to see things grow. They're building on a great heritage."

Like many in this craft beer world, Phil Bannan Sr. started by homebrewing after receiving a kit for Father's Day in 1990. Before long, his five-gallon batches weren't enough, and to maintain "marital bliss," he and his wife, Cynthia, decided to start a brewery. In 1995, they wrote a business plan, and on July 4, 1996, they brewed their first beer at Scuttlebutt Brewing Company in Everett. They had a 20-barrel brewing system and sold 170 barrels of beer that first year. The brewery is named after Cynthia, who had been nicknamed "Scuttlebutt" by her father since before she was born.

In an effort to increase its sales outside the Pacific Northwest, Pyramid Breweries Inc. opened a new brewery and alehouse in Berkeley, California, in early 1997 and also bought the Thomas Kemper Soda Company. But with the craft beer boom, the megabrewers were encroaching and other craft breweries were opening. The megabrewers controlled nearly the entire distribution network, and these difficulties affected the bottom line of Pyramid Breweries. To save money, it closed the original Kalama brewery. But its bottom line still suffered, and it lost $2.1 million in 1997. (After eighteen years, it closed the Berkeley location in July 2015.)

In 1997, Kim and Guy Sands opened Port Townsend Brewing in Port Townsend. They offered only two beers at the time: Port Townsend Pale Ale and Port Townsend Brown Porter. With the help of brewing consultant Vince Cottone, master of malting and brewing sciences Jim Pryor and professional brewers Bill Pearson and Barry Ladell, the brewery got off the ground. The brewery started with a 7-barrel brewing system. In 2003, it upgraded to a 15-barrel brewhouse, and by 2011, it could not keep up with demand, producing about 2,500 barrels. "We've gone from about a 90-barrel brew

Sponsorships have long been an important aspect of beer advertising. Olympia Beer sponsored motorcycle daredevil Evel Knievel, as well as numerous race cars, including this NASCAR 1974 Dodge Charger that ran in the twenty-four-hour endurance race in 1976 and the Le Mans Classic in 2006. *www.olympia-charger.com.*

This machinery is breaking apart fresh hops after they have been picked and separating the hop cones. This is the Loftus Ranches facility in Yakima, family of Bale Breaker Brewing. *Loftus Ranches/Bale Breaker.*

A worker moving a bale of hop cones that have been dried and compressed into a bale at Loftus Ranches in Yakima. They will move on to customers to use in their beer. *Loftus Ranches/Bales Breaker.*

Another step in the process of harvesting hops. A worker mixes the buds as they move through the machinery, possibly drying. Washington State grows the most hops in the United States. *Loftus Ranches/Bales Breaker.*

In 1994, Diamond Knot Brewing Company opened in Mukilteo. By 2005, it had grown and built a production brewery. This is the interior of Diamond Knot's production brewery in Mukilteo. *Diamond Knot Brewing*

Oliver and Pamela Brulotte founded Icicle Brewing Company in May 2010 in the Bavarian-themed town of Leavenworth. *Left to right*: Carla Carani, Megan Lewis, Pamela Brulotte and Gretchen Wearne. *Dzhan Wiley.*

Above: Everybody's Brewing in White Salmon was started in September 2008 by Doug and Christine Ellenberger. When they opened, they didn't have any of their own beers ready, so they served other brands, providing something for everybody. They now have several popular beers of their own, including Country Boy IPA. *Everybody's Brewing.*

Left: Salmon Creek Brewery & Pub was founded in Vancouver in 1994. When the original owners sold it in 2012, it was renamed Old Ivy Brewery. *Doug Moyer.*

Matt Lincecum founded Fremont Brewing Company in the Fremont neighborhood of Seattle. By 2013, it was the seventh-largest brewery in Washington. In 2014, it announced that it was building a new production brewery in Seattle to handle its demand. *Fremont Brewing Company.*

The Gold Seal beer brand was brewed by Elmer E. Hemrich's Brewery in Seattle. Other breweries also brewed the beer, including this example, which was brewed by Apex Brewing Company. This bottle is located in the Microbrewery Museum in Pike Brewing in Seattle. *Joe Mabel.*

Sicks' Rainier Brewing Company was renamed Rainier Brewing Company in 1970, and in 1977, it was sold to G. Heileman Brewing Company. In 1996, Heileman was sold to Stroh Brewing Company, which itself fell victim to increased competition and closed all its plants in 1999, including the Rainier plant. This is a view of the plant today. *Photo by author.*

Coasters, stickers, pint glasses, key chains and bottle openers are common giveaways from breweries. Here is a small collection of coasters and stickers from some current Washington breweries. As of this writing, there are three hundred active breweries in the state. *Photo by author.*

Top: The entrance to Pike Brewing Company in Seattle, located in iconic Pike Place Market. As the years went on, Pike was sold by the Finkels, but in May 2006, they bought the company back and have not looked back. They are a storied, awarded brewery and produce some very good beers. *Photo by author.*

Middle: Yakima Valley Brewing Company in Selah was purchased by Fred Martin, who sold his Martin's Beer. Old Empire Beer was brewed by United Union Breweries in Walla Walla. These bottles are located in the Microbrewery Museum in Pike Brewing in Seattle. *Photo by author.*

Left: A flight of beers is a popular way of trying small samples of a variety of beers at one sitting. Most breweries offer this in their taprooms, and in this photo from Everybody's Brewing in White Salmon, that is exactly what Jena Gustafsen is preparing to serve. *Everybody's Brewing.*

Island Hoppin' Brewery was started in 2011 on Orcas Island. Business did well, and in 2012, it moved to a new location in Eastsound. This is a photo from the taproom. *Sarah Natasha Horowitz.*

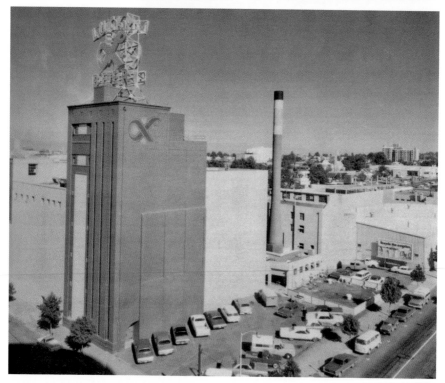

Interstate Brewing Company took over the Star Brewery in Vancouver in 1934. In 1950, Lucky Lager Brewing of San Francisco purchased the company, which began brewing Lucky Lager beer. There were many ownership changes over the years until 1985, when the plant was shut down. *Bill Yenne.*

Leavenworth became a Bavarian-themed town in the 1960s. All the buildings were remodeled to give them that Bavarian look, and any new buildings had to meet those standards. Icicle Brewing Company built one of those buildings in Leavenworth, and sales of its beer, pictured here, continue to grow every year. *Dzhan Wiley.*

Matt Lincecum, founder of Fremont Brewing Company in Seattle, was a environmentalist, community organizer, homebrewer and attorney representing wine, beer and liquor companies before realizing that he wanted to be on the other side of the business. It opened in 2009. *Fremont Brewing Company.*

This is a great old bottle from Tumwater's Olympia Beer. It is located in the Microbrewery Museum in Pike Brewing in Seattle. The Olympia plant was the last of the post-Prohibition Washington breweries to close. It was sold to Pabst Brewing Company, which sold the plant to Miller Brewing Company, which turned around and brewed Olympia Beer in the plant for Pabst. *Joe Mabel.*

Silver City Brewery was the first brewery outside Seattle to produce the official beer for Seattle Beer Week. Its beer Sieben Brau (pictured here) was sold to coincide with the 2015 seventh annual event. *Silver City Brewery.*

Travis Guterson and Mike Runion started 7 Seas Brewing in Gig Harbor in 2008. The two met while working at Silver City Brewery in Silverdale. Tap handles have become an important way to distinguish one brewery's beer from another. This is a nice photo of the tap handles in the taproom. *7 Seas Brewing.*

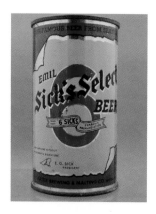

Left: All the breweries owned by Emil Sick were renamed with Sicks' in front of the name starting in the late 1950s. Select 6 Beer was one of the brands that Sick sold, along with its more popular Rainier Beer. *artsbeercans.com.*

Right: This is a great photo of Stoup Brewing co-founder Robyn Schumacher in Seattle. Along with Brad Benson and Lara Zahaba, Stoup opened in October 2013. In May 2015, they opened a long-anticipated beer garden. *Nataworry Photography.*

Stoup Brewing in the Ballard neighborhood of Seattle opened in 2013. Ballard has become a brewery hotpot, with numerous breweries clustered together. This is the sticker wall inside Stoup Brewing. *Nataworry Photography.*

Aslan Brewing Company was opened in Bellingham in May 2014, started by Frank Trosset, Pat Haynes and Jack Lamb. They brewed more than 130 pilot batches of beer to find the styles they wanted. This is the inside of their brewhouse before a planned expansion. *Aslan Brewing Company.*

Aslan Brewing Company in Bellingham is as an all-organic brewery that has become a gathering place in the city. By July 2015, it had maxed its production capacity and announced that it was expanding to a forty-five-barrel brew system. *Aslan Brewing Company.*

Left: Bale Breaker Brewing in Yakima is set in the middle of Field 41 of the family hop farm Loftus Ranches. It opened in April 2013. Its hoppy beers have proven to be very popular, and in September 2015, it announced that it was expanding. *Bale Breaker Brewing.*

Below: Redhook Ale Brewery began in Seattle as Independent Ale Brewing Company in 1982, founded by Paul Shipman and Gordon Bowker (who co-founded Starbucks and others). This is an overhead view of the bottling line at the Redhook brewery in Woodinville, which is the largest brewery (production-wise) in Washington. *Sharat Ganapati.*

Elysian Brewing Company was founded in Seattle in 1995 by Dave Buhler, Joe Bisacca and Big Time Brewery head brewer Dick Cantwell. Their first location was opened in 1996 in the Capitol Hill neighborhood. They were sold to AB Inbev in January 2015. *Doug Moyer.*

Another of the early craft breweries was started by Beth Hartwell and her husband, Tom Baune, in 1984 in the logging town of Kalama. Hart Brewing Inc.'s first beer was Pyramid Pale Ale. In 1996, they renamed the company, now with a Seattle brewery, Pyramid Breweries Inc. *Doug Moyer.*

Mike Hale is another pioneer in the craft beer world. He opened his first brewery in Colville, where he was a city councilman, in 1984. The brewery grew, and it has moved twice and is now located in Seattle. Hale brewed English-style draft ales, the first of which was Hale's Pale American Ale, saying, "My goal from the beginning was to brew the best beer I could possibly produce." *Doug Moyer.*

Port Townsend Brewing owner Kim Sands (right) and head assistant brewer Chris Weir at Washington Brewers Festival 2015. Chris holds the trophy he won for the keg toss contest. *Port Townsend Brewing.*

length [90 barrels per week] to about three times that," Guy said. "We have the ability to start producing about 6,000 barrels a year, maybe more."

Steve and Renea Metzger opened Rattlesnake Mountain Brewing Company on July 4, 1997, in Richland. Steve was brewmaster, and it produced 425 barrels of beer in 1998; by 2001, it was capturing tap handles in Spokane and bottling several beers. The brewery became known for supporting live music. Doug Ryder joined the business as brewer, Steve Metzger found another job and in 2002 they sold the business to former National Football League player and Richland resident Kimo von Oelhoffen, as well as others.

Gene Bliesner grew up south of Spokane in Fairfield working on the farm his German grandparents owned. After graduating from college, he spent twenty years in banking before buying Valley Processing fruit processing company in Sunnyside in 1980, and in 1981, he began fruit farming. He and his wife, Mary Ann, took another direction when they started Snipes Mountain Brewing, which opened on December 20, 1997, in Sunnyside. The fifteen-barrel brewery was manned by Joe Cruella and others, producing award-winning beers over the years. Tony Savoy was head brewer and manager from 2001 to 2005 before starting Flyers Restaurant and Brewery. Chris Miller, former brewer at Pacific Rim Brewing, stayed on for about seven years. They were brewing up to one thousand barrels per year by 2009. Chris Baum took over as head brewer from Chad Roberts in November 2014.

Snoqualmie Falls Brewing was opened in Snoqualmie on December 20, 1997, by Pat Anderson, David McKibben, Dave Eiffert, LeRoy Gmazel and Tom Antone. Pat and Dave were both homebrewers, and Pat wrote their original recipes; the initial beers were brewed by David on Mac & Jack's Brewery's original three-barrel brewhouse. On January 9, 1998, Rande Reed, formerly head brewer of Thomas Kemper Brewery and Pyramid Breweries Inc., became head brewer and has been with the brewery ever since. It opened its taproom in April 2006 and expanded in 2011. It now has a seven-barrel brewhouse and produced about three thousand barrels in 2014. In 2013, partner Dave Eiffert took over as general manager, and in 2013, John and Denise Snow became co-owners.

Sandy Savage is a graduate of Siebel Institute of Technology's class of 1989 and a former head brewer at Triple Rock Brewery in Berkeley, California. In December 1997, he and Vicki Savage opened North Fork Brewery in Deming. Sandy was the original brewer and developed most of the recipes they still use. The three-barrel brewing system was designed to brew true-to-style British ales. Eric Jorgensen has been head brewer since 2000. He started in the kitchen and had years of homebrew experience before taking over the brewhouse.

Mike Hall and Bill Jaquish were co-workers at the Hanford Site and also homebrewed. In 1996, they purchased the Meheen & Collins brewery in Pasco and founded Ice Harbor Brewing Company. Dave Meheen founded Meheen Manufacturing Inc. in 1992 to focus on beer bottling equipment. It brewed on old dairy equipment and open fermenters. In 2000, it hired Russ Corey to be brewmaster, and in 2005, it relocated to a former feed and grain store in Kennewick and opened a brewpub and restaurant. It upgraded to a 10-barrel system and brewed 500 barrels per year in the beginning; by 2010, it was brewing 1,800 barrels per year.

In 1995, Tacoma developer Fred Roberson met businessman Pat Nagle, and in September 1997, the Harmon Brewing Company became the first craft brewery in Tacoma. Carole Holder later bought out Roberson and partnered with Nagle. It is located in the vintage Harmon Manufacturing building in downtown Tacoma. By 2013, it was producing three thousand barrels of beer per year.

Todd Carden and Brent Norton met in 1994 while working for Maritime Pacific Brewing Company. They wanted to open a brewpub, and in March 1997, they began construction on Elliott Bay Brewery and Pub in West Seattle, the former California & Alaska Street Brewery. They opened for business on July 11, 1997. Doug Hindman was a Maritime Pacific co-worker

who joined the company in September 1997 as head brewer. They opened a second location in Burien in March 2007, and Hindman moved to that location while Chris Hemminger, also from Maritime Pacific, took over the West Seattle location in July 2006. In 2008, Dan Ashley was head brewer at West Seattle. In 2012, they added a third brewpub in Lake City, with head brewer Bill Jenkins, formerly head brewer at Big Time Brewery in Seattle. In January 2014, Bill Jenkins went to Ram restaurant, Dan Ashley moved to the Lake City location and James Goodman, formerly with Elysian Brewing Company, took over as the head brewer at West Seattle. All three locations brew certified organic beer.

Onalaska Brewing Company in Onalaska relocated in December 1996 to Chehalis, where it moved the five-barrel brewhouse from founder Dave Moorehead's garage and opened Red Dawg Brewpub. With Dave's wife, Susan, they were brewing 375 barrels per year. Beer expert Michael Jackson recognized their Onalaska Ale and two others in his 1997 book, *The Simon & Schuster Pocket Guide to Beer.* But even a beer expert couldn't keep the doors open, as it closed in early November 2001.

Pacific Northwest Brewing Company in Seattle may have been ahead of its time, as the brewpub closed in February 1997.

Pacific Rim Brewing opened in Burien in 1997 with the capacity to brew 2,500 barrels of beer per year. Founded by Charles McElevey, the brewery was "housed in a non-descript warehouse fronted by their beer 'garden,' a cement patio with iron grillwork sporting the moniker 'Rat Trap.'" One of its beers was Rat City IPA. During World War II, "white tents were erected in the area as a staging/training ground for troops…so the town became White City and, as time went on, it was bastardized to become Rat City."

After college, Aaron Burks took a world tour, sampling beers in twenty countries. After learning to homebrew, he visited and trained at brewpubs throughout the Northwest and then set out to create his brewery. In 1997, Atomic Ale Brewpub & Eatery was the first brewpub to open in Richland. "Many people had no idea what a brewpub was. I had people tell me, 'I can't go there. We have kids.' They thought Atomic Ale would be a dark, smoky tavern with sticky floors," Burks said. He was the initial brewer on a three-barrel brewing system. The building is a former A&W restaurant, and it claims to have had an "eclectic group of brewers over the years, including an auditor, an engineer, a chemist, a hippie, and a former cook & current beer enthusiast."

Cirque Brewing Company opened in February 1997 in Prosser. Founded by former lab researcher Kyle Roberson and his wife, Kaye, it was producing

about four hundred barrels a year by 1998. "It went from a hobby to a full-time baby dinosaur," Kyle said. The term "Triple Mash" was trademarked to build a reputation associated with Kyle's use of a double decoction mash regimen on all brews. The brewery closed in 1999, and Kyle went back to work in the engineering field.

Pike Brewing Company saw several changes in 1997. First off, it discontinued contract brewing, and then founders Charles and Rose Ann Finkel bought president Tom Leavitt's interest in the brewery and liquidated all their businesses. They sold the brewery, Liberty Malt Supply Company, and their wine importing business.

In May 1995, Skip Madsen moved to Seattle and began working at Pike Brewing Company. In 1997, Bill Jenkins left Big Time Brewery in Seattle, and Kevin Forhan, of Pike Brewing, became head brewer. In 1999, after the sale of Pike Brewing and "some brewery staff changes," Skip Madsen decided to leave and went to Big Time Brewery, where he worked with Kevin Forhan. In July 1999, Madsen moved on to Boundary Bay Brewery and Bistro, where he took his first head brewer position and stayed until March 2004.

Walla Walla was once a popular brewery destination. Big House Brewing Inc.—Mill Creek Brewpub was the first brewpub to open in Walla Walla in fifty years. It was founded by Gary Johnson in June 1997 with a seven-barrel brewhouse run by Troy Robinson. In 2005, the business was put up for sale, but as of today Johnson still operates it.

Everett saw the opening of Flying Pig Food and Beverage Company, co-founded by Joel Starr, in 1997. The fifteen barrel brewery took over the former Glacier Peak Brewing Company. Brewer Tom Munoz was called back to be head brewer.

Seattle Brewing Inc. in Woodinville "did not grow to sufficient volumes to sustain operations" and could not raise money in a second stock offering. Brewing as Aviator Ales, the brewery owed UB Group of India money that it could not repay and was offered an opportunity to merge into a new company, United Craft Brewers Inc. The merger failed, and the company closed in 1997.

Used to 40 percent annual growth, in 1995 Fish Brewing Company in Olympia planned a large expansion, which took place in 1996. The brewery moved across the street to a new facility. But something else happened that year: the bottom fell out of the craft beer world. By 1998, Fish Brewing Company was looking at just 3 percent growth. With the added overhead and slow growth, strife within the company and the personal lives of the

owners were taking their toll. Owner Crayne Horton said, "My enthusiasm for the business was waning. It was becoming very difficult to summon the motivation each morning to go forth and present the product to sullen bar owners in smoke-filled taverns. After all, it was only beer I was selling. The world would be no less rich if we went out of business."

Horton decided that the brewery needed a new identity and a new beer. They came up with a light beer called Wild Salmon Pale Ale. They found a worthy nonprofit organization and offered to donate a portion of the proceeds from each sale of Wild Salmon Pale Ale to the organization. In return, they received the goodwill of their customers and increased sales. The company would go on to become a leading environmental company, and in 2000, Fish Brewing Company released its first certified organic beer, the award-winning Fish Tale Organic Amber Ale.

Aaron Studen was a homebrewer back in the early 1990s. "I discovered that the beer I was brewing at home was better than the beer that I could find in stores," he said. He and his wife, Becky, opened Methow Valley Brewing—Twisp River Pub in Twisp in 1998. One reviewer said, "The town reminds me of Wild West ghost towns, and this brewery fits the rustic atmosphere."

In 1998, Larry Pratt bought out his partner, and with his wife, Ana, they ran Salmon Creek Brewery & Pub in Vancouver.

Catherine Stombo started the first female-owned commercial brewery in Seattle when Moon Ales began in her basement in 1998. The brewery lasted about a year.

Sound Brewery & Smokehouse was started in 1999 on Bainbridge Island by John Henderson. After nine months, he said, "We're starting to see more regulars. The first year is tough for any restaurant, but we're hanging in there and looking forward to a good summer."

Phillip and Carol Keith started Crab Creek Brewing, a seven-barrel brewery, in 1997 in Moses Lake. It closed in 2001.

Homebrewers Jerry Prolo and Randall Richardson from Kettle Falls started Lost Falls Brewing Company in August 1998. They released their first beer in June 1999 and opened a tasting room in Colville. The pair apparently ran the brewery until 2003, when they sold it to Chip Trudell. He had been brewing since he was fourteen and brewed on an eight-barrel system. Only open a few days per week, the locals packed the place.

Frank Helderman had experience at Pike Brewing Company and raised $350,000 in private capital to form Lunar Brewing Company in 1998. "The craft brewing market in Seattle continues to grow," Helderman said, "as all the people who've been sitting around smoking 1,000 cigarettes and drinking

Rainier for 100 years continue to kick the bucket, and the bar owners get replaced." Helderman attended the auction of Aviator Ales, purchased used equipment to open Lunar in 1999 and signed up more than thirty-five accounts. By June 2000, he was producing twenty barrels of beer per month.

Robert and Roberta Kenagy purchased a former restaurant in Chelan in 1998 and started Deep Water Brewing LLC, which operated a restaurant and lounge as a brewpub from the spring of 1999 until shortly before he sold the property on September 30, 2005. Scott Deitrich was the brewmaster.

The Central Steam Plant building in downtown Spokane functioned for seventy years until shutting down in 1986. It sat empty for ten years before plans were developed to renovate the building. Ron and Julie Wells—architect and interior designer, respectively—designed offices, a restaurant and a brewery, using much of the original interior. "We didn't know three boilers could become dining rooms. The more we spent time in the building the more I realized we had to save as much as we could," Ron Wells said. When the building opened in 1999, the brewery was an outlet of their Coeur d'Alene Brewing Company. Their sons, Spencer and Gage Stromberg, were involved in the new venture, and Spencer helped to write the recipes for the brewery. When their Idaho brewery lost its lease in 2010, the Spokane brewery was renamed Steam Plant Brewing Company. They operate a 10-barrel system in the Steam Plant building, which is listed on the National Register of Historic Places, and produced about 630 barrels of beer in 2014.

In September 1999, Jocelyn Piechowiak opened Northwest Brewhouse & Grill in Redmond. It sold its Beer Creek Beer at the brewpub. "We are near the break-even point," Piechowiak said in a June 2000 interview. "If this place is successful, we'll open a second and a third. But if you're trying to get space [for a brewpub brand] on Safeway's counter, don't even bother."

In 1999, Stroh Brewing Company itself fell victim to increased competition, closed all its plants (including the former Rainier Brewing plant in Seattle) and sold its brands to Pabst Brewing Company (the owner of Olympia Beer). Pabst turned around and sold the Hamm's Beer brand and the former Olympia Brewing plant to Miller Brewing Company, but not the Olympia Beer brand. Pabst Brewing Company contract-brewed, as it had no physical plants. In a weird twist of fate, Pabst contracted with Miller Brewing to produce its beers, so Olympia Beer, owned by Pabst, was brewed in its previous plant, which was owned by Miller—a sad day for the former Washington beer greats.

With the Rainier Brewing Company plant closed due to the Stroh's sale, it left the former Olympia Brewing plant as the largest brewery in the Pacific

Northwest. In October 1999, Miller Brewing announced plans to invest $10 million in the plant to modernize it and increase production. After a series of failed contract talks with the city of Tumwater over wastewater, Miller canceled the expansion plans and, in turn, lost its rights to the artesian water, leaving it with no reason to keep the plant open.

Bob Maphet and Brian Sollenberger were Boeing Company employees who met at the Boeing Everett Employees Wine and Beer Club. Both had homebrewed until it became "a hobby that went wildly out of control." In 1994, they founded Diamond Knot Brewing Company and leased space from Cheers Too pub in Mukilteo. They brewed beer on the weekends and slowly added accounts while keeping their day jobs. In 1999, the business had grown to the point where they purchased the pub and renamed it Diamond Knot Brewery and Alehouse. Brian Sollenberger was "incredibly knowledgeable about brewing. He was always challenging what we thought was conventional wisdom. He was really, really meticulous. He over-engineered to the point of being bombproof." In 2005, they opened a production brewery in Mukilteo. Diamond Knot produces more than six hundred barrels of beer per month.

Ted Farmer started Heads Up Brewing Company in Silverdale in 1999. The location was a bottle shop selling primarily Belgian-style beers and a brew-on-premises brewery where you go in to brew your own beer. It also sold some beer on tap, and Jeff Holcomb was head brewer in 2003.

The decade and century ended on a glum note for the microbrewery phenomenon, as more breweries closed than opened. In Washington, four shut down and one opened, while five brewpubs opened and three closed. "An Institute for Brewing Studies report showed that among the fifty largest microbreweries in the country, the fastest-growing [in 1999] was Mac & Jack's Brewery in Redmond, whose sales went up a hefty 74 percent over 1998 to more than 16,000 barrels." Seattle was also growing in brewing dominance and was the third-largest market for craft brew sales after Denver and Portland.

Chapter 7

2000-2003

A New Century

As the new millennium rolled in, the world prepared for Y2K and the end of the world as we knew it. Nothing happened, and life went on. By this time, the Internet was starting to become a powerful tool. America Online was still a profitable business, but in Washington, several breweries were closing their doors and others opening them.

Bart Traubeck grew up in Germany, and after serving in the army, he studied brewing. He sold brewing equipment and then was a brewery startup consultant. He sold Redhook Ale Brewery its first sixty-barrel system and helped owner Paul Shipman and plumber Rick Buchanan to get the system ready. When Buchanan started Buchanan Brewing Company in Oroville in 1995, Traubeck helped him and was given shares in the company. It failed in 1997, and in 2000, Traubeck bought it back from the bank. He reopened the brewery as Alpine Brewing Company on September 1, 2001. Unfortunately, Canadian tourism slowed down, and he closed the restaurant after two years. Traubeck brews true German-style beers while living two hundred miles away, traveling back and forth to keep the beer flowing.

James Gimurtu opened Birkebeiner Brewing Company in Spokane in 1994. Although brewing 3,300 barrels per year, he struggled to make the brewery work for six years and finally closed the doors on December 30, 2000.

Bob Craig was a resident of Indianapolis, Indiana, in 1979 when he "found out you could make your own beer and make it cheaply." That set him on the path of many brewers, starting Walking Man Brewing in 1999

in Stevenson, which opened in 2000. The brewery has been a breeding ground for brewers, including Jacob Leonard (recipient of the 2007 Glen Hay Falconer Foundation scholarship to Siebel Institute of Technology) and Dan Munch, both of whom went on to Widmer Brothers Brewing. Then there was former Portland Rock Bottom Inc. brewer Bolton "Bolt" Minister and, in April 2013, James Landers. The brewery has a 17-barrel system, producing about 1,200 barrels per year.

After outgrowing his brewery in Leavenworth, owner Scott Hansen merged Leavenworth Brewery with Fish Brewing Company in Olympia in 2001. He sold more than three thousand barrels of beer in 2001. The Leavenworth brewery was closed in November 2001, and the equipment sold. Hansen became vice-president of Fish Brewing Company after the merger, and all brewery operations moved to Olympia.

Celtic Bayou and Farwest Ireland Brewing Company opened in Redmond in September 2001. Tom Mazur was its first brewmaster, staying for six years. In about 2004, the brewery was renamed Far West Brewing Company. Robert "Beaux" Bowman was lead brewer until 2006, when it closed the brewery. Celtic Bayou is still open though not as a brewery.

Fort Spokane Brewery Inc. in Spokane had been successful in getting its beer into local stores. Demand grew, but the brewery didn't. The brewhouse was located in the basement, and it was damp and crumbling. "It turned into a situation very rapidly where we couldn't make enough beer," said manager Ryan Hopkins. Unable to meet demand, it lost accounts. Then it brewed six batches of beer with yeast that was baker's yeast mistakenly labeled as brewer's yeast by the manufacturer. As it started to win back customers, several chain restaurants moved into town, and its sales declined dramatically. With too many things working against them, it closed its doors in February 2001.

In 2002, Yakima Brewing & Malting Company in Yakima was bought by Black Bear Brewing Company, owned by J. Gregory Tranum, president, and Paul C. Brown Jr., vice-president and treasurer.

Bayou Brewing Company opened a themed entertainment complex in Spokane in 1997. The concept did not survive, so when it closed, Northern Lights Brewing Company in Airway Heights saw a growth opportunity and moved into the larger location, adding a restaurant.

Rocky Coulee Brewing Company was founded in 2001 by farmer Tom Schafer. Although not a homebrewer, after thirty years in farming, he was ready for a change. He planned to open the brewery on the family farm in Adams, but after problems with state and local organizations due to water

regulations, he purchased property in Odessa. Construction began in the fall of 2001, and the brewery opened its doors on June 1, 2002. In its first ten years, the brewery outgrew its original building and expanded.

Maple Valley Brewing opened around the beginning of June 2003 in Kent-Covington at the new Druid's Glen Golf Club. It included a restaurant and a brewery manned by Shawn Loring. It was later renamed Druids Brewing Company. Then, in late 2005, the brewery shut down. Loring bought and dismantled the equipment, moved it to Everett and spent the first few months of 2006 getting Lazy Boy Brewing started.

It was on June 23, 2003, that the whistle at the former Olympia Brewing Company brewery went off for the final time. A week later, SAB Miller (formerly Miller Brewing Company) shut the doors for good. Successive efforts to reuse the buildings have started and stopped over the years, but nothing has materialized. The original whistle is now at the Tumwater Valley Golf Course, where it can be heard at golf tournaments and during the city's Fourth of July celebration. SAB Miller, stomping its feet as it left town, placed a deed restriction on the property that prevented anyone from producing alcohol at the site.

In 2003, "a farmer/school bus driver, a teacher, a retired minister, and a school secretary came up with the idea of combining a bookstore and brewpub" in Dayton. Skye Book & Brew was born in a one-hundred-year-old building. In March 2004, Mike McQuary took over operations, saying, "We have revived a tradition of local brewing." He used a three-and-half-barrel system to brew a variety of beers in the basement brewery.

Frank Helderman's Lunar Brewing Company in Seattle was sold in 2003 to Mike Baker and Jeff Smiley. The brewery was renamed Baron Brewing Company after the purchase. Helderman went on to be assistant brewer at Big Time Brewery before heading to Oregon, where he has been head brewer at Terminal Gravity Brewing since 2008.

In 2003, Big Time Brewery in Seattle welcomed brewer Bill Jenkins back as head brewer after he worked in Ireland for several years.

Manuel "Manny" Chao went to school at the University of Washington (UW) after growing up in Beaverton, Oregon. His beer epiphany came when he was on a date and tasted his first non-mega beer: Blackhook Porter from Redhook Ale Brewery. He and his roommate started trying all good beer, and he kept a diary of every one. While on summer break he started homebrewing, and at UW, every class project he made about breweries. After graduating, he worked in a pub and at a homebrewing supply store in Seattle.

At a trade show, he met Jack Schropp, who along with his partner Malcolm "Mac" Rankin was running the two-man Mac & Jack's Brewery out of Schropps' garage in Redmond. Chao pestered them for a job for three months until they agreed to hire him to deliver kegs and paid him ten dollars for every keg he sold. So, he became the first employee of their fledgling brewery. He loved the job and even designed their logo.

Without a doubt, with Manny Chao's help, their African Amber Ale became the third bestselling craft brew in the state, selling twenty thousand barrels a year after five years. In 2000, a disagreement between the owners and Chao led to his leaving. He quit beer altogether and traveled. After he came back, he tried other lines of work, but beer was in his blood. His roommate, Roger Bialous, tossed out the idea to start a brewery. "I felt soured about the whole thing," Chao said. "But also, looking back on Mac & Jack's, I just feel like we got really fucking lucky. I didn't know if lightning could strike twice."

In 2002, they started brewing at home. Roger Bialous said, "People would try it, and you'd watch their eyes get big as the hop flavor hit their palate. They'd swallow, and they'd be like, 'Oh, that's weird, I got a hop flavor without the bitterness.'" When they were ready, they found a used brewing system for $28,000 in North Carolina and set it up in the former Seattle Brewing & Malting Company building in Seattle. On February 27, 2003, Georgetown Brewing Company was open for business. Reid Spencer later joined as head brewer.

Elysian Brewing Company was courted by Pyramid Breweries Inc. in 2000. "Though they did not make an offer, it was good for us anyway," co-founder Dave Buhler said. "It strengthened our resolve to make it a better business." In 2003, co-founder Dick Cantwell was named Brewmaster of the Year at the Great American Beer Festival. Elysian Brewing also won the award for Large Brewpub of the Year in 1999, 2003 and 2004.

Elysian had run a brewpub at GameWorks arcade in Seattle between 1997 and 2002. Many Seattle tech startups hosted events at the site, but by 1999, the tech sector had crashed and business had dropped. Elysian gave notice that it was leaving, and GameWorks secured its own liquor license.

In 2003, Elysian opened Elysian Brewing Company in the Green Lake area, contributing to a 45 percent rise in sales in 2003. Total barrels produced rose from 2,500 in 2002 to almost 3,000 in 2003. The company opened Elysian Brewing Company in Sodo in 2006.

BREWERY CHAINS: McMENAMINS, THE RAM, GORDON BIERSCH AND ROCK BOTTOM

Deciding whether to include these brewery chains and where to put them was a question. Since they have so many locations and each has its own in-house brewery, here they are.

The Ram restaurant was started and is headquartered in Washington. Brothers and co-owners Jeff and Dave Iverson opened the first Ram restaurant as a "Deluxe Tavern" in Lakewood on February 26, 1971. In 1995, they began brewing their own beer at each location. They have won awards for their beers, including fifteen consecutive years at the Great American Beer Festival. They have several restaurant brands and thirty locations in six states. Headquarters is in Lakewood. In 2014, as a reward to its employees, it sold 30 percent of the business to the employees. There are eleven Washington locations.

McMenamins Inc. is a whole different business model. Founded by brothers Brian and Mike McMenamin in 1974 in Oregon, they don't like the term "chain." "We're just a bunch of pubs," said Mike. "We get nervous with some of those names," added Brian. "'Chain' and 'empire' are two of the worst ones, I think." What they do "is take buildings forward and make them viable rather than a museum piece." In Washington, they have seven locations, each with its own brewery. East Vancouver Brewery in Vancouver opened in July 1999 with Tega Chijavadze as brewer; McMenamins on the Columbia Brewery opened in January 1995 in Vancouver with Jesse Grover as brewer; McMenamins Mill Creek Brewery opened in July 1995 in Mill Creek with Charlton Fulton as brewer; McMenamins Queen Anne opened in March 1995 in Seattle with Brian Lawrence as brewer; Olympic Club Brewery opened in January 1997 in Centralia; Six Arms Brewery opened in August 1995 in Seattle; Spar Brewery opened in January 2007 in Olympia; and the former Anderson School in Bothell opened on October 15, 2015, and features a seventy-two-room hotel, restaurants, a brewery, pubs, a swimming pool, a theater and outdoor spaces. The company has a total of fifty-two locations, including nine hotels. Kyle Jungck is brewer for the latter three.

Gordon Biersch Brewery Restaurant was started in California on July 6, 1988. It operate thirty-five restaurants, including a location in Seattle. Kevin Davey is the current brewmaster at that location. The locations feature a full brewery along with a restaurant, and like the Ram restaurant, it has won numerous medals for its beer. Gordon-Biersch brews German-style

beers and adheres to the German purity law for all its beers. In 1999, it was acquired by Big River Brewing Company.

Rock Bottom Restaurant & Brewery was founded in Denver, Colorado, in 1991. It has thirty-four locations across the country, and each location brews its own beer. There are two locations in Washington: one in Seattle that opened in 1996 and one in Bellevue that opened in 1999. In 2010, Rock Bottom Restaurant & Brewery and Gordon Biersch Brewery Restaurant merged, forming CraftWorks Restaurants and Breweries Inc.

There are other breweries that have multiple locations, but if they are only located in Washington they were listed separately.

2004-2010

In March 2004, brewer Skip Madsen joined Nina Law and Mark Burr to open Water Street Brewery and Ale House in Port Townsend. The building had once been known as the Town Tavern, noted for its barroom scene featuring Richard Gere and Debra Winger in the 1982 movie *An Officer and a Gentleman*. The building was owned by Chris and Dawn Sudlow, who ran Maxwell's Brewery & Pub until shutting it down. Madsen met Burr when they worked together at Big Time Brewery in Seattle. "We want people to know when they walk through the door that this is a brewery," said Burr. Law was the lead bartender at Elysian Brewing Company in Seattle and president of the new group.

In April 2004, Pyramid Breweries Inc. purchased Portland Brewing Company of Portland, Oregon, for $4.2 million. It claimed that it was a necessary move to stay competitive with other breweries.

In about 2004, Rich Dirk opened Elk Head Brewing Company in Buckley. "The place was rather barren and cold, with no more than the brewing tanks and a couple of beers on tap." Eventually, that changed, and "there are booths, a long, beautiful, polished wood table with several attractive 'stumps' for seats and a life-sized, wooden elk," as well as at least twelve beers on tap.

Kevin King began as a homebrewer in 1994. He got his start in the industry at the Ridge Pub & Grill in Seattle and then worked at McMenamins Queen Anne in Seattle, Pyramid Breweries Inc. from 1996 to 1997 and Rogue Ales from 1998 to 1999. King started Amnesia Brewing in North

Portland, Oregon, in May 2004. As the neighborhood grew, so did his brewery, eventually outgrowing its location, producing 1,700 barrels of beer per year. King looked north and found a location in Washougal where he was able to secure a larger location and to which he moved the brewery.

In 2004, Fish Brewing Company added Spire Mountain Ciders, the nation's oldest operating commercial craft cider maker, to its portfolio. Then in 2006, it replaced its original fifteen-barrel brewing system with a forty-barrel brewhouse.

The first annual Great Pumpkin Beer Festival was held in 2004 in Seattle. The event was founded by Elysian Brewing Company's Dick Cantwell as a fun way to make a party out of pumpkin beer.

Jim Quilter was born in California and was an avid homebrewer. He became a brewer at Sierra Nevada and then moved on to Butte Creek Brewing Company, Mad River Brewing Company and then Winthrop Brewing Company. In 2005, he started Iron Horse Brewing in Ellensburg, and his Irish Death Beer was one of his most popular beers. Not a fan of the business side of things, he sold the brewery in 2006 to Greg Parker, who wanted to own a brewery and asked his father, Gary Parker, to join him. He convinced his wife to move across two states to resurrect Iron Horse. They renamed the brewery Iron Horse Brewery and their flagship beer, Quilter's Irish Death Beer, after the founder of the brewery. As of 2015, it is the top-selling Washington beer in kegs and bottles in the state. They had a fifteen-barrel brewhouse and in 2014 produced about fourteen thousand barrels of beer. They built a new production facility with a thirty-barrel brewhouse in late 2015. Founder Jim Quilter died in 2009.

Pike Brewing Company produced 7,200 barrels of beer in 2005, the most in its history. It continued to win awards for its beers across the Northwest and the country.

The Flying Pig Food and Beverage Company in Everett removed its brewing operation in 2005 to expand the dining space. Joel Starr then sold the business in September 2007 to HB Hospitality LLC. It, in turn, went out of business in early 2011.

Rick Ellersick started homebrewing in his garage in 1997. He was licensed to sell beer from his garage. "When I wasn't working, it's pretty much all I'd do," he said. "I was brewing at nights and on weekends and had people stopping by to pick up beer all the time." When the time was right, Rick made the jump from owning a deli to owning a brewery. He built Big E Ales (Ellersick Brewing) near his home in Lynnwood and opened in 2005. He installed a ten-barrel brewhouse and a small pub.

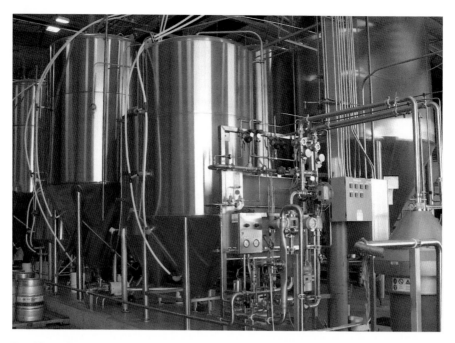

Iron Horse Brewery in Ellensburg has grown to sell the best-selling beer in kegs and bottles in the state, Quilter's Irish Death. It opened a production-only brewery in 2014 and upgraded to thirty barrels in 2016. This is some of the equipment in its spacious brewery. *Author's collection.*

Jason Tritt opened the first brewery in Oak Harbor on Whidbey Island on November 18, 2005. Flyers Restaurant and Brewery is dedicated in part to his grandfather, and the restaurant and beers are aviation themed. Co-owner and brewmaster Tony Savoy has won numerous awards for his beers. Starting as a bartender at Skagit River Brewery in Mount Vernon, in four years he was head brewer. "I just really fell in love with the beer part of it," Savoy said. "I was really in the right place at the right time." Savoy was also head brewer at Snipes Mountain Brewing for five years. Flyers opened in November 2005, and he brewed beer at Druids Brewing Company in Covington for the Flyers opening. In April 2006, it had its brewery up and running. It was at capacity in 2009 (producing eight hundred barrels), so it began looking for a space in Mount Vernon to open a pub. Instead, it began contract brewing with Skagit River Brewery, giving Flyers added capacity. In May 2015, Flyers announced that it was opening a restaurant at Skagit Valley Regional Airport in Burlington, which opened in October 2015.

Court and Katie Ruppenthal opened Laht Neppur Brewing Company in Waitsburg in 2005. The brewery is their last name spelled backward.

Court was a homebrewer for twenty years before moving to Walla Walla to learn the art of winemaking. "He quickly realized that what the valley really needed was beer—really good beer." Business was so good that in 2015 they closed their Washington location and planned a new brewery in Milton-Freewater, Oregon.

Joe Nestor was a homebrewer for eight years and then attended American Brewers Guild before starting Cashmere Brewing Company in Cashmere. He used a one-and-a-half-barrel system until upgrading to a three-barrel system, brewing fewer than five hundred barrels per year. In September 2009, the City of Cashmere revoked its business license for nonpayment after Nestor's partner in California failed to pay the bills. The brewery was shut down.

A new chapter was written for Pike Brewing Company as the Finkel family bought Pike Brewing Company back on May 1, 2006, and Charles Finkel was made president of the firm for the first time in eleven years. *Draft Magazine* has named Finkel one of the ten beer innovators who shaped the craft beer renaissance.

Pyramid Breweries Inc. was struggling financially, reporting a one-year loss of $488,000 for 2007. It sold Thomas Kemper Soda Company in January 2007 for $3.1 million to the Kemper Company, a new company formed by Adventure Funds, a Portland equity investment fund. Pyramid would continue to brew the soda under a five-year agreement.

Speedway Brewing Company began operations in Lacey in 2006. The company made "handcrafted micro beers and Texas style BBQ." The business was located in a strip plaza, but in July 2010, it closed after a landlord dispute. Its Twitter feed mentioned moving to a new location with a thirty-barrel brewhouse, but nothing transpired.

Concrete is a small town along Highway 20 in Skagit County. Bill and Kris Voigt had been self-employed for twenty-five years. In 2004, Bill won a shotgun in a raffle, but Kris wouldn't let him bring it home, so he took the money and bought his first homebrew kit and was hooked. He turned part of his upholstery shop into his brewing area and started experimenting with recipes. Before long, friends were encouraging him to start a brewery. "At first, the kids thought this was just another one of dad's crazy ideas." The idea grew, and on July 17, 2006, Birdsview Brewing Company opened.

Shawn Loring has spent some years in the brewing business. He got his start at Pike Brewing Company in the early 1990s. In 1994, he opened a brewpub in Cheyenne, Wyoming. After that closed, he went to Wynkoop Brewing in Colorado. Loring then worked at the Ram restaurant in

Puyallup and Seattle. After that, he went to work at Druids Brewing Company in Kent until that closed in early 2006. Loring packed up the 15-barrel brewing system, and in March 2006, he and his father-in-law, Mike Scanlon, opened Lazy Boy Brewing Company in Everett. Loring brewed about 1,500 barrels in 2014.

The Washington Beer Commission was the first commodity commission for craft beer in the United States. Ratified by the Washington State legislature on September 6, 2006, it was granted the opportunity to produce up to twelve beer tasting festivals per year and to use the proceeds to promote and market Washington's craft breweries. An assessment of ten cents per barrel produced by each brewery (with a cap assessment of $1,000) was also a part of the legislation. It produces some very successful and popular festivals, including the Washington Brewers' Festival.

Laughing Buddha Brewing opened in Seattle in 2007. Started by Chris Castillo and brewer Joe Valvo, it brewed beers with some different ingredients, including mango, ginger and pandan leaves. Castillo and Valvo scraped together $100,000 from family, sold Castillo's condo and moved in with Castillo's parents, just to start the brewery. It was a tough time for new breweries, but by April 2008, they had gone from 30 barrels per month to 150 barrels. In May 2008, they received a cease and desist letter from an Australian company claiming that their name violated a trademark. Rather than fight it, they changed their brewery name to Trade Route Brewing Company in April 2009. The brewery was doing so well that the founders decided that they needed a larger brewery, and the search was on.

Once a Seattle darling, financial problems finally forced Pacific Rim Brewing to close its doors on December 29, 2007. The brewery's beer had been available at more than one hundred locations in Seattle, and it even had an account in Manhattan. In business as Big Al Brewing, Alejandro Brown was a homebrewer ready to jump into the commercial business. He purchased Pacific Rim in July 2008 and in August 2008 reopened as Big Al Brewing. As a former homebrewer, he supported local homebrewers and has produced recipes from award-winning homebrewers.

In 2006, Schooner EXACT Brewing Company was started by friends Matt and Heather McClung and Dave "Hutch" Hutchinson over a batch of homebrewed beer in Seattle. They opened on January 20, 2007, and quickly outgrew their initial brew system. Two years later, they upgraded to a ten-barrel system from their initial nano-sized one and opened a taproom. In 2012, they opened a family-friendly restaurant in the SODO neighborhood of Seattle. Their beer is distributed in Washington, Oregon and in Tokyo,

Japan. The brewery is named for the first ship of non-indigenous settlers to arrive in Seattle's harbor: the schooner *Exact* carried the Denny party to Alki Point in late 1851.

Steve Hedrick was a merchant mariner, sailing as an engineer for five years, and he "perfected the art of homebrewing." After quitting the sailing world, he started Northern Ales Inc. in 2007 in Northport, population three hundred. Just six months into business, he was scrambling to stay afloat when the hop market crashed after a fire in a Yakima warehouse and poor European yields. He was able to weather the storm, and in October 2010, he outgrew the small town of Northport, expanded and moved south to Kettle Falls.

Ron Walcher was a homebrewer in Arlington, attending the American Brewers Guild in 2007. That year, he built Skookum Brewery with his wife, Jackie Jenkins, in a building on their property called "the brewery in the woods." They opened a small tasting room, which conflicted with their neighbors as they became more popular. In 2012, they moved to a new, larger location across the street from the Arlington Municipal Airport. Hollis Wood was hired as an assistant brewer to Ron in 2011 and became head brewer in 2014 on their ten-barrel system.

Scuttlebutt Brewing Company in Everett was at capacity, so it constructed a new production brewery, moved the brewhouse and started brewing on April 1, 2007. By 2013, it was producing 6,500 barrels of beer per year.

Tyson Crudup was a homebrewer in Walla Walla when two friends, Justin Goff and Erik Wydra, joined him in the garage. "Things were getting out of control in the garage," said Crudup. So in about 2008, he formed Walla Walla Brewers Inc. with Goff and Phillip Keith, the former owner of Crab Creek Brewing in Moses Lake. They used Keith's old seven-barrel system that "sat outside for about 6 years in disarray before we got it." The brewery opened in a former World War II air force barrack in Walla Walla but was closed in 2010 after a problem with the partnership. Crudup went back to homebrewing.

Joel VandenBrink moved to Washington from Michigan in 2003 and started homebrewing. "The whole world of craft beer really opened up to me." He built Two Beers Brewing Company mostly on his own, "which lessened my startup costs." He opened in Seattle in June 2008, and that first year, the nano-brewery produced about 100 barrels of beer. In 2011, he doubled the size and was the first Seattle brewery to start distributing in twelve-ounce cans. By 2012, sales were 4,500 barrels per year and growing. It contract-brewed beer for Churchkey Can Company in 2012, until

Yakima Craft Brewing Company in Yakima was started by Jeff Winn in 2008. Winn secured Bert Grant's original copper kettle (in the photo), and Yakima uses it for special brews. *Yakima Craft Brewing Company.*

Churchkey had issues with its cans and canceled production. Two Beers then used that space to open Seattle Cider Company.

In December 2007, Yakima Craft Brewing Company in Yakima built a new brewery. Founder Jeff Winn opened and served his first beer in June 2008, paying homage to Bert Grant and the brewery he started in 1982 by using Bert's original copper boil kettle for some of its brewing. It started with a three-and-a-half-barrel brewhouse, but in its fifth year (2013), it upgraded to a twenty-barrel system. In February 2009, *Beer Advocate* magazine rated its IPA A+.

Will Kemper is one of the pioneers—and, dare we say, grandfathers—of craft brewing in Washington, as well as across the world. He co-founded Thomas Kemper Brewery in 1984 and has traveled across the globe to help open other breweries. In July 2008, he and wife, Mari, decided to come home and opened Chuckanut Brewery and Kitchen in Bellingham. It has consistently won awards for its brewery's beer, usually brewing to style. In 2009 and 2011, Chuckanut won Small Brewpub of the Year at the Great American Beer Festival. Will resisted brewing an IPA until customers implored him to, so he brews a British IPA, not a Northwest one. In October 2015, Chuckanut broke ground on an eight-thousand-square-foot production brewery near the Skagit Regional Airport that will open in 2016.

Beta Brewing Company was started in Everett in August 2008 by pilot Kristofor "Kris" Kasner. He and his pilot wife opened a production-only brewery opened in 2011 that featured aviation-themed beers. They seem to have closed in 2013.

Doug Ellenberger worked for Lafayette Brewing Company in Indiana and as a distributor in Portland, Oregon, before setting out to open Everybody's Brewing in White Salmon in September 2008. Co-founded by Doug; his future wife, Christine; and other partners, they opened in a

former liquor store that was built as an Odd Fellow's Hall. They installed a seventeen-barrel brewhouse, and when they opened, they had none of their own beers ready but instead carried everything from Rainier Beer to Walking Man Brewing on tap, or "something for everybody." Their plans were to keep three of their own beers on tap, including what became one of their flagship beers, Country Boy IPA. "I was thinking," Doug said, "that's all [the beer community] needs is another IPA. But they all sell!" In 2014, Everybody's Brewing was the 8th (out of 140) best-selling brewery in the country that released packaged beer for the first time that year.

Don Webb was born in Oregon and raised in Washington. After a trip to England in 1988, he discovered British beers and, a few years later, started hombrewing. Dreaming of opening a brewery, he worked in another field for years. Donald Averill also had a love of homebrewing and for years brewed on his own while working another job and also dreaming of opening a brewery. Bryan Miller happened to know both Don and Donald and got them together. The very first batch of beer the duo brewed together, an oak-aged double IPA, took a ribbon in the Northwest regionals of the 2007 National Homebrew Competition. Webb worked at Stix Pizza & Brewing Company in Seattle and Lazy Boy Brewing Company in Everett to learn the commercial side of brewing. They founded Naked City Brewery and Taphouse in Seattle on October 22, 2008. Two and a half years after the brewery was founded, they invited Bryan to join them in the business.

Laura and Casey Rudd moved to Methow Valley in 2001, in part because Casey was "widely known as the whistle-blower whose actions…led to safety improvements at the Hanford Nuclear Reservation." They sold spec cabins for several years, often designing them while sitting at Winthrop Brewing Company. When the brewery was put up for sale in 2008, they bought it, even though "we had never brewed a batch of beer," the recession was starting and the brewery had been failing. They renamed it Old Schoolhouse Brewery, and their son, Blaze, with a physics degree but no beer experience, became their first brewmaster. "It took us a year to get our feet under us, working twelve- to sixteen-hour days," Casey said. By 2011, they were at capacity and expanded.

Jeff and Linda Greene invested in a Northern Ireland brewery in 2008 to become a distributor of a new beer. They formed Palouse Falls Brewing Company in Pullman and began importing the wort from Strangford Lough Brewing Company. The Greenes were not brewers, and the wort was inferior, forcing them to sue the company. Through a salesman, they met Mark Irvin from Northern Lights Brewing Company and decided to

contract-brew with him. He brewed four different wort batches, which were shipped to the Greenes, who finished the beer on their equipment. "It is too early to determine how many barrels we'll produce this year, but we will only be running 10 to 15 percent of capacity for now," said Jeff Greene in 2009. With only a tasting room, they were unable to purchase option on their property and on December 22, 2012, they closed their doors.

The year 2008 saw two craft brewery pioneers become one when Redhook Ale Brewery of Woodinville and Widmer Brothers Brewing of Portland, Oregon, merged, forming Craft Brew Alliance.

In 2009, Diamond Knot Brewing Company acquired Eagle Brewing Company, both in Mukilteo, and stopped brewing at Eagle. Late that same year, Diamond Knot co-founder and partner Brian Sollenberger died suddenly after an accident at his home.

In late April 2009, Pyramid Breweries Inc. agreed to be bought by Magic Hat Brewing Company of Vermont for more than $35 million in cash. Pyramid's stock was trading under $3 per share at the time. The deal gave Magic Hat access to the West Coast and Pyramid access to the East Coast. Two years later, KPS Capital Partners and its North American Breweries (NAB) bought the two breweries. NAB owned Genesee Beer and Dundee Honey Brown Beer and the rights to import and market Canada's Labatt Beer and Costa Rica's Imperial Beer. In 2012, NAB was sold to Cerveceria Costa Rica, a subsidiary of Florida Ice and Farm, for $388 million.

Travis Guterson and Mike Runion started 7 Seas Brewing in Gig Harbor in 2008. The two met while working at Silver City Brewery in Silverdale. Guterson said that he found "that one thing that motivates me." Their first location suffered a fire and delayed their opening by six months, until July 2009. In December 2015, they purchased an eighty-thousand-square-foot building in Tacoma that was once part of Heidelberg Brewing Company and will house a new production brewery and taproom capable of 80,000 to 100,000 barrels per year.

In 2006, a friend of Derek Wyckoff's suggested that they try homebrewing. They did, and it turned out so well that by the third batch they were brewing with a full-grain system. The beer was flowing, and in 2007, they decided to open a brewery in Wyckoff's garage in Kenmore. Unfortunately, the law didn't allow that, so they built a shed in his backyard to house the equipment. Originally named Trouble Brewing, they were threatened with a trademark lawsuit, so 192 Brewing LLC (the square footage of the brewhouse) was formed. In the fall of 2009, they were licensed. During their first year of production, they produced about ten barrels of beer.

Every year since then, their production has about quadrupled, as they add new recipes to their rotation.

Trade Route Brewing Company in Seattle was doing so well that the founders decided that they needed a larger brewery. Instead of looking for space in Seattle, they brought on three partners and moved south. In early October 2009, they opened a new brewery in Pacific.

Cody Morris wanted to get into the brewing business in Seattle but couldn't find a job. So, he started working at a homebrew store, where he "fell in love with the idea of small-scale, specialized wine producers." That led him to start Epic Ales in Seattle in 2009 as a one-barrel nanobrewery. In March 2013, he upgraded to a three-barrel system and opened GastroPod brewpub with chef Travis Kukull. He originally wanted to use a sake yeast for his beers, but his customers didn't like it. "To be successful at business, you have to be more than willing to admit when you're wrong."

Robert "Beaux" Bowman was born in Mississippi. He spent some time in California, moved back to Mississippi, started homebrewing and decided that "I really wanted to get into the brewing industry." He considered attending the University of California–Davis program but didn't want to go back to college. There were no breweries in Mississippi in 1999, so he planned to move back to California. Then his brother accepted a job in Redmond, so in late 2000, he moved with him to Washington. In early 2001, Beaux found a job at Mac & Jack's Brewery and became its night brewer. After a few years, he moved to Celtic Bayou for another few years. His last brewing job was at the Seattle RAM U-Village, which lasted until 2007. Then he set off to start Black Raven Brewing with Kat Gillespie. He was "supposed to open in late 2007 or early 2008." He opened in Redmond in April 2009. "The taproom was immediately too small…at that point we just overflowed into the brewery space." In 2010, it expanded, adding cold storage and a second bar. It has a fifteen-barrel brewhouse, and production capacity is eight thousand barrels. It has won numerous awards and grown to the point where Bowman doesn't run most brews but rather is overseeing the operation. "It's been a transition for me because I originally got into brewing because I didn't want to sit at a desk."

Gary Vegar spent twenty-eight years in public education before making the move to private enterprise. In May 2009, he and his wife, Carol, along with Dave and Brenda Keller, opened Horse Heaven Hills Brewery in Prosser. Gary ran all aspects of the brewery, including the brewing. In 2013, with business growing, it decided to expand; purchased a one-hundred-year-old building in Prosser; and built Horse Heaven Saloon on the first

floor, a bed-and-breakfast on the second floor and a banquet facility in the basement. They installed a larger brew system in the brewery that produced 350 barrels in 2013.

Tim Rockey started as a homebrewer, eventually talking to Mike Davis, brewmaster at Harmon Brewing Company, for advice on starting a brewery. On July 1, 2009, Tim and Renee Rockey opened M.T. Head Brewing Company in Graham. Brewing on a seven-barrel system, it produces about two hundred barrels per year. Because of its size, distribution is limited, and most of the product is sold at the brewery.

Jeff and Tessie Thompson opened Grove Street Brewhouse, the first brewery in Mason County, in October 2009. Located in a former Pontiac car dealership in the town of Shelton, they hired Adam Orrick to help put their seven-barrel brewhouse together and as head brewer. He got his start at Lazy Boy Brewing Company in Everett, "just to make sure that working in a brewery was what I wanted to do." He went on to Doemens Academy in Munich to learn the art of brewing, and Grove Street was his first job. "It was a bit daunting, stepping in as a brewmaster right off the bat," he said. "There's a lot to learn, but I'm happy with the way things have been worked out." In 2011, Orrick left the brewery to work at Pike Brewing Company, and Leah Thompson eventually took over as head brewer. Grove Street closed its doors in December 2013.

Matt Lincecum was an environmentalist, community organizer, homebrewer and attorney representing wine, beer and liquor companies. "Working as an attorney with clients in the brewing industry, it suddenly occurred to me that I was on the wrong side of the desk," he said." With just $10,000, he leased a location and convinced investors to believe in his vision. They bought a used fifteen-barrel brewhouse from Red Lodge Brewing Company in Montana and named the brewery Green Lake Brewing Company but changed it to Fremont Brewing Company, which opened in July 2009 in the Fremont neighborhood of Seattle. Their flagship beer, Universale Pale Ale, represents their Fremont neighborhood. Their property allowed them to sublet to Blue Marble Energy, which used Fremont's spent grain to make its product. By April 2010, they had purchased a used canning line. Their head brewer, Matt Lincoln, came from Goose Island Brewing in Chicago, Illinois.

Tom Martin started homebrewing in the mid-1990s, growing his own hops and winning awards at the Puyallup Fair. Then, in about 2004, he moved to Carlsborg. In 2009, his neighbor, who happened to own a local restaurant, stopped by and tasted his latest beer. By December 2009, he had his brewery

license, and in February 2010, the first keg was dispensed at a fundraiser. That led to the neighbor carrying the beer at his restaurant. Martin's one-barrel Fathom and League Hop Yard Brewery beer was available at several locations and was selling out as fast as he could brew it. But he didn't rush to expand. "I'd like to expand slowly over time. If I could grow it into a larger business by the time my kid graduates," that would be fine.

Odin Brewing Company opened in the South Park neighborhood of Seattle in December 2009. Like Fremont Brewing Company, it was during the financial crisis and was an iffy proposition. Founded by Daniel Lee, who left the marketing department at MillerCoors, he said, "I learned a lot about mass branding and marketing, and I know how much of an impact craft beer has had on the big breweries; it's not just an annoyance to them anymore." Lee brought Brian Taft on as brewmaster, and a year or so later, former Mac & Jack's Brewery brewer Nick Heppenstall took over as head brewer. With a fifteen-barrel brewhouse, from the onset Odin Brewing focused on food-friendly beers using ingredients like juniper, ginger or even angelica. A few years into operation, it stopped growler sales at the brewery to concentrate on production. It opened Asgard Tavern in Seattle as its satellite tasting room. In late 2014, Odin announced that it was moving to Tukwila after having "outgrown the facility in South Park faster than we expected," Lee said.

In 2008, Dick's Brewing Company in Centralia moved into a new location. It opened a tasting room in 2009, and that year, founder Dick Young died. His daughter, Julie Pendleton, carries on his tradition. It produced 4,413 barrels of beer in 2014.

Bernie Düenwald is an Ivy League graduate of Dartmouth College. After graduation, he spent more than fifteen years farming wheat and malting barley and served as a charter commissioner on the Washington Barley Commission and then worked for a malt distributor. He was educated in brewing at the Siebel Institute of Technology, while selling malt to breweries. In 2005, Düenwald returned to Washington and began working toward starting a brewery.

In 2009, he opened Golden Hills Brewing Company in Airway Heights, where he was brewmaster, salesman and deliveryman. He created great lagers but was chasing his tail trying to make the brewery profitable. He brewed 650 barrels in 2012, and at the end of the year, one of his original investors, Orlin Reinbold, brought another investor, Jason Miller, into the company, reinvigorating it. By June 2013, the brewery had been renamed Orlison Brewing (Orlin and Jason combined). In August 2013, it became

the first inland northwest brewery to start canning its beers and took on the motto "Brew No Evil." "Maybe what Spokane needs is a lager brewery, and certainly the Northwest needs a good lager brewery. 95 percent of the beer sold in the U.S. is lager," said Düenwald. "People think it has to be an ale to be full-flavored. We're living proof that that's not the case." The brewery has a thirty-barrel system and produced about two thousand barrels in 2014.

Slip Point Brewing was a nanobrewery that opened in a private home in Clallam Bay around 2010. It closed in 2011.

Rhett Burris was a brewer at the Ram restaurant in Tacoma. He founded Burris Brewing LLC in June 2009 in Tacoma. He contract-brewed his beer through Lazy Boy Brewing Company in Everett and debuted his first beer in January 2010. He did not start his own brewery, and although the business was discontinued in October 2010, some beer appeared to be distributed after that.

Jim Jameson developed his love for beer while living in Oregon. During the summer of 1979, he tried every import beer available at Produce Row Café in Portland, Oregon. Jameson started homebrewing in 1992 after receiving a beer kit from his wife, Kim. He started *Northwest Brew News* in 1994, which had grown to have more than fifteen thousand subscribers by 1997. He focused on his homebrewing and, in 2007, started thinking about starting a brewery. In 2008, Foggy Noggin Brewing LLC was issued a Washington State business license, and the process began. Jim built a shed-size brewery in his backyard and turned his garage in Bothell into a tasting room. He opened his half-barrel brewery in January 2010, brewing English-style ales, using authentic English malt and hops to create true-to-style beers.

West Highland Brewing was started by Don Stewart and Sam Simms in Vancouver in February 2010. They named the brewery after their love for West Highland White Terriers and their more than twenty-five years combined brewing experience.

Michael McMahon started as a homebrewer. He took a job at Leavenworth Brewery until it closed in 2001, after which he returned to Whidbey Island. He wanted to start his own brewery, and in early February 2010, he opened a homebrew store and Olde World Ales and Lagers. Plans were to brew sixteen to twenty-one kegs of beer per week, as "quality starts to wane past that point," he said. The business closed, possibly in 2011, and McMahon moved to Bend, Oregon, where he worked at Old Mill Brew Werks and became a partner in the same business when it was became Craft Kitchen and Brewery LLC.

In 2007, after learning how to brew from friends, books and classes, Alex Dittmar became obsessed with crafting good beer. In 2008, he won his first competition as a homebrewer at the San Diego County Fair for what is now the Jet City ESB. Airways Brewing Company opened in Kent on March 11, 2010, with a small taproom and a half-barrel brew system. Shortly after opening, it began brewing larger batches at a brewery in Seattle. In October 2012, it upgraded to a ten-barrel brewhouse and opened a second location, also in Kent, on November 1, 2012.

Andy Husted brewed beer at home, experimenting until he had recipes he liked. "People are starting to realize there are as many depths and flavors to beer as there is to wine," he said. He and wife, Jessica, with partners Chal Davidson and Reina Powers, opened Der Blokken Brewery Pub opened in Bremerton on March 17, 2010. The name Der Blokken is a made-up Dutch word for "black," signifying the darkness of Andy's first beers.

Station U-Brew opened in Puyallup in late April 2010. Founded by Steve Samples, he served six of his own beer on tap, while providing instruction and a location to brew beer for the novice.

In January 2004, Water Street Brewery and Ale House in Port Townsend started what became the annual Strange Brewfest. That first year, a handful of breweries showed up, but each year it grew. Like the name, the festival became known for the unusual beers often brewed just for the event. In December 2008, and for about a year and half afterward, Water Street Brewery struggled with a landlord-tenant dispute, and in late June 2010, it was evicted and closed its doors. The Strange Brewfest continued on at the local American Legion post.

The post office in Pullman was constructed in the 1930s, and by the 1970s, it had outgrown the facility, so a new, larger one was built. In 2002, Pullman resident Tom Handy purchased the original building and renovated it. In 2003, it was added to the National Register of Historic Places. Handy opened a wine bar and restaurant in the building and later rented a portion of the building to a startup winery. He began homebrewing beer with winery owner Patrick Merry. After the winery moved out of the building, Handy turned his wine bar into Paradise Creek Brewery, opening on June 1, 2010. Brewing on a 7-barrel system, by late 2012 it was at capacity, but there is not room to expand. It produced 850 barrels of beer in 2014.

Valhöll Brewing Company was started by Jeff Holcomb (head brewer), Jordan Rogers (brewer) and Aaron Kallio (sales). Holcomb was previously head brewer at Heads Up Brewing Company (with Rogers) before it closed in 2008. His beers used flavors like sweet potato and licorice and were

generally higher alcohol content. Valhöll Brewing opened on August 14, 2010, and its Viking-themed taproom opened in 2012. It produced about 100 barrels in 2012 and in 482 barrels of beer in 2013. In 2014, former Grove Street Brewhouse and Pike Brewing Company brewer Adam Orrick became its head brewer, and it produced 668 barrels.

Rick Hewitt started brewing when he was twenty-two. "I brewed my first batch of beer in my college apartment with a buddy after watching the Super Bowl in 2005." He read books about beer and some of the craft beer pioneers and decided that he wanted to open his own brewery and concentrate on lager beers, not as popular in the craft community. Hewitt started Emerald City Beer in the former Rainier Brewery in Seattle in August 2010. "I'm going to be the first one to make beer there in a decade. How cool is that? The old Rainier lagering tanks are still there just outside my door." He named his first beer Dottie's Seattle Lager after his grandmother, who was the daughter of a German hop farmer. The brewery was open until at least mid-2013, but it has since closed its doors.

California native Tom Curry is a fan of Fremont Brewing Company and California's Russian River Brewing, which he said have influenced his brewing style, which is "aggressive California-style ales, with a Northwest twist, using fresh Northwest ingredients." He opened Barhop Brewing in Port Angeles in 2010. In 2012, it moved to a new location.

Kurt Ahrens developed an interest in "flavorful" beers while in college in Denver. He moved to Seattle with his wife, Lori, and started homebrewing in about 1990, brewing every other weekend. While traveling for his insurance job, he would find "local breweries and brewpubs to taste their beers and check out the operations." While traveling in Europe, he and his wife "developed a love of the many ales available including cask or real ale." After moving to Mount Vernon, he continued to homebrew until 2009, when they bought a commercial building in Mount Vernon. "We found some used brewing equipment [four barrel] in Anaconda, Montana, from the Rocky Mountain Brewing Company." North Sound Brewing was licensed in the summer of 2010, and its taproom opened September 3, 2010, although it had sold kegs to three local pubs by August.

Kevin Klein started homebrewing in 1998 and has been a member of North Seattle Homebrewers since 2000. He received a doctorate in molecular biology from the University of Washington but knew brewing was what he wanted to do. He opened Northwest Peaks Brewing in the Ballard neighborhood of Seattle in November 2010. It is a nanobrewery making less than one barrel of beer per batch. Instead of having a few flagship beers

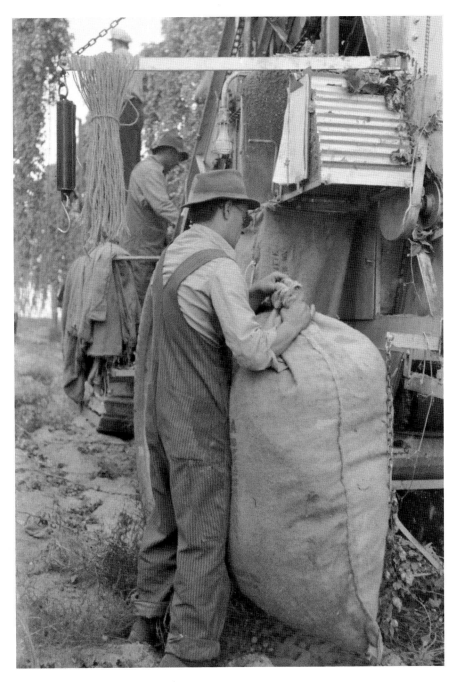

Harvesting hops was a labor-intensive operation, from the cutting to the baling. This photo shows taking sacks of hops from portable-type mechanical hop picker at Yakima Chief Hop Ranch, Yakima County. *Farm Security Administration—Office of War Information Photograph Collection, Library of Congress.*

available at all times, it releases two new beers each month. Klein is an avid mountaineer, and all his beers are named after a peak climbed by him in the Pacific Northwest.

Mike and Chardell Sutherland started White Bluffs Brewing LLC in Richland on November 20, 2010. Their mission was "to create beer with character for people with taste." Mike had more than twenty-seven years of experience and brewed on a 7-barrel system. He brewed 237 barrels in 2013, and in 2015, they built a new brewery.

Scott Ruppelius started Two Sisters Honey in 2004 in Kennewick. Named for his two daughters, he first worked with bees to help pay for college and, by 2012, had twenty-five hives. He got his start in beer when he was given a homebrew kit as a gift. In 2010, he started Two Sisters Honey and Brewery with his friend Ryan Hintz using honey from the apiary. By 2015, they had four different beers available.

Headknocker Brewery was formed in March 2005 by Jim and Maria Pettyjohn and Justin and Lara Blasko. Jim and Justin had been homebrewing since 1995 when, in 2005, an "opportunity to commercialize our hobby presented itself." So they built a direct-fire three-barrel brewing system on their wives' family farmstead in Monroe in an old dairy barn. In 2010, they had their first beer release, and although the business does not seem to be producing beer, it is still active.

Parker's Restaurant & Brewery was opened in West Longview in 2005 by Tony and Josey Parker. In 2010, brewer Tony installed fermentation equipment in the kitchen, which was already cramped. In 2012, they bought a former restaurant that was double the size in Castle Rock and moved the business, with plans to bottle distribute. They produced forty-eight barrels in 2014.

Riverport Brewing Company was founded in 2008 and opened in 2010 in Clarkston, started by Marv Eveland; his wife, Karen; and Pete and Nancy Broyles. The brewery has a seven-barrel brewhouse. Marv was the first brewer until about 2013, when the Broyles bought out the Evelands, and now Pete is the brewer.

The first decade of the twenty-first century ended with the craft beer phenomenon growing at a red-hot pace. The next five years, though, would change the brewing landscape unlike any five years since brewing began in the 1800s. By 2014, there would be five breweries per capita (100,000 twenty-one and older adults), ranking the state seventh in the country. But more impressively, Washington would have the second-most breweries in the country, behind only California.

2011-2012

2011

Christopher Engdahl began homebrewing while in high school and continued during college. After traveling to Europe, he decided to focus on Belgian- and French-style beers. "I saw a lot of focus on Northwest style, hoppy brews, and I wanted to do something a little different," he said. Engdahl propagates his own yeast from an original strain from a Belgian monastery. He quit his computer job, started Lantern Brewing in Seattle in 2010 and brewed his first beer in January 2011. The nanobrewery was located in a basement, and there was no tasting room. "It's not the best ambiance for the public," said Engdahl, who sold his beer primarily at the local farmers' market until 2013. Lantern Brewing moved to a larger location, upgraded to a larger brewing system and, in May 2014, opened a tasting room.

American Brewing Company was opened in January 2011 in Edmonds by real estate developer Neil Fallon, with veteran brewer Skip Madsen as head brewer. By 2013, American no longer had enough capacity to meet its demand, so plans were made to take the brewery public to raise cash for expansion. After the offering was made in 2014, it sold almost $1 million in shares, and the stock shot up from $0.50 to $2.50. It eventually dropped back down and traded under $1.00.

Slippery Pig Brewery opened in Poulsbo in mid-February 2011, specializing in in-season ingredients grown on owner Dave Lambert's farm. "We started this with the farmers' market in mind. If it's not in season, you're not getting

it." In the summer of 2014, it moved into a larger location in downtown Poulsbo and produced 107 barrels of beer in 2014.

Steve Roerig opened Battenkill Brewing Company in a barn in Poulsbo in March 2011 and made "familiar beers. Very drinkable." Roerig did not have a tasting room, which made his brewery tough to experience, and after a year, he closed. "I'm going back to being a regular homebrewer, which I've always enjoyed."

In 1993, Tim Kovach opened the Sailfish Grill in Monroe. The following year, he opened the Twin Rivers Brewery next door. Adam Hoffman took over the restaurant and brewery in February 2011 and opened the doors to the public on March 15, 2011, as Adams Northwest Bistro and Brewery. Greg Boyer runs the brewery, where he produced sixty-seven barrels in 2011 and was up to ninety-seven barrels by 2014.

Ken Thoburn started homebrewing in college. He co-founded Wingman Brewers Inc. in Tacoma on April 19, 2011. It brewed more than 90 barrels that first year on a 1-barrel system. One year later, it moved into a larger building and added a taproom. In October 2013, it debuted a 7-barrel system, keeping the 1-barrel as a test system. Still growing, in 2014 Wingman produced 566 barrels of beer.

Oliver Brulotte and family moved to Leavenworth in 2001 and opened München Haus Bavarian Grill & Beer Garden. Brulotte's family has been hop farming in Moxee for four generations. After a family trip to Germany, they decided that the Bavarian-themed town of Leavenworth needed a German brewery since Leavenworth Brewery had closed in 2001. Oliver and Pamela Brulotte founded Icicle Brewing Company in May 2010. They constructed a brand-new Bavarian-themed building and opened in April 2011 with Dean Priebe (who was awarded a scholarship from the Glen Hay Falconer Foundation to the World Academy of Brewing at the Siebel Institute of Technology) as head brewer. Priebe previously won a pro-am competition with Pike Brewing Company in 2008 as a homebrewer. Icicle Brewing Company produced 1,007 barrels in 2011 and was up to 3,956 in 2014.

Homebrewers Brad Ginn, Mark Hood and Steve Mattson, along with Alan Moum and John Cockburn, started Sound Brewery in Poulsbo in late 2010. Ginn, award-winning brewer and head of the West Sound Brewers Club, was head brewer. The other members were involved in management and distribution. They found a used 7-barrel copper-clad system in California and installed a bottling line. The brewery opened in mid-April 2011 and quickly gained fans. By 2014, it was producing 1,350 barrels of beer per year and maxing its system.

The years had not been kind to the former Columbia/Heidelberg brewery in Tacoma. During the 1980s and 1990s, the buildings were used for band rehearsal spaces, and several fires contributed to the building deteriorating. In 2008, the Tacoma Landmark Preservation Commission declined to make the brewery a historic landmark, which sounded its death knell. In July 2011, the building was demolished to make room for a Holiday Inn. Much of the large old lumber was reclaimed and made available for resale. The brewery, once a landmark and seller of Alt Heidelberg Beer, was now a memory amid the new, small craft breweries.

Brad and Bruce Budge were cooks in Spokane in 2007 when they decided that they wanted to open a brewery. They eventually quit their jobs, bought a homebrew beer kit and began learning how to brew beer. With help from their family, they were able to build a seven-barrel brew system. In January 2010, Budge Brothers Brewery LLC was licensed, and in May 2011, it opened its doors. Bruce is the brewmaster, and Brad runs the taproom.

Pike Brewing Company in Seattle contributed many brewers to the Washington landscape through the years. In 2011, head brewer Drew Cluley left for a second stint at Big Time Brewery in Seattle, this time as head brewer. He took over for his brother-in-law, Bill Jenkins, who was leaving to spend time with his family.

In September 2011, Baron Brewing Company owner Jeff Smiley announced that he was moving his brewery out of Seattle. Baron had produced German-style beers and had a line of pirate-themed beers. It would continue to operate Pillagers Pub as its Seattle brewpub and put the brewery up for sale. Smiley moved the brewery to Chehalis and renamed it Xela Brewing, where he planned to produce Mexican-style beers. It did not pan out, as Smiley was unable to sell the Seattle brewery and never built the Chehalis site. Pillager's Pub was still in operation, just not selling his beers, but by the end of 2012, it had also closed. He sold his pirate-themed Three Skulls Ales to Northwest Brewing Company, and it continues to produce some of the original Laughing Buddha Brewing beers, as well as Three Skulls Ales.

Westport Brewing Company was opened by Robin Duus on December 22, 2011, in the city of Westport. It stakes a claim to being "the first microbrewery on the Washington Coast since 1944." It brewed beers using local ingredients and ferment using ambient temperatures. It brewed nineteen styles of beer in a three-barrel brewhouse located in the garage. In 2015, Duus began looking for someone to take over the brewery, but complications with the property made it difficult and the brewery closed suddenly in September 2015.

"Born from a friendship and chance to drink on the job," William "Billy Jack" Newman and Loren Ahrens liked what they created, so they started Wet Head Brewery Corporation in November 2011. The long process was completed in January 2013, when they opened their doors. They produced thirty-one barrels of beer in 2014.

In 2002, Engine House No. 9 was purchased by Dick Dickens, and head brewer at the time was Doug Tiede. "When I started here in 2000, I was new to the Tacoma area," said Tiede. With its Tacoma Brew, he said, "I thought it was interesting to have a recipe based on a real Tacoma institution." Then, in August 2011, the X Group (John Xitco and Jeff Paradise) purchased the business, with Shane Johns as head brewer.

Ean Forgette and Joe Montero were neighbors and homebrewers. Living near Brickyard Road, they started Brickyard Brewing in Woodinville, opening on October 17, 2011. "We've been brewing beer for a long time and wanted to make a name for Woodinville brewing," said head brewer Forgette. They started with a small one-barrel brew system but quickly found that the demand for their beers exceed their production capacity. They entered into an alternating proprietorship with Twelve Bar Brews to brew on opposite weeks, allowing them to expand their capacity, and brewed specialty beers on the former system.

Joe Nestor, who had run Cashmere Brewing Company, opened Columbia Valley Brewing in Wenatchee in July 2011. During the grand opening weekend, it ran out of beer, and five weeks after opening, it expanded the system twice.

Ryan Hilliard started homebrewing in his early twenties. In 2009, he was one of only seventy-five homebrewers who made it to the Great American Beer Festival in Denver. He and friend Adam Merkl spent a year and a half visiting breweries in Seattle as they tried to figure out how to open a brewery. Before finding a location, they purchased a used copper-clad 15-barrel brewhouse from Sacramento Brewing. In October 2011, Hilliard's Beer opened in the Ballard neighborhood of Seattle, and from day one, it sold its beer in tallboy cans. Todd Garrett was head brewer from the start, after homebrewing for about six years before being hired. By 2013, Hilliard's had produced 3,500 barrels of beer. The brewery scored a touchdown with its Seattle Seahawks–themed 12th Can Beer in January 2014. It produced twelve thousand cases of the beer. "It's just been flying off the shelves," said Hilliard. "We've had to realign our expectations on this." It certainly didn't hurt that the National Football League team went on to win the Super Bowl that year.

Ryan Hillard and Adam Merkl started Hilliard's Beer in Seattle in 2011. They began canning beer from the beginning, focusing on the retail end. This photo shows their canning line and brewing tanks inside their Ballard brewery. *Michelle Rizzo.*

Friends Eric Surface and Brian Maher opened one-barrel nanobrewery Mt. Tabor Brewing in Portland, Oregon, in 2010. By February 2011, "we were growing too fast, and our friend who managed the space was growing faster," so they had to vacate. In October 2011, Surface reopened in his hometown of Vancouver. A part-time business, he operated the now 7-barrel brewery for three years, producing more than 165 barrels of beer each year. In 2014, he opened a new 15-barrel brewery in Portland, Oregon, but also kept the small Vancouver brewpub open.

Frank Cooper started New School Brewing in Richland with lofty aspirations. The company was formed in November 2011 with head brewer Rob Hall, formerly with Ice Harbor Brewing Company. Phase one was a simple brewery and public house, a concept they called "Guerrilla Brewing," which included live music, commercial artist gallery space and Wi-Fi. The brewery went out of business in late 2014.

Billy and Emily Burt started Republic Brewing Company in Republic in June 2011. Located in the town's historic fire hall, they brew on a two-

barrel system. Billy began homebrewing while attending the University of Montana and hearing a cellular biology professor lecture on the science behind brewing. He continued to perfect his recipes over the next ten years. They produced about four hundred barrels in 2014.

Elysian Brewing Company opened a new 60-barrel production-only brewery in Seattle in November 2011 with an annual production capacity of 130,000 barrels. In 2011, it produced 9,782 barrels, which jumped to 58,399 in 2014. The company opened a new location near Westlake Center in 2014, which does not have on-premises brewing.

Tom Wytko had been homebrewing for fifteen years when friends and family told him to "quit your day job and just do this." He balked at the cost and time involved until finally, in 2011, he and wife, Whitney, built the brewery on their property in Moses Lake and started St. Brigid's Brewery. Wytko, who brews on a three-barrel brewing system, said, "it's fun playing with and finding out what people like and dialing in on it and making it." The brewery name came from an Irish nun who crafted ales in the 1700s. They opened a taproom in Moses Lake in 2013.

St. Helens Brewing Company was started in Toledo in November 2011 by Chris and Callie Fraser. While selling their beer, they became friends with the owner of Harry's Place in Toledo. Jack LeDuc kept their beer on tap, and they became regular customers. In late 2012, he offered to sell the restaurant to the Fraser's. "All along, they've absolutely supported us," said Callie Fraser. On January 1, 2013, they reopened as St. Helens Tap House & Grill, offering twenty taps, with five of their own beers available. They closed on December 31, 2015, for unknown reasons.

Brothers Rich and Ray Nesheim were homebrewers. Rich was a contractor, and Ray became head brewer at their Triplehorn Brewing Company, which opened in Woodinville on August 25, 2011. From day one, they were open seven days a week. They were going to start with a three-barrel system but went with a ten-barrel system. As for their beers, "It's always a battle to choose between brewing what you like to drink or what sells best," Rich said.

Woodinville saw another brewery open on November 1, 2011, when Twelve Bar Brews opened. Founded by Kirk Hilse, a homebrewer with eighteen years of experience, he dry-hops all his beers for a fragrant finish. The brewery has a fifteen-barrel system and was production only. A small taproom was rarely open, "I was so busy making beer, I had no time to serve it, and that meant the tasting room went dark a lot of the time." For the brewery's first anniversary, he expanded and opened the taproom.

He formed a partnership with Brickyard Brewing to share his brewing equipment, brewing alternating weeks.

Dan and Heather O'Leary "discovered craft beer when we lived in Portland, Oregon." Three years later, they moved to Minnesota and found that there were no breweries. "Having never brewed a batch of beer in my life, I began talking to people about opening a brewery," Dan said. He brewed almost weekly for two years, winning several medals. After approaching five banks and fifteen investors, they were unable to secure financing. Then Dan's job sent him to Seattle. In Puyallup, they opened nanobrewery DUO Brewing in their detached garage on October 4, 2011. Although the brewery seemed to attract some attention, it survived until its second anniversary but was closed in 2013.

Vashon Brewing Company was started in Vashon by Cliff Goodman, a homebrewer with twenty years of experience. In 2010, he donated a case of his homebrew to an auction, and "it turned out to be really popular." By September 2011, he had built a nanobrewery in a shed at his home, the first brewery on Vashon. "To me, there's something magical about brewing beer. To me, it's amazing to take hops and malted barley, water and yeast and make it into something different." He sells his beer in kegs and growlers and brews gluten-free beer. Instead of eliminating the wheat, he uses a fermentation enzyme to break down the gluten in 100 percent organic malted barley. The spent grains feed island livestock, he reuses water from the brewery and spent hops and yeast are composted for the garden.

Mark Holland and brewer Nick Kannarr started Vital Brewing in Everett in 2010 while Kannarr worked as brewer at North Sound Brewing in Mount Vernon. They were licensed in 2011 and may or may not have opened, but they dissolved the company in 2013. Kannarr moved on to become head brewer at Big Time Brewery in Seattle in 2014.

Terry Hackler said that opening a brewery was "an idea formed over thirty years ago at the very beginning of the craft beer movement." He homebrewed for many years and tried all styles of beers, which "led me to develop some of our tried and true recipes as well as all the experimental and new varieties that we continually dream up." In December 2011, he opened Twelve String Brewing, the first brewery in Spokane Valley. It has a 7-barrel brewhouse fabricated from food processing tanks. It keeps eighteen of its own beers on tap and has an extensive barrel aging program. It brewed 603 barrels in 2014.

2012

Dave Powell and Timothy Czarnetzki were roommates and homebrewers in Washington, D.C. Powell went into education and lived in several cities before landing in Seattle. Czarnetzki moved to Seattle when they decided to open a brewery and enlisted Sean Bowman for social media. On January 13, 2012, they opened Urban Family Public House in the Ballard neighborhood of Seattle while looking for a brewer. They hired Justin Quinlan as head brewer, and Urban Family Brewing Company began. In April 2014, they announced that they were shutting down the brewery and moving it to the Interbay neighborhood, near Fisherman's Terminal, but kept the Public House open.

Acadian Farms & Brewery was started in Carson by Benton and Nicole Bernard in February 2012. It was a "beloved" location in the Columbia River gorge. Over time, not all its neighbors were happy with the traffic, often calling the authorities. On Mother's Day 2014, it held an event with acoustic music that attracted an unexpectedly large crowd and drew the ire and attention of public officials. A public hearing was held to shut down the brewery, but with supporters backing it, it was able to appease the officials, but at a cost. It contemplated moving to a larger facility, but after shutting down for the winter of 2014, it decided not to reopen in 2015; instead, it put the brewing equipment and farm up for sale.

In February 2012, Rainy City Ales announced that it was planning to open a non-gluten brewery in the Ballard neighborhood of Seattle. "The base grain of our beer is millet, not barley or buckwheat." It operated as a homebrew operation while it tried to get licensed, but it never opened.

Sunny Parsons started Heathen Brewing with Rodney Stryker as a production-only brewery in Hazel Dell, near Vancouver, in late 2011. Parsons built the brewery, after mortgaging some rental property he owned, in a barn on his property. "For the next year, my thing will probably be events—I'm trying to get into brew fests," Parsons said. With Stryker as head brewer, the pair won numerous awards its first few years. By the end of 2014, it had produced 752 barrels of beer. In early July 2015, it opened Heathen Brewing Feral Public House in Vancouver.

Puyallup resident Eric Akeson started homebrewing in the 1990s. After getting married in 2003, he stopped brewing while raising a family. In about 2010, Akeson returned to homebrewing and, in 2011, built a 1-barrel system in a building in his yard. He started Puyallup River Brewing Company on December 1, 2011, and opened its doors in early April 2012. All his beers

Sunny Parsons started Heathen Brewing with Rodney Stryker as a production-only brewery in Hazel Dell, near Vancouver, in late 2011. Parsons built the brewery in a barn on his property. With Stryker as head brewer, it won numerous awards its first few years. In early July 2015, it opened Heathen Brewing Feral Public House in Vancouver. *Rodney Stryker.*

are named after Puyallup or Mount Rainier landmarks. Business grew until February 2013, when he opened Puyallup River Alehouse, a twenty-four-tap taproom in downtown Puyallup to showcase his and other beers. In June 2015, he won Small Brewery of the Year at the Washington Brewers' Festival after winning three medals. This prompted owner Akeson to increase "capacity from 15 barrels a month to 130 barrels," with a new 7-barrel brewing system he expected to arrive in November 2015. He closed his taproom on August 8 to concentrate on brewing and bottling his beer.

Kulshan Brewing Company opened on James Street in Bellingham on April 2, 2012, founded by Dave Vitt, a homebrewer who returned home to Bellingham. With only two breweries in town at the time, he felt that there was room for more. Tom Eastwood became head brewer so Vitt could concentrate on the business aspect. The brewery has a 15-barrel brewhouse and produced 3,227 barrels in 2014.

Dirty Bucket Brewing Company opened in Woodinville on April 14, 2012. Founded by brothers Steve and Chris Acord and Steve's wife, Sharon, the former homebrewers were ready to take their craft to the commercial level.

They started on a half-barrel Sabco Brew-Magic system, brewing every night. A year later, they acquired an additional 1,800 square feet within the same complex, upgraded to a three-barrel brewhouse and added enough fermenters to expand brewing.

In 1994, Larry and Ana Pratt opened Salmon Creek Brewery & Pub in Vancouver. Eighteen years later, in April 2012, they retired and sold the business to David and Arlene Nunez, owners of By the Bottle, located next door. They, in turn, hired Tom Munoz as their brewmaster. The brewery was renamed Old Ivy Brewery, and in 2014, it closed the taproom at By the Bottle to direct business into the brewery.

Bainbridge Island Brewing Company was started on Bainbridge Island by father-and-son team Chuck and Russell Everett in 2011. They opened in June 2012 in the Copper Top Loop off Sportsman Club Road. Russell was an "award-winning homebrewer and former professional brewer" and an alcoholic beverage lawyer.

Drew Colpitts went to University of California–Davis and spent some time at MillerCoors, Gordon Biersch Brewery Restaurant in Seattle and others before starting Seapine Brewing Company in Seattle with Adam Smith in 2011. Their tasting room opened in mid-2012. Colpitts is a master brewer and the "wizard" behind their flavors. He started on a three-and-a-half-barrel system. In early September 2015, they closed their shop while they moved and upgraded to a new fifteen-barrel brewing system and taproom in Seattle, which opened in mid-November 2015.

Dirty Bucket Brewing Company is located in Woodinville and opened in 2012. Founded by brothers Steve and Chris Acord, as well as Steve's wife, Sharon, the former homebrewers started on a half-barrel system, brewing every night. A year later, they acquired an additional 1,800 square feet within the same complex and upgraded to a three-barrel brewhouse. This fermenter is autographed by their mug club members. *Michelle Rizzo.*

Amnesia Brewing announced that it was leaving Portland, Oregon, for Washougal in the summer of 2012. A new fifteen-barrel brewing system would produce six thousand barrels per year. Sean Thommen started working for the company in 2007 and then attended the Siebel Institute of Technology in Chicago. He came back to Amnesia to be head brewer.

Northern Lights Brewing Company in Spokane ran into some trouble in 2012. With a new partner, brewery veteran John Bryant, founder and brewmaster Mark Irvin wanted to expand the reach of their beer. The brewery purchased a bottling line and began releasing its beers in Denver, Colorado; New York City; and Spokane. It was producing 1,500 barrels per year at this point. As it looked at the other markets, it realized that Starr Hill Brewery in Virginia had a beer named Northern Lights IPA and that company was partially owned by Anheuser-Busch. After trying to contact the other brewery's lawyers and not receiving any response, it decided to rebrand the brewery. "No-Li Brewhouse is a hometown brewer with aspirations of a regional brewery that builds an even stronger Spokane centric identity as a national craft beer destination," Bryant said. They also decided to call their pale ale Silent Treatment Pale Ale after not receiving a response to their calls.

The Waters family owns the Carson General Store in Carson. Kevin Waters went to school in eastern Washington, where he got involved in the homebrewing scene, even working at a homebrew store in Spokane. After returning home, he decided that he wanted to start a brewery, and Backwoods Brewing Company opened in June 2012. The nanobrewery is located in the storefront next to the family's general store. In January 2016, they moved the production side of the brewery to a larger location in Stevenson for their twenty-barrel system.

Water Buffalo Brewery was opened in July 2012 in Walla Walla by Michael Rossi. He brews on a one-barrel direct-fired/solar custom-built system. Water Buffalo Brewery self-distributes and has a tasting room that is open by appointment. He produced eight barrels in 2014.

Jack Hatley received the gift of a homebrew kit from his wife, Francine, in the early 2000s. He found that he had a knack for brewing, and it grew into a garage project until 2012, when Whiskey Ridge Brewing was born in Darrington. In 2015, it moved to a new location in downtown Arlington, where its taproom serves from six taps.

Melody Bacchus thought that after her kids were grown she would do something different, so she put her restaurant in Quilcene up for sale but didn't receive a single response. She found beer interesting and went online to learn about making beer. She invested $16,000, bought a small brewing

system and began brewing fifteen-gallon batches of beer in November 2012. "The first time it went real well," she said. But it took some work to perfect the beer to the styles she liked. She decided to turn the restaurant into a brewery, and 101 Brewery was born. Two of her kids moved home to help with the brewery, and all her beer names are logging related.

Beljica Brewing opened in Chewelah in 2012. Founded by Alexander Freeman, the brewery is "named after a peak near Mount Rainier that his great-grandfather scaled and helped name." With his three-barrel system, he may have had the first gluten-free brewery in the state, but it has since closed.

John Julum was a homebrewer for twenty years when he and wife, Michelle, decided to open Big Block Brewing LLC, the only licensed brewery in Sammamish, in 2012. Brewing on a 1-barrel brewhouse located in their garage, they produced about 250 barrels in 2014. Selling just growlers and kegs, they didn't advertise their address, but in October 2015, they opened a new taproom in Sammamish. Named for big block car engines, the bar top features a tire burn out done by the owner.

Doomsday Brewing Company was founded in September 2012 by friends Erik Cloe and Jake Walton. Both were homebrewers and started brewing in a shop on Walton's property in Vancouver. "We came up with the name in December 2012 when the Mayan calendar was ending and we were all supposed to die," Cloe said. "We didn't die…so we came up with doomsday is brewing," he said. "Something is always around the corner that is going to kill us." They didn't have a taproom and quickly outgrew their brewery, so they moved to the former Rail Side Brewing location in Washougal. Doomsday has a seven-barrel brewhouse.

Lake Stevens Brewing Company opened in Lake Stevens on April 1, 2012, but appears to be closed.

Dungeness Brewing Company opened in Port Angeles on July 17, 2012. In November 2013, it added a second brand from homebrewer Colin Smith, Klahhane Ridge Brewery. It produced thirty-five barrels of beer in 2014.

Duvall Springs Brewing was started in Duvall by friends Jake Seibert, Brady Hoyle and Chris Lagerstad. They opened on July 21, 2012, brewing "deep in the woods" in a "secret shed." Requests to visit the brewery were not allowed for various reasons, but their beers were on tap at Duvall Tavern.

Rob Ziebell moved to Vancouver, next door to Jeff Seibel. Seibel was interested in the brewing equipment that Ziebell had brought, and the two started homebrewing together. They started Ghost Runners Brewery with Amy Seibel in a building on the Seibel's Vancouver property in October

Reuben's Brews was founded by Adam Robbins and opened in August 2012. The brewery has fared well at competitions, and in May 2015, it opened a larger location a block away. This was taken during Seattle Beer Week 2015, at Rye Beer Fest, in the new location. *Author's collection.*

2012 using a homemade brewing system, brewing about eight barrels per month. By November 2014, they had begun construction on a ten-barrel brewhouse and tasting room, the former opened in February 2015 and the latter in April. Co-founder Rob Ziebell stepped down from active involvement in the business in 2015.

Adam Robbings loved beer, so much so that his wife bought him a homebrew kit "to shut me up to some extent." In his first year of brewing, he won the people's choice award in a Seattle beer festival. He then enrolled in the University of California–Davis brewers program to enhance his skills and prepared to open a brewery. In August 2012, Reuben's Brews LLC opened in Seattle. Named after his son, the business is family run, with his brother-in-law Mike Pfeiffer relocating to Seattle to help run the brewery. In May 2015, they opened a new, larger brewery a block from their start. They won a gold medal at the 2015 Great American Beer Festival and Mid-Size Brewery of the Year at the Washington Beer Awards. In November 2015, they hired brewer Dean Mochizuki as experimental brewer after thirteen years with Pike Brewing Company.

Outlander Brewery and Pub was started in Seattle by Nigel Lassiter and Dragan Radulovic, opening on August 3, 2012. Located in a house, former homebrewer Lassiter brews on a three-and-a-half-barrel system, creating experimental beers and often not brewing the same beer twice.

Bryan Trunnell started Krausenwerk Brewing (Kastellan Brauerei) in Lacey in a building behind his home. Erik Heimann and Trunnell were the brewers. They opened in 2012, focusing on German- and Belgian-styles beers, using all German and Belgian malts and grains. They brewed about two barrels per month while working other jobs. The brewery shut down in January 2015 when Trunnell became partner of O-Town Brewing in Olympia.

Brandon Peterson, Benjamin Buccarelli and Tom Raden began thinking about starting a business in December 2010. Menace Brewing was formed

in Ferndale in 2012 with one-time Kulshan Brewing Company brewer Buccarelli as head brewer. Initially only available at two locations, it quickly gained a following and had to double its brewing capacity within the first year. In October 2013, it opened Local Public House in Bellingham to serve as its taproom. "My vision [for the bar] is to be a hub for the great beer scene developing here in Bellingham," Buccarelli said.

A nanobrewery was opened in Manson in July 2012 by Lee and Ray Medina. Lake Chelan Brewery brewed on a one-barrel system. The Medinas own the Village Market deli next to the brewery and used that as their tasting room. By the following year, they were looking at upgrading to a two-barrel system. They brewed eighty-one barrels of beer in 2014.

Iron Goat Brewing Company in Spokane is named after the famous Garbage Goat in Riverfront Park. The brewery was founded by couples Greg and Heather Brandt and Sheila Evans and Paul Edminster. Greg and Paul met at a local bar, where they discussed similar interests, including homebrewing. That was when they started brainstorming opening a brewery. Their wives were behind them (Heather also homebrewed), and by May 2011, they had a business license; in June, they purchased a used 8.5-barrel brewing system from Spanish Peaks Brewing in Bozeman, Montana. They opened the brewery and taproom in early June 2012 and brewed 179 barrels of beer the first year but brewed 720 barrels by the end of 2014. By 2015, they were out of space and purchased a 1920s-era building. They expect to move into their new space—with brewery, warehouse, taproom and kitchen—in early 2016.

Ramblin' Road Craft Brewing was started by Brian and Danielle Guthrie and her brother, Will Spear, in late 2012 in Spokane. The Guthries were homebrewers for about five years when they decided to move back to Spokane from Seattle and open the brewery. Although distributing beer by the end of 2012, they didn't finish the full brewery and taproom until February 2014. In 2014, they produced 198 barrels. "I can't believe we've made it. It's a dream come true," said Brian. They have a 10-barrel direct-fire brewhouse visible through a large glass door.

Nate Schons began homebrewing while living in New Zealand in 2002. "I discovered you could brew beer at home. Good beer. Beer you wanted to drink," he said. When he returned to Washington, he worked at Cashmere Brewing Company in Cashmere. In 2007, Schons met Becca Gray, who didn't drink beer. "I showed up for our second date, and he was brewing beer. It really wasn't something I was into. And then he began describing the process," she said. She was hooked. "People often asked

us if they could come and learn about brewing beer," Grey said. "We always said yes. No one ever came" until Jim Parker, who began brewing with the couple in 2009, which led to a new friendship. In 2011, they started Island Hoppin' Brewery on Orcas Island with eighteen investors. After a year, they needed to expand and moved to a new location in Eastsound, and on September 21, 2012, they opened a new taproom. Schons mans the five-barrel brewhouse.

Nate McLaughlin was a homebrewer and attended craft brewing classes at Chemeketa Community College in Salem, Oregon. He liked to brew Belgian-style beers and won awards as a homebrewer. "In 2009, I set out to open a small-scale craft brewery," he said. He started Justice Brewing LLC in Everett. In 2011, he started looking for a location, and on September 15, 2012, he opened the brewery in his detached garage.

Loowit Brewing Company was founded on January 9, 2010, in Vancouver by friends Devon Bray and Thomas Poffenroth, who had homebrewed "together for about seven or eight years." They collected a seven-barrel brewhouse, including unsealed bulk dairy tanks, and opened on October 19, 2012. By its first anniversary, it had become the first Vancouver brewery to bottle beer since Lucky Lager closed in 1985. It won a gold medal at its first competition in 2013.

Melissa McClendon didn't come to brewing the way nearly anyone else did. A native of Cashmere, she worked at a winery on the East Coast before moving back to start a winery. Realizing that the market was full, she opened Milepost 111 Brewing Company in Cashmere on October 22, 2012, five months late and 25 percent over budget. With no previous brewing experience, she started brewing ten gallons of beer at a time, but she got the restaurant going and filled the twenty-seven taps with other company's beer and cider. She didn't have any of her beer on tap until the fall of 2014. The brewery produced ten barrels in 2014.

Robert Horner was a homebrewer for eight years when he, Piper Corbett and a third partner founded Propolis Brewing in Port Townsend in June 2012. They started on a 1-barrel system, producing about 110 barrels per year. They brew herbal ales, using locally sourced herbs and spices. About 95 percent of their ingredients are certified organic, and they grow about 70 percent of the herbs they use in their beers, releasing two beers per month. When Propolis opened, they only sold their beer in 750ml bottles, but by 2015, they were at production capacity. They expanded using community-sourced capital to open a taproom and larger 10-barrel brewing system. They produced 114 barrels in 2014.

Mike Davis started homebrewing when he was nineteen years old. "After two batches, I tried my hand at all-grain brewing." He read and liked to stick to traditional recipes. He started Rail Side Brewing Limited in Washougal in 2009 with his wife, Anka, and two friends, opening on August 18, 2012. "It was a long process, but it was worth it," Davis said. The brewhouse was seven barrels, and in 2014, it moved to Vancouver.

Coeur d'Alene Brewing Company in Idaho closed in 2010, and the former owners wanted to get back in business after losing their lease after twenty-three years. Gage and Spencer Stromberg and their parents, Ron and Julie Wells, opened River City Brewing in late 2012 in a building that the Wells owned in Spokane. They brought former Coeur d'Alene Brewing brewer Cody Ragen and brewed two Coeur d'Alene Brewing beers. They were production-only but opened a tasting room, producing about two thousand barrels of beer in 2013.

Scott Kirvan and Connie Jacobs started Slaughter County Brewing Company in Port Orchard on August 3, 2012. The pirate-themed brewery had a three-barrel brew system. "We're going for an Irish, maritime and pirate pub all in one," said Kirvan. He had been a homebrewer for about twenty-five years, and he liked to brew English-style beer. "Beer is his real passion," Jacobs said. They produced 198 barrels in 2014.

Strong Arm Brewing was founded in Renton by friends Cincinati Smith (sales and marketing), Robert Bittner (head brewer) and Mack McClinton (operations) in 2012. Bittner had been homebrewing for about fifteen years. They purchased a two-barrel stainless system, were licensed in January 2013 and opened the doors to the garage brewery later that year. They produced 27 barrels in 2014.

Tacoma Brewing Company was started by Morgan Alexander on October 31, 2012, in downtown Tacoma. He began homebrewing in high school using apple juice and Baker's yeast. It was "horrible stuff, but it was alcohol." He converted his Amocat Café into the brewery, and in December 2012, he used Kickstarter to purchase a larger system. Tacoma produced 101 barrels in 2014.

Homebrewer B.J. Garbe ran Papa's Sports Lounge & Casino in Moses Lake and thought that a brewery "would be another unique element to this business." Ten Pin Brewing Company was founded in 2012, and the 3-barrel brewery "made behind a see-through wall near the bar area in the casino," opened in late July 2013. Jim Madden, a homebrewer for twenty years and chemical engineer by trade, was brought on as head brewer. Located next to Lake Bowl, in August 2015 it broke ground on a new brewery capable of producing 7,500 barrels. It expects to be fully operational by March 2016.

Big Barn Brewing Company in Mead started like many, with a desire to open a brewery after homebrewing. Craig Dietz and Brad Paulson have a collected fifty years of homebrewing experience between them and constructed the brewery in a barn on the Bodacious Berries & Fruit farm in the summer of 2012. With their wives, Jane Dietz and Mardi Paulson, the brewery had a soft opening during Oktoberfest 2012. Using fruit juice from their farm, they brewed fruit-flavored beers on two nanobrewing systems and struggled to keep up with the demand, sometimes brewing five batches a week. In early 2014, they moved to a seven-barrel brewhouse and increased production, producing 187 barrels in 2014.

Bluebird Microcreamery & Brewery was an outgrowth of the small ice cream chain in Seattle owned by Josh Kessler Reynolds. With the help of brewer Steve Luke from Elysian Brewing Company, they installed Naked City Brewery and Taphouse's former two-barrel brew system at the Greenwood location. The brewery opened on November 15, 2012, and longtime homebrewer Tom Schmidlin ran the system, producing dessert-focused beers. They produced 14 barrels in 2014.

Mike Montoney homebrewed for about twenty years, "wanting to make it more than a hobby for a very long time." With friend Michael Painter, they started Rainy Daze Brewing in Silverdale and opened on October 1, 2012. Montoney brewed on the one-and-a-half-barrel system from Battenkill Brewing Company in Poulsbo. They produced 255 barrels in 2014.

Mark Zech said that he comes from a long line of brewers. He started homebrewing in 1985, and in 2012, he and his wife, Francisca, opened Washougal Brewing Company in their garage in Washougal on a 2-barrel brewing system. They then opened Mill City Brew Werks, a restaurant and brewery, in Camas on June 13, 2013. He had a 10-barrel brewhouse, with plans to open a brewpub in Vancouver and a production brewery and distribute in Seattle. They produced 660 barrels in 2014.

John Robertson and Scott Hansen founded Bellevue Brewing Company on January 26, 2010, in Bellevue. Robertson had a background in real estate and was a longtime Bellevue resident, and Hansen was founder of Leavenworth Brewery and vice-president of Fish Brewing Company. Brewing veteran Al Triplett was chairman of the advisory board, and head brewer Tony Powell joined in May 2012. Bellevue Brewing took eighteen months to open, "almost unbearable at times," but on December 20, 2012, it opened the doors. It produced 1,528 barrels of beer in 2014.

Chapter 10

2013-2014

2013

Dave Quick began homebrewing in about 1992 and "fell in love with the process and have continued brewing ever since." In 2012, he and wife, Cirri, leased a former fruit-and-equipment warehouse and opened Badger Mountain Brewing in Wenatchee in January 2013 with business manager and partner Jim Blair. They produced 546 barrels in 2014.

Erik Davis started homebrewing in 2010. In August 2011, Herbert Benjamin Friendly Brewing LLC was founded by Erik and Nikki Davis. The name came after they met many "herb friendly" people when they ran promotional events at raves and clubs. They go by Herbert B. Friendly Brewing and, in August 2012, upgraded to a nanobrewery and opened a tasting room in Renton in January 2013. They produced 4 barrels in 2014.

Ed and Wanda Smith ran Peak's Pub in Port Angeles. Ed started brewing for the pub on a half-barrel system until demand for his beer grew. Ed bought a twenty-barrel brewhouse from Germany, and they added a garden to grow some of their ingredients. Twin Peaks Brewing & Malting Company opened in late January 2013, but due to sickness, they permanently closed the brewery in April 2015.

Populuxe Brewing opened in the Ballard neighborhood of Seattle in February 2013. Peter Charbonnier said, "I started as a home brewer, and my gear slowly outgrew the garage. In 2012, my wife, Amy [Besunder], and I decided to make the leap and open up commercially." They leased

a building and started the brewery, which was a 1.5-barrel nanobrewery. "I was only homebrewing for five years before I went pro," Charbonnier said, "but in my last year, I brewed 260 batches." In November 2015, they upgraded to a 7-barrel brewery. They produced 218 barrels in 2014.

Shrub Steppe Smokehouse Brewery opened in late February 2013 in Richland. Started by brewer Kyle Roberson, Kevin Miller and Steven Maiuri, they brewed eight beers. Roberson previously ran Cirque Brewing Company in Prosser before that closed. He opened a separate restaurant, also in Richland, in November 2014.

By late 2012, Skye Book & Brew in Dayton had closed, and in its place, Chief Spring's Fire and Irons Brew Pub opened in February 2013. Fire chief Mike Spring started the brewery with his wife, Ann. While learning to homebrew, he took a homebrew class at Ice Harbor Brewing Company in Kennewick. They purchased former owner Mike McQuary's recipes, "and we'll keep producing them."

Darin Hartley was a homebrewer before deciding to start a brewery in 2012. In February 2013, Unicycle Ale Inc. opened in Poulsbo, brewing and bottling forty cases per month and selling mainly at the Poulsbo Farmers' Market, with a taproom in the future. It produced eighteen barrels of beer in 2014.

Toren Heald and his friend Brian Peterson took a homebrewing class that neither particularly loved. But the class got Heald to purchase a homebrew kit, and the pair starting brewing beer. "Time after time and recipe after recipe, the beer was coming out fantastic." Soon they upgraded to a half-barrel system and brewed weekly. After a year, they brought friend Mike Miller on as a partner and found commercial space with Vessel Wines in Woodinville, where Blue Lightning Brewing opened in February 2013. Heald was head brewer. The brewery appears to have closed in mid-January 2016.

Geoff Middleton fell in love, like many do, with "the brewing process and craft brew industry while homebrewing in college." He likes adjuncts, even adding fresh blueberries to the very first batch he brewed in college. Every homebrew he shared with friends and family pushed him closer to opening a brewery. His fiancée convinced him to do it while the craft beer craze was hot, and Middleton Brewing in Everett opened in February 2013. He brews on a one-barrel brewing system, and future plans include bottling. He produced seventy barrels in 2014.

Like Emerald City Brewing, Machine House Brewery hoped to capture some of the lost allure of the great Seattle Brewing & Malting Company by

opening in the former machine shop of the brewery. Founded by Bill Arnott and Alex Brenner in Seattle in 2011, they opened their doors on March 9, 2013. Arnott was head brewer at Tipple's Brewery in Norfolk, England, before moving to the United States in 2010 and brews authentic English-style beer. They purchased their 7-barrel system from Two Beers Brewing Company and use two open-top fermenters and then transfer directly into casks or kegs for finishing. They imported three beer engines to hand-pump the beer into imperial pint glasses. They produced 321 barrels in 2014.

Max Scudder was going through a rough time in life and began homebrewing with friends. Beerded Brothers Brewery was started with his stepbrother, Gabriel Pederson, in 2013 in Vancouver. The brewery is located in a shop in their parents' yard, and Max also carves their tap handles. They produced 16 barrels in 2014.

Haley Woods and David Keller combined their love of bicycles and beer, as well as a desire to own a business, when they started Peddler Brewing Company in the growing Ballard neighborhood of Seattle in 2012. They ran a successful Kickstarter campaign to help fund some minor, but important, items and opened their doors on March 8, 2013. The brewery has a bike work station with stand, tools and a pump for public use, as well as indoor bicycle parking. Dave's younger brother, Mike Keller, joined the brewery in July 2014 to help with sales and distribution, including keg and bottle deliveries by bicycle. In May 2015, they opened a large beer garden at the rear of their brewery, and they produced 398 barrels in 2014.

Standard Brewing Company was opened in the Central District of Seattle in March 2013 by Justin Gerardy, a homebrewer who wanted to "get his brews into the neighborhood." The 1-barrel nanobrewery was in 1,100 square feet of space, including the tasting room. That grew to 2,000 square feet, four additional fermenters and more equipment, maxing the space. "We're squeezing every last drop of beer out of our space, constantly struggling to maintain our twelve taps," Gerardy said in 2015. He was able to stay in his location by leasing the business closing next door and adding a 7-barrel brewhouse, as well as food, a yeast lab and barrel aging project. The expansion was expected to be complete by early 2016. Standard produced 173 barrels in 2014.

Decorated homebrewer Janet Spindler had wanted to start a brewery for twenty years. "I remember my first good beer. It was Bert Grant's Scottish Ale. That was the first thing I wanted to do as a homebrewer—something like Bert Grant's." She originally planned to open a nanobrewery on Spinnaker Bay, but it fell through. On April 25, 2013, Spindler and partner Elissa Pryor

Working in a brewery is a rather labor-intensive job. This photo of lead brewer Jack Phillips of Spinnaker Bay Brewing in Seattle hard at work. *Spinnaker Bay Brewing.*

opened Spinnaker Bay Brewing in Seattle, in the former Lucky's furniture store, which may have served as something other than a furniture store. Spindler brewed on a 4-barrel system. At the time they opened, they were Washington State's only 100 percent woman-owned and operated brewery. In February 2014, they hired Janelle Pritchard as head brewer. She started at Pike Brewing Company and also worked at Lunar Brewing Company, Snoqualmie Falls Brewing and Northwest Brewing Company. The brewery produced 270 barrels in 2014.

The great-grandparents of Patrick Smith, Meghann Quinn and Kevin Smith first planted hops in the Yakima Valley in 1932, the year before Prohibition ended. In April 2013, Bale Breaker Brewing opened its doors in Field 41 of the farm in Yakima, surrounded on three sides by a field of Cascade hops. Started by Kevin and Meghann Quinn and her brother, Kevin Smith, they have a 30-barrel brewery. They produced 7,781 barrels in 2014, and in September 2015, they announced that they were adding a 16,200-square-foot addition for increased storage, larger fermenters and a faster canning line.

Terah Brice decided that she "wanted a hobby" she didn't have to go out for. She had been homebrewing and had office management experience working at Double Mountain Brewery. "It was there that I fell in love with the ambiance of brew pub life and truly started learning about 'craft' brewing." As a stay-at-home mom, she started Barnstormer Brewing in a converted barn on her property in Carson in May 2013. She produced ten barrels in 2014, but in October 2015, she announced that her property was for sale and that she was shutting down the brewery but would continue to homebrew.

Rooftop Brewing Company was started by Craig Christian; his wife, Jessica Cohen; Parker and Angela Wittman; and Tyson Carlson. Craig

and Tyson had both homebrewed separately with Parker until he brought them together. Their one-barrel, "charmingly rough-around-the-edges alley garage brewery and tasting room" opened in the Queen Anne neighborhood of Seattle in June 2013. Business was good, but they needed a bigger location and a rooftop. In September 2014, they closed in order to find new location, which they did, blocks from their start. They reopened in August 2015 with a rooftop beer garden and fifteen-barrel brewing system, as well as an additional brewer, Kyle Feldman.

Steve Ewan homebrewed for about fifteen years; about five years into it, he decided that he wanted to go pro. "I told everybody I was going to start a microbrewery, and they'd go, 'Oh, yeah, sure.'" He purchased Hale's Ales original twelve-barrel electric brew kettle used in Colville from Northern Lights Brewing Company. In the fall of 2012, Ewan started Hopped Up Brewing in Spokane Valley. They opened in June 2013 in a former International House of Pancakes (IHOP) building. Ewan, also a fan of hot rods and hoppy beers, said that they all lend themselves to the brewery name. It produced about three hundred barrels of beer in 2014.

In March 2012, Narrows Brewing Company was formed by Scott Wagner, Gordon Rush, Matt Smith, Thair Jorgenson and Chris Dewald in Tacoma. A few of them had homebrewed, but "we just sort of got the idea to open a brewery and we got together and decided on a name and a location and jumped in," Wagner said. They hired Joe Walts from Madison, Wisconsin, to be their head brewer. He brought a non-Northwest perspective to his brewing, tweaking some recipes for the Northwest hoppy crowd, and they opened on July 12, 2013. Located right at Narrows Marina, boaters can dock and visit the brewery. They produced 1,374 barrels in 2014.

Hopping Frog Brewery was founded in February 2013 in Newport by friends Casey Brooks, Mike Brown, Scott Hilton, Pat Buckley and Marty Robinson, who had been homebrewing for at least a decade together. The brewery was located on head brewer Brooks's property, which was nicknamed "Hopping Frog Farms" by his kids after pulling the lid off the hot tub one night revealed dozens of little frogs. A few of the founders had been brewing Solar Flare IPA for twenty years, which became Solar Frog IPA. They had a 7-barrel brewhouse, and their grand opening was held in mid-July 2013. In February 2014, the business was renamed Top Frog Brewery because there was another brewery in Ohio with the same name. They produced 60 barrels in 2014.

Mt. Pilchuck Brewing Company was started in Snohomish by Jesse Podoll and Tyler Hale. They were licensed in August 2013, brewing on a two-

barrel brewing system. It is Snohomish's first production only brewery and produced fifty-five barrels in 2014.

John Carothers and Ryan McGee first met at a Beer Judge Certification Program (BJCP) class. Then, in 2009, they bumped into each other again. They were both members of the Mt. Si Brewing Society homebrew club in Snoqualmie, and after talking, they both wanted to start a brewery. Joe Rovito worked with Carothers (all three worked for Microsoft) and joined the team. Cathy Carothers, John's wife, joined, and Hi-Fi Brewing was born in October 2012, with construction beginning in March 2013. Located near Black Raven Brewing, when the Black Raven crew saw their brewing equipment drive by, "they filled up a bunch of growlers and went down to help unload it and propose a toast." Hi-Fi hired former Harmon Brewing Company brewer Mike Davis as its head brewer and opened in Redmond in August 2013. It produced 503 barrels in 2014.

Cousins Jarrett and Erik Skreen were both homebrewers, Erik for about fifteen years and Jarrett for five. They decided to open a brewery in their hometown of Longview after a morning homebrew session, and Ashtown Brewing Company opened in September 2013. It started with a used six-barrel system but currently runs on a ten-barrel system and produced about three hundred barrels in 2014. With business doing well, it is looking to upgrade to a twenty-barrel brewhouse.

Old Rock Brewery was opened in September 2013 in Duvall by Ray and Christine Pitts. They run a nanobrewery near the banks of the Snoqualmie River and produced sixteen barrels in 2014.

River Time Brewing was started in Darrington by Lon Tierney and Troy Bullock on September 13, 2013. They found that business slowed a lot in the winter, so instead of shutting down, they closed the taproom down in November 2014 and upgraded to a 3-barrel system. On July 5, 2015, they opened a new brewery and taproom in the historic old city hall in Darrington but kept the original taproom. They produced 891 barrels in 2014.

Burdick Brewery was started with a one-barrel system in Seattle by Max Leinbach. He opened in October 2013, and "we brewed a few great beers, some average beers, and a few where the recipes hit the trash can very quickly." By July 2014, it had shut down to install a new seven-barrel brewhouse and reopened in August, brewing twenty-three barrels in 2014.

Jeremy Hubbell is a native of New Orleans, Louisiana. He started brewing in the garage at his business, H-Squared LLC, in 2011 after realizing that the Friday beer parties for his employees were getting expensive. It took several subpar batches to get him serious about homebrewing. Being an

entrepreneur, he thought that other newbies like him might be facing the same problems he was. So he started Geaux Brewing in Bellevue as a brewery but also a place where homebrewers could "get hands-on information about brewing." He opened on October 19, 2013, and produced 117 barrels in 2014.

According to a dictionary, a stoup is a drinking cup, cask or tankard. Stoup Brewing in the Ballard neighborhood of Seattle was opened by chemist Brad Benson; his wife, English major Lara Zahaba; and Washington's first female Cicerone, Robyn Schumacher, in late October 2013. Benson had more than twenty years' brewing experience, working for breweries on the East Coast. Zahaba had been in the wine industry, and Benson is head brewer, but Schumacher assists on their 15-barrel brewhouse. On May 9, 2015, they opened a long-anticipated beer garden. They produced 1,562 barrels in 2014.

William Reichlen has been homebrewing since 1992, after returning from his stint with the marines. "I had a tendency to bring my beer everywhere I went and let people try it," Reichlen said. In August 2013, he started Colockum Craft Brewing in Kittitas while in his final year of a chemistry education and beer trade program at Central Washington University. He won a business plan contest and started with a half-barrel brewing system. By November 2013, he had already upgraded to a one-and-a-half-barrel system, and in 2014, he produced forty-two barrels of beer.

Grant Merrill and Phil Chou met in grad school in Minnesota. They were in the chemistry program and went on different career paths after graduation. Chou eventually became a "beer and wine chemist," including a stint at Miller Brewing Company. In about 2011, they both realized they were tired of large organizations and opened Dirty Hands Brewing Company in Vancouver in early November 2013 in a space that had been the *Columbian* newspaper building, hence the name Dirty Hands. It has a 3.5-barrel brewhouse located on two floors of the building and produced 143 barrels of beer in 2014.

Jeff Barnett worked with Skip Madsen at American Brewing Company for several years before he opened Salish Sea Brewing in Edmonds with his wife, Erika, in November 2013. The small location was cozy, but on brewing days, "it's Tetris when we put everything away." By 2015, they were brewing about six hundred barrels per year with brewer Michael Green and leased the space next door, doubling the size of their taproom in May 2015.

Chris and Maria Tiffany started Bog Water Brewing Company in their Cranberry Road Winery in Westport in January 2012 and opened in late

2013. After their head brewer left and took some of the equipment, former homebrewer Jon Bennett was left with a one-barrel system when he began working part time. In May 2015, he became head brewer of the new ten-barrel system. It produced twenty-six barrels of beer in 2014.

Michael Noble started Waddell's Neighborhood Pub & Grille in Spokane and was featured on the television show *Diners, Drive-Ins and Dives*. In December 2013, it opened a second location in Spokane as Waddell's Brewpub and Grille. Head brewer Bryan Utigard previously worked as a brewer at No-Li Brewhouse. The business is named after baseball legend Rube Waddell (and distant cousin to one of Noble's original partners). It produced 405 barrels in 2014.

Five friends—Greg Gramenz, Jill Kramer, Billy Burdick, Seth Mashni and John Stinson—started Bad Jimmy's Brewing Company in Seattle in 2013 across the street from Hale's Ales. A Kickstarter campaign raised $15,621 in July 2013, but it did not open until late December. Billy and John were both successful homebrewers (Billy for twenty-one years). When transitioning

Five friends started Bad Jimmy's Brewing Company in Seattle in 2013. Two of the owners were successful homebrewers, but not all the recipes translated to the larger system, so they began experimenting, creating new and unique brews. This is the inside of the brewhouse. *Michelle Rizzo.*

some recipes to the larger brewery system, they didn't translate, so he started experimenting, creating some new and unique brews. The brewery is named after Billy's former beer gut, which they affectionately called "Bad Jimmy." The brewery produced 265 barrels in 2014.

West Seattle Brewing Company was started in Seattle by Drew Locke, Kevin Fawcett and consultant Charles McElevey in January 2012. Delays kept the nanobrewery's opening until December 2013. "I've been a brewer for twenty-two years," said Fawcett, "but never commercially like this, always a homebrewer, and I know a lot of people in the industry." Things changed, and Locke bought out Fawcett and brought in new partners. He closed the brewery in late 2014 to do a major remodel, including espresso and food, and upgraded to a seven-barrel brewhouse, reopening in May 2015.

2014

The year 2014 was one of the most prolific in terms of new breweries opening and several closing. More breweries opened in Washington during the year than probably any other state. Seattle continued to lead the country in number of breweries.

Chris Smith isn't interested in being the next big thing or winning medals. He isn't necessarily interested in distributing outside Washington. He brews beers that people like, and that's okay with him. He started brewing beer in his basement and seeing what friends thought. That's when he decided to open a brewery. He originally planned a 1-barrel system, "but we couldn't make the numbers work with regards to real estate costs." When Lowercase Brewing opened on January 17, 2014, in Seattle, it had a direct-fire 3-barrel brewhouse. It is located next to Burdick Brewery and shares a roll-up door. It produced 127 barrels in 2014.

Vaughn Bay Craft Brewery is a nanobrewery started in January 2014 in Vaughn by Tim Masbruch, but it may not have gotten off the ground.

Eric Brandjes had been a homebrewer for twenty years when he opened the first brewery in Enumclaw in February 2014. Cole Street Brewery had a 2-barrel direct-fired brewhouse. With a view of Mount Rainier from its patio, it produced 136 barrels in 2014.

In the 1980s, Eric Rough spent time in Germany. After returning home to California, he wanted to start a German brewery but went into the IT field. After getting laid off, he and his wife, Lisa, started Tin Dog Brewing in January 2013 in Seattle. They opened their doors on February 15, 2014,

and both brew Belgian-style beers in a two-barrel brewery. Lisa likes to experiment with her brews, and they produced forty-eight barrels in 2014.

As their employment situation was changing, Shawn and Deb Carney decided to open Zythum Brewing Company in February 2014 in Fairfield. They use spent grains in a line of snack foods as well as grind the grains into flour for bread and pastries. They have an on-site greenhouse that utilizes the carbon dioxide and wash water produced in the brewing process to grow herbs and greens for use in their restaurant. They produced 25 barrels in 2014.

David Kilgour was born in Maine. He spent eight years working at White Birch Brewing and Atlantic Brewing Company before moving to Lake Placid, New York, to another brewery. He met a woman who took a job in Washington and ended up in Roslyn, where he worked at Roslyn Brewing Company. After two and a half years, he started Wild Earth Brewing Company in Roslyn in February 2014 and served his first Belgian-style ales in April. He brewed small batches for the taproom with limited distribution but couldn't make enough. He said that his "facility was not big enough to grow into" and closed in December 2014, planning a larger production facility. He permanently closed in October 2015.

English Setter Brewing was started by longtime homebrewer Jeff Bendio in Spokane Valley on February 1, 2014. Jeff said, "This is basically a hobby that got out of control!" Brewing beer that his friends and family liked kept his driveway filled and him running out of beer. Although both own businesses, he and his wife decided to open a brewery and taproom. Brewing on a one-barrel system, they added a three-barrel system, brewing more than two hundred barrels in 2014.

Whitewall Brewing Company was opened on March 1, 2014, in Marysville by Sean and Laurel Wallner and Aaron and Lori Wight. They were Marysville's first craft brewery, with ten beers on tap and a taproom. They started on a two-barrel system and within a year upgraded to a seven-barrel system. They produced about two hundred barrels in 2014.

Josh Blue started homebrewing in 2011, and although "the first beer was awful," he was "determined to get it right." After three years, he asked friend and co-worker Quinn Chalk if he wanted to open a brewery. Hop Crew Brewing started in Sequim, and it delivered its first keg of beer on February 27, 2014. It has no taproom.

Ben Lukes started brewing in his college dorm room. He worked at Big Sky Brewing Company in Missoula, Montana, for six years. Lukes and his wife, Christy, founded Perry Street Brewing Company in 2012 in Spokane.

"Once we found the neighborhood, it felt like Missoula," Ben said. "I met Christy in Portland and…and the Perry district is the closest thing I've found to that in Spokane." It opened its doors on March 13, 2014, with a 7-barrel system and produced about 3,400 barrels in 2014.

Sherman Gore, Jason Bos, Tyson Corsen and Richard Tiffany had more than twenty years of brewing experience between them when they started brewing together in 2013 and formed Brothers Cascadia Brewing in Battle Ground. Northwood Public House and Brewery in Battle Ground was founded by Eric and Paula Starr in 2014 in the former Laurelwood Public House & Brewery. To get the Little Dipper Brewing Company started, they hired brewery consultant (and now owner of Culmination Brewing in Portland, Oregon) Tomas Sluiter. Among their employees they found the founders of Brothers Cascadia Brewing, who became the brewers for Northwood.

Top Rung Brewing Company was started by Casey Sobol and Jason Stoltz (both are full-time firefighters). "It's a hobby that exploded," said Stoltz. Before starting, they shared their business plan with others and found eight

The author (left) and Whitewall Brewing Company owners Aaron Wight and Sean Wallner discussing how they started the brewery and their goals as brewers. Within a year of opening, they had to upgrade from a two-barrel system to a seven-barrel system to keep up with demand. *Michelle Rizzo.*

investors. They opened in Lacey in April 2014. Stoltz mans their ten-barrel brewhouse, which produced three hundred barrels in 2014 and expects to double that amount in 2015.

Eric Knudson was a mega beer drinker before tasting a friend's homebrewed beer. "It was very fresh, and I was amazed at the flavor," he said. So, he started homebrewing. "Once I got into it, it was actually shocking how easy it was to brew a batch." A police detective by day, he started Nosdunk Brewing Company in Walla Walla in September 2012 but did not release his first beers until early 2014. He produced seventeen barrels in 2014. Nosdunk is Knudson spelled backward.

Erik Svendsen started homebrewing while in college. He was only twenty and couldn't buy beer, but he could buy the ingredients to make it. Svendsen was an accountant by trade, and when a restaurant in town purchased a 1.5-barrel system but had no one who knew how to brew, it asked Svendsen. He eventually took over full time until the owners decided that they didn't want to run a brewery. At the end of 2013, Erik and his wife, Michelle, bought the brewing equipment, formed North Jetty Brewing and opened a taproom in Seaview in April 2014. They produced about 165 barrels in 2014, but demand grew faster than they anticipated. In April 2015, they installed a new 10-barrel system, projected to produce 750 barrels in 2015.

In the summer of 2012, Frank Trosset, Pat Haynes and Jack Lamb decided that they wanted to try their hand at brewing. They built a pilot brewery in downtown Bellingham and began the "research to develop the knowledge and skills needed to start our own commercial microbrewery and restaurant." Aslan Brewing Company was started with a commitment to "organic ingredients, locally sourced goods and low-impact practices." They brewed more than 130 pilot batches looking for the styles they wanted. In late summer 2013, they began construction, done primarily by the founders and Boe and Don Trosset. Don later became one of the owners. The brewery opened in May 2014, and in October, a reporter from the *Bellingham Herald* tore the young brewery apart, giving some of their beers "F" grades and a "work in progress." It produced 842 barrels in 2014. Everything worked out because in July 2015 it had announced that it had maxed capacity and was expanding to a 45-barrel system.

While living in San Francisco, California, husband-and-wife team Chad and Colleen Kuehl discovered craft beer and started homebrewing. They spent time overseas and began writing a business plan for a brewery. When they settled in Seattle, Chad went to brewing school and worked at

Hilliard's Beer, where he learned how to start a brewery from Ryan Hilliard. The couple then opened Wander Brewing in Bellingham on May 2, 2014, with a twenty-barrel brewhouse. Less than a year later, they doubled their brewing capacity. "We've been very happy, and we feel very fortunate that we've had such an amazing first year. This has kind of always been in our plan," said Colleen.

Andy Lea started in the beer business working for Pyramid Breweries Inc. when it was located in Kalama. Over a ten-year period, he worked his way up to brewer. When the brewery expanded and moved to Seattle, Andy didn't. Steve Sharp was homebrewing for more than five years when a group of twelve "mostly retired, successful business people" started "talking about starting a local brewery in the Cathlamet Marina." They finally sat down and opened Drop Anchor Brewery in Cathlamet on May 3, 2014, producing 250 barrels of beer in 2014. In early 2015, the brewery caught the attention of Anchor Brewing Company in San Francisco, California, which sent a cease-and-desist letter for using the word *Anchor* in its name. Instead of fighting the bigger brewery, it was renamed River Mile 38 Brewing Company in time for its first anniversary.

Kyle Stevens started homebrewing in 2010. As a musician and performer with nerd-rock band Kirby Krackle, he has traveled the country, tasting many craft beers. When he decided that he was ready to start a brewery, he wanted to open in Shoreline, north of Seattle. Although a location wasn't locked down right away, he opened Charging Hippo Brewing Company in May 2014, brewing on the equipment at Justice Brewing in Everett. It is still an active brewery, without a location to brew, but it hopes to be back in production in 2016.

Jeremy and Tara Eubanks met in high school and went to different colleges in Washington, and when he was hired at Microsoft, they moved to Seattle. There he became interested in brewing beer and poured many batches out the first five years. While in grad school, he wrote business plans for starting a brewery. In May 2012, they decided to start a brewery. "It was a 'if I don't do it now, I probably won't do it' mentality," he said. Without any investors or other financial help, nanobrewery Flycaster Brewing Company opened in Kirkland in mid-May 2014 to capacity crowds in its taproom. It produced eighty barrels in 2014.

"We used to call each other by Spanish don names when we were out carousing and thought it might make a good name," Bill Heston said, referring to Five Dons Brewing, he owns with homebrewing friends Art Stiltner, Mike Busley, Tom Hayes and Sean Heiner. With Stiltner as brewer,

Five Dons opened in Longview in early June 2014. It signed a lease in 2011, and it took three years and some miscommunication to get the brewery off the ground. It produced forty barrels in 2014.

Triple R Brewery LLC opened in the Wallingford neighborhood of Seattle in June 2014. Started by homebrewers Rick Larsen, Richard Rahn and Roy Starin, they operated a nanobrewery in Larsen's garage and produced five barrels in 2014.

SnoTown Brewery was opened in Snohomish in 2014 by Frank Sandoval. It was production only, and in early August 2015, he and co-owner Keri Jensen opened a new brewery and taproom. He purchased the two-barrel brewing system from Whitewall Brewing Company.

Brewbakers Brewery in Lake Stevens was started by Bob and Eleanor Brubaker in 2011. They opened their brewery in June 2014. They have a small taproom, producing sixteen barrels of beer in 2014.

David and Jennifer Marshall met when they both worked for Pyramid Breweries Inc. in Seattle. David had worked in the wine industry and became head brewer at Pyramid and then manager of quality, process and development. Jennifer worked in office administration and marketing for Pyramid. As homebrewers for twenty years, they started Burwood Brewing Company in Walla Walla by hosting weekly pint nights where they offered one hundred pints of whatever beer they brought, always selling out. They were able to upgrade from their one-keg pilot system to a 5-barrel system. Their grand opening was June 21, 2014, and they produced about 250 barrels in 2014.

Mt. Index Distillery was started in Index by Charles Tucker, Anthony Gross and Lorraine Obar. In 2014, they added a brewery and became Mt. Index Brewery and Distillery. The brewery opened on July 18, 2014.

Four friends—Craig Martinson, Glenn Adams, Lee Martin and Vance Hanbidge—started homebrewing in Martinson's garage. Eventually, demand outstripped supply, and they upgraded to a one-barrel system. That led them to start Lake Tapps Brewing Company in Sumner in late August 2014. Martinson is head brewer at the brewery and taproom. It is located in the former Riverside Tavern, which is slated to be in the path of a street after a bridge replacement, potentially forcing it to move the brewery. It produced sixty-nine barrels in 2014.

By 2013, Fremont Brewing Company was the seventh-largest brewery in Washington, producing 12,400 barrels of beer. By August 2014, it had announced plans to open a production brewery in Seattle a block from Redhook Ale Brewery's original brewery. Installation of an 80-barrel

brewhouse, with the capability to brew 250,000 barrels per year, would make it the largest craft brewery in Washington. "It sounds like a lot right now," said founder Matt Lincecum. "But is that a lot if we [craft brewers] continue to gain market share? Maybe 250,000 barrels isn't a lot in ten years." The new multimillion-dollar expansion is expected to start production the winter of 2015–16.

The Pacific Brewing & Malting Company in Tacoma was reopened by Steve Navarro and Brent Hall in September 2014. Navarro is head brewer, and the brewery makes plenty of comparisons to its predecessor. Photos of the original brewery adorn the walls, and a social media campaign about it drew thousands online. "Our one-hundred-year-old history sparked more interest than we could ever imagine," Navarro said. In early 2015, it doubled capacity and hired a dedicated sales manager, Andy Kenser, who had worked at Pike Brewing Company, Harmon Brewing Company and the Ram Restaurant and Brewery. It produced 118 barrels in 2014.

Dan Sowers was homebrewing for about five years and decided in 2013 that he wanted to open a brewery. "A friend of mine once said I should run my brewery under the table and be an 'outlaw.'" One barrel Outlaw Ales opened in his Bonney Lake garage in September 2014. He produced one barrel in 2014. In 2015, he moved to Edgewood and reopened in his garage.

Firefighter Rob Horn of Olympia has sixteen years of brewing experience and a degree in brewing technology from the Siebel Institute of Technology. He had wanted to start a brewery for at least ten years, and for the last five, he brewed award-winning beer. In mid-September 2014, he opened one-barrel Triceratops Brewing Company in Olympia out of his garage. He can't do growler or tasting fills, but by January 2015, he was looking to expand to a ten-barrel system and move out of the garage. The expansion should take place in 2016. He produced 15 barrels in 2014.

Cole Rinehardt had homebrewed for about twenty years when his wife, Sarah, finally said that she wanted a return on his expensive hobby. "My beer had gone from good to great. When people would come over and try the beer, many asked if they could buy some, but I had to tell them no," he said. So, in 2013, they decided to start In the Shadow Brewing at their home in Arlington. He built a shed in his yard, sold his Mach III Mustang and opened the three-person capacity brewery in September 2014. He brews in a two-barrel brewhouse, producing seven barrels in 2014.

Flying Lion Brewing opened in Seattle on October 22, 2014, and is run by Griffin Williams. His parents were chemists, and his father homebrewed

for as long he can remember. Griffin and his two brothers had an annual Christmas stout–making contest that he won every year. When his elder brother asked if he'd be willing to run a family brewery, he jumped at the opportunity, and his brothers provided support long distance. Griffin uses everything from "pecans to birchwood and spruce tips to molasses" in his beer recipes. Two months after opening, he was already pushing capacity and produced sixty-three barrels in 2014.

Dan Williams is an electrician by trade but loved to homebrew, experimenting with different flavors and herbs. After he had major shoulder surgery, he started brewing more often. "I couldn't do anything else," he said. "So I started brewing every day." Thoughts of returning to fuse boxes left his mind as he and wife, Kristen, started Downpour Brewing in Kingston. They opened on October 25, 2014, and have a three-barrel brewing system. They produced thirty-five barrels in 2014.

Wally Wakeman worked for a company that asked him to move to California to keep his job. He decided that he wanted to stay near his family in Vancouver. He had been a homebrewer for several years and tried to find a brewing job in Washington or Portland, Oregon, but "nobody had room for an old guy with only homebrewing experience." So he started Brother Ass Brewing with his wife, Liz, and built a three-barrel brewhouse. They opened in October 2014, and he likes to experiment with one-off batches, producing six barrels in 2014.

In 2010, Kevin Bushnell purchased a homebrewing kit while living in Colorado. He never used it until he landed in Seattle. In the fall of 2012, he and good friend Dwight Farrington "got to talking about homebrewing. Dwight had done a ton of brewing back in the day and nearly went pro." After one brew session, Bushnell was hooked and within days was building a homebrewery. He became committed to "creating an all electric homebrewing system." After completing the 3-barrel system, he convinced his son, Kempton, to move to Seattle. They brewed two to three times a week, supplying their neighbors with beer, and opened the doors to Bushnell Craft Brewing in Redmond on November 6, 2014. They hired Jamie Richard as "brew master and alchemist" and produced 151 barrels in 2014.

Odd Otter Brewing has a strong military tie, as three of the five owners (John Hotchkiss, Owen McGrane and Pablo Monroy) are current or previous military personnel and two (John and Owen) are army physicians. The other two owners, Derrick Monroy (married to Pablo) and Teresa Smith, have managerial experience. Pablo was a homebrewer who "replicated nearly perfectly a beer that cannot be purchased in the United States." Owen

was also a longtime award-winning homebrewer. They opened in late November 2014 in Tacoma. They ran a successful Kickstarter campaign in March 2014 and raised $19,396 toward completion of the self-financed brewery. It is located in a former "Sailors and Soldiers club during World War I, and later a USO that accepted African-Americans during World War II." It has a seven-barrel electric brewing system and produced forty-two barrels in 2014.

Nathan and Sara Reilly owned a successful café in downtown Olympia but wanted to open a brewpub. They formed Three Magnets Brewing Company in 2014. The fifteen-barrel brewhouse was manned by Patrick Jansen and Jeff Stokes. The opening was delayed some months, until November 2014. A few months after opening, in February 2015, a piece of artwork was loaned to the brewery to adorn its walls. It is believed to have been commissioned by the Olympia Brewing Company in the early 1900s. It is a five-panel stained glass with "images of Mount Rainier, Tumwater Falls, the Olympia Brewing Company horseshoe logo, forests and a sun setting in Puget Sound." It was above the back bar at Merchants Café and Saloon in Pioneer Square in Seattle for many years before being returned to the brewery after falling into disrepair. When Olympia Brewing Company closed, the artwork was donated to artist Bill Hillman since the Olympia Tumwater Foundation felt it was too expensive to repair. He repaired it and loaned it to the owners of Three Magnets Brewing for as long as they want to display it. Three Magnets produced 279 barrels in 2014.

The former Olympia Brewing Company plant in Tumwater was sold in late November 2014. SAB Miller released the deed restriction in 2013.

John and Stacey Sype got their start in homebrewing just a little different. A dental instructor gave them all of his brewing equipment. After they moved to the Pacific Northwest in 2007, they upgraded the brewing system, and in 2011, they decided to open a brewery. John (who is a physician) met Grady Warnock, a fellow homebrewer and University of Washington grad. They hired Grady as head brewer and sent him to the Siebel Institute of Technology in Chicago to hone his brewing skills. When he returned, he helped with construction and perfected his recipes. In December 2014, they opened Sound to Summit Brewing Company in Snohomish and produced thirty-seven barrels in 2014.

There was no epiphany when Dru Ernst decided to start a brewery. "It's more of a decade of experiences that built up to where we are now." With business partner Eric Mathiasen, Dru started brewing in his kitchen and then moved to his backyard. He brews primarily German-style beers. Lee

Yanik; Steve Baumgart; Craig Pessolano; Dru; his wife, Sara Giuffrida; and Mathiasen started Dru Bru in Dru's garage in Seattle in 2012. In December 2014, they officially opened a brewery in Snoqualmie Pass with a fifteen-barrel steam-fired brewhouse. They expected to brew more than seven hundred barrels in 2015.

Tom Schmidlin was head brewer at Bluebird Microcreamery & Brewery since 2012 when he announced in March 2014 that he was leaving to start his own brewery. The name Postdoc Brewing "started off a few years ago as a running joke, but when we thought about what to name the actual brewery we couldn't come up with anything better." The brewery was founded by Schmidlin; his wife, Julie Lindemann; and friends Jonny and Debbie Chambers. They opened a fifteen-barrel brewing system in Redmond in December 2014 but did not have their grand opening until February 27, 2015.

In late 2014, Kulshan Brewing Company in Bellingham announced that it was building a 30-barrel brewhouse capable of 15,000 barrels per year, nicknamed K2. Founder David Vitt hoped to get back to brewing. "It's something I miss," he said. K2 opened in May 2015, and "it will help us to keep up with local demand." K2 will produce its flagship beers, and the original location will produce experimental, seasonal and specialty brews. In 2014, it produced about 3,100 barrels of beer and expected to produce about 6,000 in 2015.

And so the busiest year in Washington beer history was in the books. It could not possibly get any crazier than that year, could it? The craft beer craze had to be winding down by now.

Chapter 11

2015

As 2015 opened, the craft beer craze did not stop. More breweries opened, even in Seattle, where there is no end in sight. But beyond that, several established breweries announced expansions. As the writing of this book winds down, more and more breweries are still opening. At the beginning of the year, at least nine new applications for licenses were in progress, but some will inevitably be missed. Washington's biggest breweries were Redhook Ale Brewery (257,754 barrels in 2014) and Elysian Brewing Company (58,399 barrels in 2014), followed by Georgetown Brewing Company (55,790 barrels in 2014) and Mac & Jack's Brewery (45,602 barrels in 2014). After that, there is a huge drop-off in production, with the next-closest brewery being Fremont Brewing Company, with 18,995 barrels produced in 2014.

But the biggest news to start 2015 occurred on January 23, when Seattle's Elysian Brewing Company announced that it was being bought by beer giant Anheuser-Busch InBev SA. The news astounded tens of thousands of craft beer fans across the country.

Co-founder and head brewer Dick Cantwell, in a statement released by the company, said, "Throughout our journey we've been focused on brewing a portfolio of both classic and groundbreaking beers and supporting innovation and camaraderie in the beer industry. By joining with Anheuser-Busch we'll be able to take the next steps to bring that energy and commitment to a larger audience." It sounded authentic. It is a business, and maybe they were ready to cash out and retire to an island.

But Cantwell was different. He was a proponent of the Brewers Association and the author of several books on brewing, and he helped craft the definition of a craft brewery, something Elysian Brewing Company

would no longer be able to claim. (That definition is "less than 25 percent of the craft brewery is owned or controlled (or equivalent economic interest) by an alcoholic beverage industry member that is not itself a craft brewer.") Not long after, Cantwell said that it was not the outcome for which he had hoped. There were two investors plus the three founders who voted on the sale. He was the lone dissenting vote. "I liked the idea of combining with another brewer," he said, "certainly because you would be working with like-minded people. I guess I don't want to dwell on the might-have-beens because this is where we are. I also don't want to be discourteous with A-B. But I hoped it might have been a different brewery."

There was a lot of discussion about the sale for weeks. But the first sign that there might be a problem occurred on Sunday, February 1, 2015. Anheuser-Busch ran a one-minute Budweiser commercial during the Super Bowl that ran head-on into its purchase of Elysian Brewing Company just two weeks earlier. The commercial declared that beer wasn't supposed to be fussed over but drank. It ended with, "Let them sip their pumpkin peach ale. We'll be brewing us some golden suds." Elysian Brewing brewer Steve Luke had brewed Peach Pumpkin Ale, something that was not lost on Dick Cantwell, founder of the annual Great Pumpkin Beer Festival. "I find it kind of incredible that ABI [Anheuser-Busch InBev SA] would be so tone-deaf as to pretty directly (even if unwittingly) call out one of the breweries they have recently acquired, even as that brewery is dealing with the anger of the beer community in reaction to the sale. It doesn't make our job any easier, and it certainly doesn't make me feel any better about a deal I didn't even want to happen."

Things were relatively quiet for a while. Then, on April 13, 2015, Dick Cantwell announced, "I resigned from Anheuser-Busch. The tenor of the deal, mainly from the point of view of my former partners and me, was such that I can't possibly work with them into a future of any duration. My concerns were never even considered as a factor of whether we should or shouldn't. From the start it was me against everyone else, with no regrets expressed." He wasn't even talking to his former partners. A few days later, Cantwell was scheduled to be on a panel at the Craft Brewers Conference in Portland, Oregon, with Elysian Brewing Company co-founder Joe Bisacca, but he declined to participate. Bisacca, when asked about the pumpkin peach beer commercial, said, "We've taken a lot of snipes at Bud over the years and rightfully so. So they took a snipe at us. Big deal. We're all in the same industry. We do the same thing. It's a sibling rivalry. We have latitude to poke fun at them, and they have latitude to poke fun at us."

Dick Cantwell's last day at the brewery he co-founded was May 13, 2015. He had a non-compete clause, but after the time lapses, who knows what he might craft. He was able to get back into craft beer in July 2015 when the

Brewers Association announced that he was named "quality ambassador," a newly created position, allowing him to travel and teach about brewing quality control.

Two Harps Brewing was a small pico-brewery that was started by a father-and-son team in Kennewick. Over the years, it evolved into a craft brewery owned by Brian and Sue Harp. The part-time business was capable of producing no more than five hundred barrels a year on a homemade one-and-three-quarter-barrel system. It was not big enough to keep up with demand, so it closed in early 2015.

O-Town Brewing in Olympia is a joint effort of S&M Brewing (Matt Smith and Neil Meyer) and Bryan Trunnell, formerly of Kastellan Brauerei. This partnership was formed on January 1, 2015. Each brewer kept their best styles to form a unique mix of Northwest- and European-influenced beers.

Laurie and Doug Robinson started Berchman's Brewing Company LLC in Yakima in October 2014. Doug's deceased father, Berchman (also Doug's first name), is the face of the company. Doug built a small two-barrel brewhouse on his property, and the Robinsons, both farm raised, "hold a strong interest in crafting beers that showcase the Yakima Valley's assets." Their nanobrewery became fully operational in January 2015.

Holy Mountain Brewing in Seattle was started by three friends and homebrewers—Adam Paysse, Colin Lenfesty and Mike Murphy—in January 2014. Lenfesty is head brewer and had previously worked as a brewer at Schooner EXACT Brewing Company, Bainbridge Island Brewing Company and Big Al Brewing Company. He worked there for about thirteen months before quitting to start Holy Mountain. "We're doing almost everything ourselves, from cutting concrete to digging ditches to plumbing glycol. This is a brewery built by brewers," said Lenfesty. From the start, they concentrated on not having a flagship beer, with plans on producing barrel-aged and sour beers, as well as other unusual beers. "We wanted to avoid the IPA rat race from the start…a big goal of ours is to add an element of diversity to the local scene," said Mike Murphy. They opened their ten-barrel brewhouse and tasting room on January 23, 2015.

Sourcing your ingredients locally is one thing, but growing your own is another. Dan Dvorak and Steve Wells had been homebrewing together for about five years when they opened Black Label Brewing Company in Spokane on January 31, 2015. In 2012, they started growing hops on land Dvorak's father-in-law owned. In 2013, they ran a successful Kickstarter campaign to help fund their energy-efficient nanobrewery. They plan on running all LED lights on solar and wind power. Dvorak became a licensed beekeeper to tend hives for their kolsch honey. Another project in the works is a bike-powered grain mill.

Mike and Lisa Beckman opened 238 Brewing in Mead on their Legacy Farm Christmas tree farm in January 2015. The name comes from the old telephone prefix for Green Bluff. The small one-barrel brewery opened in a two-hundred-square-foot century-old mill house, and its beers all have telephone-themed names. In June 2015, it upgraded to a three-barrel system with plans for an eventual ten-barrel brewhouse and a larger taproom.

In early February 2015, Sound Brewery announced that it was building a new production brewery across the street from its original location, capable of producing ten times as much beer using a mash-filtration brewing system not typically found at small breweries. "We're the first ones in Washington State to use this," founder Mark Hood said. "It's a fairly old technique for giant breweries, but it's brand new, like two years old, for small breweries. This thing uses way less water, way less power and it gets 98 percent extract out of the malt." It also started looking for a second taproom location in the Seattle area.

Frank Lawrence and Jeff Howell met while working at Caffe Ladro in Seattle. They both found they liked beer, and in the early 2000s, they began to homebrew together. After talking about starting a brewery, they finally started planning in mid-2013 and "realized it was the perfect counterbalance to their coffee careers." Their brewery, Counterbalance Brewing Company, opened on February 4, 2015, in Seattle. They have a ten-barrel brewhouse, with Frank as head brewer.

Randy Schroeder and Brian Thiel originally planned to open an Irish pub, but when Randy received a homebrew kit one Christmas, they began brewing together and decided to open a brewpub. After attending the Great American Beer Festival, Brian realized that he could not find a good gluten-free beer for his wife, so he and Randy saw that as an opportunity. Their eventual partner Jason "Ig Jones" Yerger in California had been gluten-free and began brewing his own, as well as blogging about his experience. By chance, Brian saw a post that Yerger made and contacted him, and the three met in Seattle. Yerger was brewing beer, and Brian and Randy had a business plan and name for the brewery. They opened Ghostfish Brewing Company in Seattle on February 5, 2015, and it is the only brewery in Washington serving only gluten-free beers.

After spending twenty years as a homebrewer, James Stoccardo went to University of California–Davis to expand his brewing knowledge. When his brother introduced his friend Renato Martins to his brother's beer, the two got together a week later and started planning a brewery. Stoccardo was brewmaster in Outer Planet Craft Brewing in Seattle. They started brewing in December 2014 and found the learning curve steep, dumping ten barrels of beer. They found their way, and the three-barrel nanobrewery opened on February 20, 2015.

Cascadia Homebrew opened in March 2015 in Olympia. Founded by homebrewer Chris Emerson, his brewery is not the typical one. It is first a homebrew supply store and also a brew-on-premises store, but it is also where he sells his own beer on tap. There are two other locations where you can brew your own beer in Washington: Gallagher's Where-U-Brew in Edmonds and Station U-Brew in Puyallup.

In March 2015, Laura and Casey Rudd announced that they were selling Old Schoolhouse Brewery in Winthrop. They were searching for a knowledgeable buyer who could take it to the next level. Profit was up 40 percent at the beginning of 2015, and they were producing one thousand barrels per year. They are at capacity and "feel like we're holding it back," Casey said.

Downtown Yakima saw the opening of a new brewery in April 2015 when Hop Nation Brewing Company opened. Founded by brewmaster Ben Grossman, he has worked for Coors Brewing Company, Chateau Ste. Michelle Winery, Bert Grant's Pub and Lagunitas Brewing Company. He runs a ten-barrel brew system and hop research lab.

Chainline Brewing in Kirkland is the brainchild of Scott and Michelle Holm. In June 2014, they announced that they had a location and began construction. In November 2014, they started a Kickstarter campaign to fund building a deck that would face the trail. It was funded, and in April 2015, they opened their doors. Another interesting aspect to Chainline Brewing is that it purchased its used Czech-style brewing system from Japan, where it had been used as a decoration.

In early 2015, American Brewing Company founding brewer Skip Madsen left, and Adam Frantz stepped in. Frantz had been production brewer at Mac & Jack's Brewery for three years. With a degree in biology, Frantz plans to start a sour program, increase its barrel program and experiment with different elements, such as spruce tips instead of hops. The company also acquired Búcha, a brand of certified organic sparkling kombucha drinks, in April.

Jim Weisweaver and Karen Larsen took a different path to opening a brewery. They were both mega beer drinkers until they tried the homebrew of Mike Floyd, a member of Greater Everett Brewer's League. "Mike's stuff…was incredible." Weisweaver learned how to homebrew and, with Larsen, joined the homebrew club. When Larsen had a business project for college, she chose a brewery, and that gave them further incentive. In 2010, they started the permitting process, and in April 2015, they opened At Large Brewing in their Marysville garage. They have six beers on tap and limited hours to keep their neighbors happy.

Mark Ihrig started Boxing Cat Brewery in Monroe in 2001, closing after a short time. He took a second shot at brewing when he opened Sumerian Brewing Company in Woodinville in April 2015. Founded with his wife,

Holly, they recruited Tyson Schiffner as brewmaster. His experience included stints at Redhook Ale Brewery, Chateau Ste. Michelle Winery and Betz Family Winery before joining Sumerian.

No-Li Brewhouse founder Mark Irvin decided to step out of the company picture in April 2015. The company was preparing for a major expansion, and he said, "It's not like I'm burned out on beer altogether, but at the same time, I'm not up to the level of commitment that's going to be required." Production was expected to hit ten thousand barrels in 2015, and Irvin agreed to remain as a consultant for a year. Brewery operations manager Damon Scott took over as head brewer.

Lumberjack Brewing Company was opened on May 2, 2015, on a rural farm in Maple Valley by Jacob and Melissa Earl. Jacob brews on a one-barrel brew system, and their brewery is not easily accessible, so they have limited availability for tastings and keg pickup.

Cash Brewing Company opened on May 2, 2015, in Silverdale. It was started by Tom Cash after his popular sports bar Tommy C's in Port Orchard was forced to move after its leased space was foreclosed. Cash had planned to open a brewery inside Tommy C's, already purchasing the three-barrel system and applying for licenses. Bill Poss is head brewer.

Hemlock State Brewing Company was formed in 2012 by friends Jerret Botch, Mark Dunford and Michael Ernst. Ernst and Botch started as homebrewers in 2010, eventually purchasing a used one-barrel brew system from a shuttered Oregon brewery. They were licensed in 2015 and brew out of Botch's garage, with plans to open a taproom and restaurant.

Blackbeard's Brewing Company opened in Westport on May 25, 2015, just in time for Memorial Day weekend. Founded by Ryan and Katy Montes de Oca, Ryan is the brewmaster. He started homebrewing in college and designed and had his brewing equipment built years before starting the brewery. It features homemade pizza, and by early July 2015, it was already looking to expand.

Hellbent Brewing LLC opened on May 30, 2015, in Seattle. Head brewer Brian Young had experience at Redhook Ale Brewery, Gordon Biersch Brewery Restaurant and Rock Bottom Restaurant & Brewery before starting Hellbent. They have twenty taps in their adult-only tavern. The other owners include Chris Giles, John A. Guinn and Randy Susumu Embernate.

Lucky Envelope Brewing was started by Raymond Kwan and Barry Chan. Chan taught himself how to brew after buying a homebrew kit. After becoming friends, Kwan and Chan discussed "starting a brewery, and he [Kwan] thought maybe we should do a sports pub. The brewery seemed like a good route to go." In September 2013, they started putting together their plan and opened in Seattle on May 7, 2015, to coincide with the start of the seventh annual Seattle Beer Week, which ran from the seventh to the

seventeenth. They have a fifteen-barrel brewhouse with plans to produce three thousand barrels per year. The name Lucky Envelope comes from their Chinese-American heritage—coins are strung on a red ribbon from the older generation to younger generation during the lunar New Year, meant to bring good fortune.

By 2015, Silver City Brewery was the oldest brewery west of Seattle and became the first brewery outside Seattle to brew the official Seattle Beer Week beer, Sieben Brau, or seven beer, for the seventh annual event. With double-digit growth, it sold its ten-barrel brewing system to Cloudburst Brewing and upgraded to a thirty-five-barrel system.

Homebrewer Shane Noblin opened New Boundary Brewing in Cheney in late May 2015. A native of Oregon, Noblin was working in Alaska, running a print shop and homebrew supply store, but he wanted to start a brewery. He and his wife, Melanie, drove across Washington looking for a location and settled on Cheney. With a five-barrel system and catalogue of two hundred recipes, Noblin plans to keep five of his nine taps for his own beer.

On June 19, 2015, Wet Coast Brewing opened in Gig Harbor. Founded by Bryan and Molly Copeland and Aaron and April Johnson, they brew on a three-and-a-half-barrel system with plans to bottle and can their beers.

Hellbent Brewing opened in May 2015 in Seattle. Head brewer Brian Young had previous brewing experience before starting Hellbent with Chris Giles, John A. Guinn and Randy Susumu Embernate. This shows a brewer at the brewing equipment. *Hellbent Brewing Company.*

Aaron was a homebrewer, but "Bryan is really good at putting recipes together. We're designed after the Prohibition era, kind of like a speakeasy," Johnson said.

Almost all the owners of Dreadnought Brewing have a tie to the military: founder Steve Huskey and his wife, Anne, were both in the army; Steve's father, James, was in the Marine Corps; Kristi Browne was in the air force; and Sandra Jordan's husband, Sean, was in the navy; The other owners are Clinton Langevin, Kyle McFarland and Heath Clark. Huskey had been homebrewing since 1991 but took a break and restarted about 2005. He decided to go commercial after getting good feedback from friends and opened on June 25, 2015, in Monroe.

GSP Craft Brewing in Gig Harbor was started by husband-and-wife team Jim and Nancy Giacolone in 2013. The name derived from their two German Shorthaired Pointer (GSP) dogs. As longtime homebrewers, they built their brewery without any public or private financial aid and opened in late June 2015.

In early July 2015, Yakima Craft Brewing Company owner Jeff Winn put the business up for sale. Family matters in Boise, Idaho, and the ability to make the business a regional brewery are what led to his decision. "What I don't want is to have somebody come in from the outside, snap it up and move it somewhere else," he said. "My first dedication is to Yakima, and my first preference is that the brewery continue in Yakima. We're in a position where we can pick and choose and find the right buyer. The idea is to produce more beer and get it farther afield. This brewery is capable of being a regional brewery, and that's the next challenge."

Brier Brewing was started by Morgan Ferry in Brier in the summer of 2015. The nanobrewery and taproom are located in his home but are not open to the public. The custom-built half-barrel system is regulated by a controller designed, built and programmed by the software engineer.

Barrel Mountain Brewing opened in Battle Ground in July 2015. Founded by Troy Steigman, the fifteen-barrel brewhouse is manned by Ryan Pearson, who attended Siebel Institute of Technology brewing school.

Another brewpub opened in Spokane in early July 2015 when ten-barrel Benniditos Brewpub opened. It was founded by Chris Bennett, who owns a pizzeria of the same name, with Zach Shaw as head brewer. Shaw was co-owner of the Pacific Hop Exchange in California and "was part of the '90s Bay Area brewing scene that spawned the likes of Lagunitas and Russian River."

Nine Yards Brewing opened in late July in Kenmore. It was founded by Andrew Rogers, Ethan Savaglio and Paul Holzknecht.

Destiny City Brewing opened in Tacoma in early August 2015. Founded by Ben Brown and Aaron Poole, they operate out of Brown's garage. The

former homebrewers brew on a half-barrel system while keeping their full-time jobs. "We learn something new every week," said Poole.

Josh and Whitney Norris of Half Pint Pizza in Tacoma and partner Calvin Treible were preparing to open Sluggo Brewing Company adjacent to the restaurant when thieves smashed the front window in late July 2015. Over a four-hour period, thieves came and went, looting his bicycle- and skateboard-themed brewery. A fundraiser was established by friends and raised several thousand dollars. Named after longtime record store Sluggo Music, the "mini-micro" brewery opened in September 2015.

Friends Dane Scarimbolo and Garrett Burnside started Apocalypse Brewery in 2013 in Kent after graduating from college. Dominique Torgerson and two others later joined. They were forced to change the name in early 2015 due to legal conflicts, and it became Four Horsemen Brewery. It has a three-barrel brewhouse not open to the public.

In late August 2015, Lopez Island Brewing brewed its first batch of beer. Located on Lopez Island, the brewery was started by Michael and Cecelia Noreen, with former homebrewer Mike brewing.

Flying Bike Cooperative Brewery is a member-owned cooperative brewery that features member beer recipes and member input in all aspects of the business. It welcomed Kevin Forhan as its first employee and head brewer, whose previous work included Big Time Brewery, Pike Brewing Company and Elysian Brewing Company. His last position before joining Flying Bike was as regional brewer for the Ram restaurant chain. It brewed its first batch on July 1, 2015, in its seven-barrel brewhouse in Seattle, next door to Naked City Brewery and Taphouse, and officially opened its doors on August 15, 2015.

Mount Vernon's Skagit River Brewery head brewer Mike Armstrong departed the brewery in 2015 after eighteen years to co-found Farmstrong Brewing Company in Mount Vernon. Co-founders included Todd Owsley and Daniel Cameron. Owsley previously started Superior Beer Distribution LLC to focus on craft beers but later sold to Odom Corporation. The brewery came together rather quickly when Skagit River Brewery offered its twenty-barrel brewhouse to it. In turn, it would begin to contract-brew all of Skagit's beer. It was licensed in late June 2015, and the brewery officially opened on September 19, 2015. Its plan is to focus on Northwest-style beers, and the flagship will be made from Skagit Valley wheat, barley and local hops.

Washington State University operates the Mount Vernon Research Center in Skagit Valley, where it tests thousands of strains of barley and other plants. Skagit Valley Malting Company was founded by Wayne Carpenter in Mount Vernon in 2010 and opened in 2014 to produce on-demand custom malt for brewers and distillers. The wheat and barley is grown in Skagit Valley with help

from WSU and then malted by Skagit Valley Malting Company, which owns proprietary software and equipment to accomplish the task. "We've had visits from the top malters in the world," Carpenter said. "We've been told that no one in the world is doing what we're doing." They can provide distillers and brewers with unique malt flavors not previously available.

Michael Difabio and Mark Doleski started Fortside Brewing Company in Vancouver in May 2015. "Mark and I have both been home brewers for many years," said Difabio. They have a 3,900-square-foot brewery and taproom and fifteen-barrel steam-fired brewhouse. Their grand opening was in mid-September.

R.J. and Kristi Whitlow opened 5 Rights Brewing Company on July 2, 2015, in Marysville. R.J. was a homebrewer for more than twenty years, picking up styles he liked while traveling. "I didn't like beer until I tried real European beer." Mike Floyd of Greater Everett Brewer's League got R.J. back into brewing after a break. R.J. interned at Reuben's Brews and started gathering equipment until it was time to launch the brewery. The brewery is in their garage, so there is no taproom and only growler fills.

Awkward Brewing was launched in Lake Stevens on July 20, 2015, by Amanda Poliak. It began in 2008 when her husband had a goal of trying 365 new beers in one year. He surpassed that goal, and together they began homebrewing. They trademarked the brewery name and began the process to start a brewery, even though both have full-time jobs. Amanda brewed on a Brew-Magic system, eventually upgrading to be able to brew a half barrel at a time. "I basically sell out everything I make," she said. "It's been great."

Bavaria Brewing Company was opened on July 24, 2015, in Sammamish by Don Oehlecker. "We strive to bring back a type of beer that was brewed for hundreds of years throughout the southern regions of Germany."

"The idea of Badass Backyard Brewing started in my garage with some buddies one afternoon while brewing on a homebrew setup," said Charlene Honcik. A homebrewer for five years, she brews in a shop in her Millwood backyard and opened in August 2015. Honcik plans to install a fully automated two-barrel pilot system and open a taproom.

Beardslee Public House was founded by celebrity Chef John Howie. Established in 2014, the ten-thousand-square-foot brewery, restaurant and distillery opened in Bothell in August 2015. Brewing on a ten-barrel system is former Big Time Brewery and Pike Brewing Company brewer Drew Cluely.

Bob Stallone had been homebrewing since the 1970s. In December 2014, he started Thirsty Crab Brewery in Langley on Whidbey Island. The small brewery opened in 2015, and the beer is available at several locations on the island.

Wobbly Hopps Brewery was started by Jon and Sheree Jankowski in Bremerton. Jon was a homebrewer and started planning in July 2014. In

February 2015, they purchased a building downtown, where they set up a five-barrel system and opened their doors on September 5, 2015.

In early September 2015, Fox Island Brewing opened up on Fox Island. With twenty years of homebrewing experience, Jim Dignam started the brewery in his garage. The beer is initially being sold through Zog's, a beer garden on the island. Dignam also grows his own hops, saying the the soil is well suited for it.

Bellwether Brewing Company opened on September 29, 2015, in Spokane, founded by Dave Musser and homebrewer Thomas Croskrey, who is the head brewer. His goal is to bring back Old World styles such as braggot and gruit. They have a one-and-a-half-barrel brew system.

On October 6, 2015, a new twist in the merger game took place when Pacific Brewing & Malting Company of Tacoma announced that it had entered into an agreement with American Brewing Company of Edmonds to acquire its brewery and related business operations. "We are excited about the opportunity to continue the tradition of innovation that American has started," stated Pacific Brewing co-owner Brent Hall. "The addition of the American brand will complement our growth strategy and give us a larger presence in Washington craft beer." American would continue to run its other businesses.

Crucible Brewing Company was founded by Richard Mergens and Shawn Dowling in March 2015. He had previously worked as a brewer at Mac & Jack's Brewery for two years before moving to Hi-Fi Brewing for a short time and then Redhook Ale Brewery, where he spent nine months before starting Crucible. The brewery opened in Everett on October 2, 2015.

On October 17, 2015, the grand opening of Double Bluff Brewing Company took place in Langley on Whidbey Island. Started by Daniel Thomis and his wife, Marissa, he is originally from Switzerland and moved to the States to attend college. The couple lived in Boston for twenty years, during which time Daniel used his chemistry background to homebrew. In 2013, they decided to move to Whidbey Island after taking an online test that gave that location as their only choice of destinations. They moved in November 2014 and started planning the brewery after arriving.

On October 24, 2015, Trap Door Brewing opened its doors in Vancouver, founded by Bryan Shull; his sons, Zane and Zakary Singleton; and investor David Forster. Zane earned his degree at University of California–Davis and is head brewer on a fifteen-barrel system. Although new to the brewing industry, Shull said, "My father and grandfather both worked for Great Western Malting for years. Brewing has been in the family." Trap Door has a neighborhood "Co-Hop" where local residents grow their own hops with rhizomes provided by the brewery. "We'll create special brews celebrating the neighborhoods the hops are grown in."

Bolton "Bolt" Minister had a slightly different route to becoming a brewer. "I was a history major at Washington State University in Vancouver, where I wrote several papers on German immigration and the brewing industry. So it was a historical interest in the growth of the American brewing industry that first got me brewing beer with my wife at home." His first job was at Philadelphia's Steaks & Hoagies in Sellwood, Oregon. He then went to Astoria Brewing Company in Astoria, Oregon, before moving to Rock Bottom Inc. in Portland, Oregon, and then becoming brewmaster at Old Town Brewing, also in Portland. In December 2014, Minister suddenly parted ways with Old Town Brewing. His partner in the new project was Charlie Hutchins, whom he met while working at Rock Bottom. "We complement each other's skill sets really well," Minister said. 54°40' Brewing Company opened in Washougal on October 24, 2015 and will be the third brewery in the town. It has a fifteen-barrel brewhouse and offers its beers in bottle and draft.

In April 2015, Cody Morris of Epic Ales and GastroPod in Seattle announced that he was opening a new restaurant and brewpub in Seattle called Mollusk. By August, Morris and head chef Travis Kukull had changed their plans, and on September 11, 2015, Gastropod and Epic Ales closed their doors so they could concentrate on their new brewpub with a seven-barrel brewhouse. Mollusk opened its doors on October 31, 2015.

Dunagan Brewing Company opened on November 10, 2015 in Tacoma. Owner Jesse Dunagan worked in California and said that the San Diego brewing scene is why he decided to start a brewery.

Carl and Stephanie Leach opened North 47 Brewing Company in late November 2015 in Tacoma. They have a three-barrel brewing system in the new brewery.

Resonate Brewery + Pizzeria opened on November 10, 2015, in Bellevue, even though the brewery wasn't quite ready. Founded by Mike Ritzer, it features fresh pizza and a variety of beers.

Optimism Brewing Company opened in Seattle in late November 2015. Founded by husband-and-wife team Troy Hakala and Gay Gilmore, the brewery took some time to come together. Troy has never liked corporate beer, but while living on the East Coast he learned about Samuel Adams Beer. After reading about founder Jim Koch, he decided that he wanted to start a brewery. He began homebrewing in 1992 and then worked in a different field until 2013, when they began planning the brewery.

In early 2014, John Fosberg announced that he was opening Gig Harbor Brewing Company in Gig Harbor. But after "an exhaustive nine-month search," they had to look outside the area and found a location in Tacoma. Fosberg is one of the organizers of the annual Gig Harbor Beer Festival held in May of each year. The brewery, and its ten-barrel brewhouse, is run by

head brewer Bethany Carlsen, who previously was a head brewer with Big Horn Brewery. It was ready to open on August 15, 2015, but it had a major electric problem that delayed the opening until late November.

Tasha and Jesse Wilson met while they both worked at Hale's Ales. Tasha worked there from 2010 to 2012, where she started bottling beer and worked her way up to cellar manager. She took a break to have a baby and then worked at Sound Brewery in 2015. Jesse graduated from Western Washington University with a degree in history and decided that he wanted to brew historical beer styles. He worked at Hale's Ales from 2011 to 2012 and then went to Port Townsend Brewing, where he was an assistant brewer. In August 2014, they raised more than $31,000 to start Lovecraft Brewing Company in Bremerton. They have a three-barrel brewing system and taproom and opened in late November 2015.

Structures Brewing opened in Bellingham in late November 2015, started by former Pittsburgh, Pennsylvania homebrewers James Alexander and Ryan Miller. They have a small adults-only taproom.

Winery Des Voigne Cellars in Woodinville opened one of the first legal breweries inside a winery on December 12, 2015, when B-Side Brewing made its debut, allowing customers the opportunity to sample wine or beer.

Steve Luke started working for Allagash Brewing while in college and then went to Captain Lawrence Brewing (in New York); moved to the marketing department at Harpoon Brewery in Boston, Massachusetts; and then went back to Allagash "and worked my way up to the brewhouse." He became head brewer at Cambridge House Brewpub in Connecticut and attended the brewer's program at University of California–Davis. His wife took a job in Seattle, and he became head brewer at Rogue's Issaquah Brewhouse. "After a year there, Dick Cantwell drunkenly offered me a job at the Cask Beer Festival, and I held him to it." It was about 2011 when he started working at Elysian Brewing Company in Seattle, "primarily developing new recipes and experimenting with new hops and other ingredients." He is the genius behind Peach Pumpkin Ale and Space Dust IPA and headed up Elysian's barrel aging and sour programs. In January 2014, Luke started Cloudburst Brewing (with a dozen silent partners). He purchased Silver City Brewery's ten-barrel brewing system. The brewery opened on January 7, 2016 and is a taproom only.

Mike and Annette Hatten own a restaurant and fruit stand in Naches. Mike was a homebrewer who has medaled in competitions. He opened Bron Yr Aur Brewing Company behind his current businesses in early January 2016.

In July 2015, the Local Public House in Bellingham and Menace Brewing of Ferndale started a fundraising campaign to raise money for a major expansion. While the expansion would help Local Public House, it would

also house Washington's first nonprofit brewery, The Bellingham Beer Lab. The Beer Lab would "serve as a brewery incubator as well as an open creative space for home brewers, professional brewers and all those interested in the craft beer industry." The expansion and lab are expected to open in 2016.

Chambers Bay Brewing Company is a small nanobrewery in University Place. Started by Tim Cosgrove, Brian Coy and Shawn Svetich, they expect to open in 2016.

Tony Luciano began brewing in 1998 when he met Whatcom Brewery Incorporated founder Lloyd Zimmerman on a ferry to Alaska. While taking an organic chemistry class at Western Washington University, it all came together. "The teacher was explaining all the enzymes and chemical reactions, and I was like, 'Hey, those are things I read about in my beer books—will you explain it?' He did, and my beer got pretty good." Luciano started Stones Throw Brewing Company in 2013 with Jack Pflueger in Bellingham. The pair moved into a house on a residential street in Fairhaven where they began work on the brewery. Built in the backyard with shipping containers, the garage became a taproom with radiant floor heating using expelled heat from the beer coolers. The brewery will open in 2016.

The Incubator Brewery is a new concept in Spokane, announced in early 2015, but it didn't get off the ground until late summer. Chris Batten of RenCorp Realty is behind the idea to allow up to five breweries, or homebrewers, to share equipment and test their beer. Young Buck Brewing Company and Little Spokane Brewing Company are the first two announced for the project, with plans on opening in early 2016.

Several breweries announced expansions and several were in the construction phase as this book went to press, including Subdued Brewing, Illuminati Brewing and Gruff Brewing, all in Bellingham. Ravenna Brewing Company in Seattle, Triple Point Brewing in Kirkland, Iron Hop Brewing in Woodinville and Quartzite Brewing Company in Chewelah are all scheduled to open in 2016.

Washington has an amazing brewing history with some very sustaining brands, like Olympia Beer and Rainier Beer. Like many brands in many cities, they changed ownership over the years, but they were founded here and have their fans.

The current craft beer industry is unlike the days of the past in so many ways, yet it bares much resemblance to it at the same time. Starting with people like Bert Grant and Charles and Rose Ann Finkel at Pike Brewing Company, a new wave of breweries and brewpubs has emerged. Growing at an incredible pace, the number of breweries far surpasses what Washington had before Prohibition. But like the way brewers built a brewery with a saloon that became the neighborhood congregation place, this new wave is

doing much the same thing. Each has its own identity and tries to attract its own core group of customers.

How the industry has influenced itself is a story in itself, trying to follow an employee of one brewery as he or she starts his or her own brewery. The number of brewers who came out of Thomas Kemper Brewery, Pike Brewing Company or Big Time Brewery, or countless others, shows how the industry has fostered its own growth.

As long as the state of Washington continues to grow, the number of breweries that stay open for the long term may be endless. There will probably be some morphing of the industry as it settles and new breweries stop opening weekly. Until that time, enjoy it while you can, as every new brewery opening is another page in the Washington history books. It's a mighty fine time to drink a Washington beer.

BIBLIOGRAPHY

For additional citation and source information, see the document attached to the book's product page at arcadiapublishing.com.

Books

Bagley, Clarence. *History of Seattle from the Earliest Settlement to the Present Time.* Chicago: S.J. Clarke Publishing Company, 1916.

Becker, Bart. *Seattle Brews.* Bothell, AK: Northwest Books, 1992.

Brewers and Bottlers Universal Encyclopedia. Chicago: Brewers Publishing Company of America, 1910.

Craemer, Josef Ludwig. *The Royal Bavarian Castles in Word and Picture.* Munich: self-published, 1900.

Dunlop, Pete. *Portland Beer: Crafting the Road to Beervana.* Charleston, SC: The History Press, 2013.

Galenson, Walter. *The CIO Challenge to the AFL: A History of the American Labor Movement, 1935–1941.* Boston: Harvard University Press, 1960.

Giddins, Gary. *Bing Crosby: A Pocketful of Dreams, the Early Years 1903–1940.* Boston: Little, Brown and Company, 2001.

Grant, Frederic James. *History of Seattle, Washington: With Illustrations and Biographical Sketches of Some of Its Prominent Men and Pioneers.* Seattle, WA: American Publishing and Engraving, 1891.

Hines, Harvey K. *An Illustrated History of the State of Washington.* Chicago: Lewis Publishing Company, 1894.

Hirsch, Maurice L. *Advanced Management Accounting.* N.p.: Cengage Learning EMEA, 2000.

An Illustrated History of Southeastern Washington, Including Walla Walla, Columbia, Garfield and Asotin Counties, Washington. N.p.: Western Historical Publishing Company, 1906.

Krebs, Peter. *Redhook.* New York: Four Walls Eight Windows, 1998.

Lyman, William Denison. *Lyman's History of Old Walla Walla County, Embracing Walla Walla, Columbia, Garfield and Asotin Counties.* Chicago: S.J. Clarke Publishing Company, 1918.

Meeker, Ezra. *Hop Culture in the United States: Being a Practical Treatise on Hop Growing in Washington Territory.* Puyallup, WA: E. Meeker & Company, 1883.

————. *Ventures and Adventures of Meeker, Ezra: or, Sixty Years of Frontier Life.* Seattle, WA: Rainier Printing Company, 1909.

Meier, Gary, and Gloria Meier. *Brewed in the Pacific Northwest.* Seattle, WA: Fjord Press, 1991.

Men of the Pacific Coast: Containing Portraits and Biographies of the Professional, Financial and Business Men of California, Oregon and Washington, 1902–1903. N.p.: Pacific Art Company, 1903.

Moore, Stephen T. *Bootleggers and Borders: The Paradox of Prohibition on a Canada-U.S. Borderland.* Lincoln: University of Nebraska Press, 2014.

Musson, Robert A. *Brewing in Cleveland.* Charleston, SC: Arcadia Publishing, 2005.

One Hundred Years of Brewing: A Complete History of the Progress Made in the Art, Science and Industry of Brewing in the World, Particularly During the Last Century. Chicago: H.S. Rich and Company, 1901.

Prosch, Charles. *Reminiscences of Washington Territory: Scenes, Incidents and Reflections of the Pioneer Period on Puget Sound.* Seattle, WA: Frontier and Pioneer Life, 1904.

Prosser, William Farrand. *A History of the Puget Sound Country, Its Resources, Its Commerce and Its People.* Puget Sound, WA: Lewis Publishing Company, 1903.

Rizzo, Michael F., and Ethan Cox. *Buffalo Beer: The History of Brewing in the Nickel City.* Charleston, SC: The History Press, 2015.

Salem, Frederick William. *Beer, Its History and Its Economic Value as a National Beverage.* Hartford, CT: F.W. Salem & Company, 1880.

Schneider, Stephen. *Iced: The Story of Organized Crime in Canada.* Mississauga, ON: John Wiley & Sons, 2009.

Sketches of Washingtonians: Containing Brief Histories of Men of the State of Washington. Seattle, WA: W.C. Wolfe & Company, 1906.

Stover, Karla Wakefield. *Hidden History of Tacoma: Little-Known Tales from the City of Destiny.* Charleston, SC: The History Press, 2012.

Stream, Kurt. *Brewing in Seattle.* Charleston, SC: Arcadia Publishing, 2012.

Thomson, E.A. *Cartoons and Caricatures of Seattle Citizens.* Seattle, WA: General Lithographing & Printing Company, 1906.

United States Brewers' Association Thirty-Second Brewers' Convention. New York: N.Y. Economical Printing Company, 1892.

A Volume of Memoirs and Genealogy of Representative Citizens of the City of Seattle and County of King, Washington: Including Biographies of Many of Those Who Have Passed Away. New York: Lewis Publishing Company, 1903.

Yenne, Bill. *Great American Beers.* St. Paul, MN: MBI, 2004.

PERIODICALS AND OTHER SOURCES

American Brewers' Review. September 1898–November 1916.

American Carbonator and American Bottler. March 1904–December 1904.

Banking Law Journal. January 1933.

Beercanhistory.com. "ABC's of Cans (A to D)." http://beercanhistory.com/abcs.htm.

Best's Insurance News. October 10, 1921.

The Brewers' Journal and Barley, Malt and Hop Trades' Reporter, and American Brewers' Gazette, Consolidated. New York, various dates.

Cases Determined in the Supreme Court of Washington. Vol. 102. Bancroft-Whitney Company, 1918.

The Coast. Honor L. Wilhelm, Coast Publishing Company, 1908–9.

Coopers International Journal. August 1906.

The Federal Reporter: Cases Argued and Determined in the Circuit District Courts of the United States. Vol. 47. West Publishing Company, 1892.

Grain Dealers Journal. "Grain Trade News." September 25, 1906.

Ice and Refrigeration. February 1910.

Industrial Refrigeration. September 1912.

National Archives. "Teaching with Documents: The Volstead Act and Related Prohibition Documents." http://www.archives.gov/education/lessons/volstead-act.

The Pacific Reporter. Vol. 120. 1912.

Reports, Addresses, Proceedings of the Annual L.N.A. Convention. Vol. 48. New York: United States Brewers' Association, 1908.

Sick, Emil G. *Memoirs of Sick, Emil G.* N.p., 1971.

State of Washington Tenth Biennial Report of the Secretary of State, 1907–08. Olympia, WA: C.W. Gorham, 1909.

Washington Public Documents. Vol. 3. Washington State, 1906.

Western Brewer: And Journal of the Barley, Malt and Hop Trades. N.p.: Gibson Publishing Company, various years.

The Wine and Spirit Bulletin. Bulletin Publishing Company, June 1915.

INDEX

INDEX

Index